LIVES and WORKS
Talks with Women Artists

Lynn F. Miller/Sally S. Swenson

The Scarecrow Press, Inc.
Metuchen, N.J., & London
1981

Frontispiece by Lore Lindenfeld (photo by Jon Daniels)

Library of Congress Cataloging in Publication Data

Miller, Lynn F.
 Lives and works, talks with women artists.

 Contents: Louise Bourgeois -- Judith
Brodsky -- Radka Donnell-Vogt -- [etc.]
 ·1. Women artists--United States--Interviews.
2. Feminism and art--United States. 3. Art,
Modern--20th century--United States.
I. Swenson, Sally S. II. Title.
N6512.M518 709'.2'2 [B] 81-9043
ISBN 0-8108-1458-7 AACR2

CONTENTS

Introductions iv

Louise Bourgeois 2

Judith Brodsky 15

Radka Donnell-Vogt 37

Deborah S. Freedman 57

Frances Kuehn 74

Lore Lindenfeld 91

Cynthia Mailman 106

Alice Neel 121

Howardina Pindell 130

Faith Ringgold 157

Betye Saar 176

Susan Schwalb 185

Nancy Spero 202

May Stevens 213

Amy Stromsten 228

For my children,
Jennifer Lyn Miller
and
Jonathan Daniel Miller,
in hope that they read
of these lives and
learn to shape their own

INTRODUCTION I

Since 1971 I have worked with
the artists whose lives are
documented in the following
interviews, as well as with
many others, arranging ex-
hibits, corresponding by letter,
and conversing by telephone.
All their lives are worthy of documentation, and the neces-
sity of selection for a book format is a cause of some sad-
ness to me because of those who are not included here.

As coordinator of the Women Artists Series at the
Mabel Smith Douglass Library of Douglass College I installed
almost one hundred art shows working side by side with these
women. We talked about their work and my own and about
our lives. The way that women synthesize life and art in a
unifying vision--the process of interplay between the shapes
of their lives and the way they shape their work--began to
impress me as a unique aspect of the creative process.

Through the energies and actions of the women's move-
ment in the 1970s I have learned this about women and their
art: whether or not there is a female iconography or a fe-
male aesthetic, there is a woman's life lived in a woman's
body. The life stories gathered here from women of various
ethnic and cultural backgrounds, women who work in a wide
diversity of media, styles, and techniques, demonstrate for
me that drive toward synthesis that is the common element
in the work of women artists. It is the fact of being women
that unites us. I am not sure if it shows in the work. I
know that it shows in the lives. By reading about these
women's experiences in art making and in the art world, we
all may discern the thread that unites us.

Pulling together all the pieces into one whole work is
something that women artists do. Quiltmakers have done it
as part of American tradition for years. Putting our lives
together, putting our works together, putting a women's move-
ment together, all from fragments that to others may often
seem disparate--these are basic creative acts. In some
ways then, Radka Donnell, quiltmaker, speaks almost meta-
phorically for all women artists when she describes her

iv

evolution--not in the specifics of her unique life, but because quilting stands for the act of piecing together the life and the work.

The idea for this book emerged from a meeting between Sally Swenson and me. Sally had come to the Douglass Library when I was curating the Women Artists Series; she wanted to introduce herself to me both as an artist and as a trained oral historian of art. She wanted to meet and interview the women artists whose work I had been showing in the Series, of which she had heard. After several talks, we agreed that she would collect taped interviews with some of these women and that these tapes, serving as documentation of varied lives and styles, could be part of the Rutgers Libraries in some way. Sally gathered all the interviews (except for the Radka Donnell piece), and I agreed to find a publisher, to have the tapes transcribed, and to edit the transcripts and the book. What you will read are interviews, gathered by Sally, with women artists I had chosen for exhibition, selected by both of us, and edited by me.

I would like to extend special thanks to Laura Bell and Mary Jane Jamicky for transcribing into typescripts the cassettes of interviews. Thanks also to Enid Dame for research assistance. To coauthor Sally Swenson, an artist and a trained oral historian of art, special thanks for her patience with and understanding of my life and work problems.

LYNN F. MILLER

New Brunswick, New Jersey

For my mother,
Bertha Nolan Shearer

INTRODUCTION II

To be an artist of any serious-
ness is a terrible struggle,
but to be an artist who is a
woman is many times more
difficult. Why is this true?
Where are the serious women
artists?

The search for answers to these questions was what
drove me to be involved with this book. It occurs to me that
the most important element that ties all women artists to-
gether is the pieces of their lives. Women artists must work
in pieces--pieces of time, pieces of money, pieces of materi-
als. Women have always had the leftovers from society with
which to work. Even so they have accomplished memorable,
if not at times great, work. The handmade quilts of the past
and present are a fine example of what women with creative
gifts can accomplish with leftover fabric and leftover time.

For many years I have been interested in reading and
listening to artists speak about their work and lives. I have
found that the lives of men artists both alive and dead have
been well documented. Artists who are women, however,
have been sadly neglected; not only their work has been over-
looked, but their lives and ideas as well. It is just now that
the work of women in all fields is being recognized. Listen-
ing to these women speak about their work has made me re-
alize the need for women artists to communicate with one
another. I found a thread that runs through all the artists'
lives: they have worked almost totally by themselves, in
isolation. Even though some got support from family and
friends, support from the art world and the world at large
was absent. The artists ranged greatly in age and in their
chosen media and styles. Although their lives and ideas vary
greatly, they often faced similar problems, problems partic-
ular to women. They often have had to earn a living, or
raise and care for children, and still make art--which until
recent years has been difficult if not impossible to show.
Museums and galleries are just now beginning to give atten-
tion and credit to the work of women artists.

I believe that it is important to state that because I

vi

am an artist my approach in the interviews is somewhat different from that of an art historian. Mine is a nonhistorical position. I dealt with each interview from the standpoint of what each artist was saying about her work. It is an intuitive approach, and I concentrated the bulk of my questions on the development, focus, and meaning of the artist's work: when did she know she wanted to be an artist; who helped her and gave her support; where did she receive her schooling; which artists influenced her and were mentors. The main part of each interview was a discussion with the artist about her work as it is now, and how it has developed and is continuing to develop. It was imperative to know how these women felt about the feminist movement; for no matter where they stand on this issue, they all have enlightening thoughts about feminism today. It was interesting to find that many of the artists experienced some form of prejudice in relation to their work.

One of the purposes of this book is to provide role models for young women. It is important for them to know that other women have been, are being, and will continue to be a major artistic force, and that it is now possible for women artists finally to get credit and exposure and be collected--and to be understood and appreciated in their own right. These women have woven their lives through their art. Their inspiration comes from that source, from their highly personal yet isolated selves. This gives their work a special and powerful force and beauty.

SALLY S. SWENSON
Pittstown, New Jersey

"Mothers and Daughters," by Sally S. Swenson (1980)
Mixed media, 4'6" x 2'9"
Photo credit: Sally S. Swenson

LIVES
AND
WORKS: Talks with Women Artists

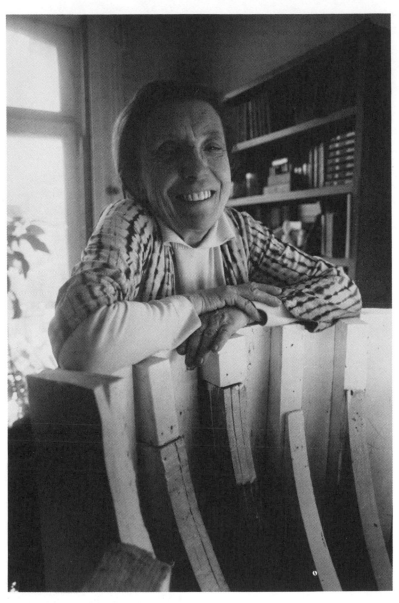

LOUISE BOURGEOIS, sculptor, was
born in Paris and was educated at the
Lycée Fenelon (Baccalauréat, 1932);
the Sorbonne, 1932-35; the Ecole du
Louvre, 1936-37; the Academie des
Beaux-Arts, 1936-37; the Academie de
la Grande Chaumière, 1937-38; and the
Atelier Fernand Léger, 1938. Her work
appears in the Museum of Modern Art;
the Whitney Museum; the Fogg Art Mu-
seum, Cambridge, Massachusetts; New
York University; and others. Bourgeois
now lives in New York City. A selected
bibliography of writings about her work
includes Daniel Robbins, "Sculpture by
Louise Bourgeois," Art International,
October 1964; William Rubin, "Some Re-
flections on the Work of Louise Bour-
geois," Art International, April 1969;
and J. P. Marandel, "Louise Bourgeois,"
Art International, December 1971. Her
exhibitions include the Whitney Biennial,
1973; Sculpture: American Directory
1945-1975, Washington, D. C., 1975; and
American Sculpture, University of Ne-
braska, Lincoln, 1970.

SS / How early in your life did you think you wanted to
become an artist? I know you studied other things
later?

LB / I became an artist, whether I wanted to or not, when
my parents, who repaired Aubusson tapestries, needed
someone to draw on canvas for the weavers. Very
early it was easy for me to draw the missing parts
of these large tapestries. There were always miss-
ing parts, whether an arm, a leg, or something else.
It was my duty to put it back on canvas. The idea
of being an artist did not occur to me, because from
the beginning doing "art" was a useful thing--for which
my parents were thankful. But it pleased them; I was
able to help them, and for me there was certain pres-
tige within the family in helping my parents. Later
the reasons for being an artist changed, and also
later I went to school seriously and I had no time
for drawing, for working with the tapestries. How-
ever, my first experience was drawing.

SS / I know you went to school and you studied other
things, including philosophy.

LB / Definitely. I went to lycée. Later, at the Sorbonne,
I studied geometry. I was able to see in mathemat-
ics some relationship between the point, the line, and
the plane, some relation among them that could be
the equivalent, that could symbolize the complicated
and difficult relationships that I had with members
of my family. For me, geometry became a symbol
for human relations, except that it was better, be-
cause in geometry things never go bad. If certain
things occur, if certain lines meet, an angle is born.
You cannot fail. It's not going to fail; it is eternal.
I found in rules of mathematics a peace and a trust
that I could not place in human beings. This sub-
limation was total and remained total. Thus, I'm
able to avoid or manipulate or process pain.

SS / In your work later that's true, too.

4

LB / It is true today. I am able to get along with people
 because I do my work, because my personal problems
 are translated and sublimated. Artists have access
 to a means that other people do not have, the use of
 deep motivation and sublimation.

SS / In your work I sense a very strong feeling of isola-
 tion and loneliness. Was that when you came to this
 country and the coldness of the city?

LB / No, that is not a physical loneliness, since I have a
 family and children; and in fact I'm not lonely at all.
 It is an existential loneliness that has to be. It is
 not a physical or actual loneliness. It is a loneli-
 ness that comes from somewhere else. I'm not quite
 sure that anybody knows that. But yes, of course,
 my work reflects alienation definitely.

SS / I was thinking maybe the alienation of the modern
 city, too?

LB / No, I don't think so, because after all I came to this
 country after marrying an American student and I
 never left New York. I am very fond of New York.
 I couldn't live anywhere else. No, I don't feel alien-
 ated in the city. It's a different kind of loneliness.
 It is a kind of loneliness that has to do with anxiety.

SS / Personal?

LB / Yes, very personal.

SS / Do you want to talk about your early development as
 a sculptor?

LB / If you are interested in solid geometry, which was
 what I was studying at the Sorbonne, then you might
 consider doing solid geometry making a sculpture.

SS / Yes, but I meant more in the physical, actual sense,
 when you started to make sculpture, after you came
 to the United States.

LB / Yes, the reason why was that suddenly I was lucky
 enough. My family, not my past family, but my
 descendants and myself moved to a place, a crazy
 place called Stuyvesant's Folly, on Eighteenth Street

and Third Avenue. This extraordinary building, which
has been torn down unfortunately, boasted a fantastic
mansard roof. The house was mostly used by a
writer and by people who were very quiet (nobody
ever went on the roof). Suddenly I had an open space,
which explains the size of my early sculpture. It was
working in open air in the sky. It was a fantastic
experience. It did influence me very much.

SS / Do you think the space that you work in, the size of
the room, affects your work a great deal?

LB / Definitely. In this set-up I have a backyard or a
garden, whatever you wish to call it, and I have ac-
cess to the street since I live in a brownstone. I
couldn't live anywhere but in a brownstone, by the
way.

SS / I know you work in various media; how does that af-
fect the quality of the piece? Do you have different
times, different moods, that make you work in dif-
ferent media?

LB / Well, the question of the medium is secondary to me.
Because I think that to be a sculptor is to have things
to say. I wouldn't say to have ideas because that is
intellectual. But there is something that you want to
say, and nobody is going to keep you from saying it.
This is really the basis of my occupation. The wish
to say something antedates the material; the material
is completely secondary. I'm not saying that mate-
rials are not important. I love materials. They are
important, but secondary. When you want to say
something, you consider saying it in different ways,
just as a composer would play in different keys, or
different instruments. Little by little, and generally
by a process of elimination, after trying everything
else, I find the medium that suits me. Sometimes
the same idea or subject appears in several different
media.

SS / In your work you do softer things as opposed to more
rugged. Does that have anything to do with male and
female? Do considerations of gender affect which
material you use, such as hard materials for the
male, for example?

LB / That is true, even though I do not design it that way.
 All my work from the beginning has to do with the
 relations of men and women. This being so, it does
 affect the material. Gender being part of the subject
 will determine what material is chosen. But the
 choice of material is not only conditioned by this; it
 is conditioned also by whether you want the piece to
 remain over time or to be a temporary work. When
 I work in latex (my last three shows were pure la-
 tex), I have to give up the idea that the work is eter-
 nal. It is not the same as marble, really. But with
 the kind of documentation that we have today the work
 can have a temporary span of time. It can be tem-
 porary because the documentation is almost as impor-
 tant as the work, which was not true in the past.

SS / I know you use plaster. These works are very frag-
 ile, but if they're not injured in any way, they should
 last.

LB / I have a great deal of liking for plaster, because any
 material that you can pour is really a very rich ma-
 terial. Compared with metal that you cannot manip-
 ulate to be what you want, plaster is very close to
 our emotions and very close to the kind of impetuous
 wish you have when you want to do something. Plas-
 ter will respond, but it is not strong.

SS / In much of your sculpture there seems to be a power-
 ful sense of confinement. Do you think that's due to
 the fact that women have been confined, or is this
 something else more personal than that?

LB / Confinement, where do you see confinement?

SS / In the sense that a house is confinement. Women
 have been confined in the home.

LB / Confinement is a very important problem for many
 women; it is an important problem, but it was not
 my problem. My primary problem was the disturb-
 ing sexual activities of my parents, of my father.
 That was my hang-up. So the confinement, no, that
 is not part of my experience. I broke away and
 moved to America.

SS / I was thinking of an emotional confinement. I was

thinking of the large piece at the Hamilton Gallery
show, the one surrounded by the fence.

LB / So you experience the fence around it as a fence.
Several people said that to me, but it wasn't. It
was not my intention. I'm always very happy when
people give me an interpretation that is a complete
surprise to me. It means that the piece functions
on many, many levels and will be able to stand many
interpretations. Now this was not my intention. It
was not a fenced-in instinct. The name of the piece
was "Confrontation," so that all the elements confront
each other and could not turn away from each other.
They had to face each other.

SS / In some of your pieces, I sense a frightening quality
as well as the erotic. Would you comment on that?

LB / You're referring to "Femme Couteau." I try to give
a representation of a woman who is pregnant and who
tries to be frightening. Now to try to be frightening
is not the same thing as being frightening. She tries
to be frightening but she is frightened. She's fright-
ened for the child she carries. And she's afraid
somebody is going to invade her privacy or bother
her in some way and that she won't be able to defend
what she's responsible for. Now the fact that she's
frightening is open to question. Some people might
find it very touching. She's frightened herself; she
tries to be frightening to others. Yes, but the preg-
nancy's very important to her, whether you consider
it erotic or not. It is erotic to me because it had
to do with the relation of the two sexes.

SS / And the end result of sex. It's also true that when
women are pregnant they are frightened, too. Maybe
the first time.

LB / I had this experience in the last week; some very,
very young women seemed to be completely unafraid
of having an abortion. Completely unafraid. I
couldn't have done that. I couldn't have considered
that. I feel all kinds of fears and think the fears
are different. Like in that particular piece, it is not
the childbirth, it is the physical vulnerability of that
belly that somebody could hurt.

"Confrontation" (1978)
Latex and wood environment, 60' x 20'
Hamilton Gallery
Photo credit: eeva-inkeri

SS / Yes, when I was pregnant I felt vulnerable, walking
 on the street. Do you think that women are more
 vulnerable than men?

LB / No, I don't think so. I think that we learn very
 well, and we become quite strong.

SS / Our defenses are different.

LB / Very. I think the difference is that women admit so
 easily to being terrified and men for some reason do
 not like that. They do not like to admit it.

SS / They have to keep up their image. It seems that in
 your work over the years you have a recurring
 subject. Would you like to say anything about that?

Even though you interpret it in very many different
ways, you seemed to always involve the same subject.

LB / I think that the work is consistent, but that is be-
cause the person remains the same and because the
problems have not been completely resolved. I'm
completely free from allegiance to material, as I
said. But on the other hand, I'm very consistent,
and faithful to my subject.

SS / In some of your pieces, like "Femme Couteau,"
there's a wrapped feminine figure. Is this wrapping
protective?

LB / I think we have talked about that before when you
mentioned the frightened and the frightening. The
fact that this woman is wrapped indicates that she's
frightened. She has to protect; it's a giveaway. Ac-
tually the knife is not an aggressive knife, it's a de-
fensive knife. It has the shape of a penis because
in her imagination she experienced the penis as a
weapon. So she steals a weapon in order to defend
herself. Now whether the whole problem comes from
sex or from the desire for survival is open to ques-
tion. The whole subject may predate sex. It is just
a matter of survival. Do you understand what I mean?

SS / Yes. This is like a fetish piece in a way.

LB / Oh, no, these are not fetishes at all.

SS / Were you ever influenced by so-called primitive
sculpture?

LB / No. In fact, I dislike it. Anybody who works with
symbols has to understand the vocabulary of the twen-
tieth century. This piece has to do with the sadness
that we talked about a while ago, the alienation. The
twentieth-century artist who uses symbols is alienated
because the system of symbols is a private one. Af-
ter you have dealt with the symbols you are still pri-
vate, you are still lonely, because you are not sure
anyone will understand it except yourself. The ran-
som of privacy is that you are alone.

SS / In your work you have your own language.

LB / Right. If you have the privilege of a private lan-
 guage, you have the danger of having nobody under-
 stand it except yourself.

SS / Your work is singular and revolutionary. Do you
 think of yourself as a revolutionary artist?

LB / No, I see myself, as several people have said, as
 an eccentric. Eccentric means away from the center,
 and that is true. I am not a revolutionary, but very
 independent, and this has been my great privilege,
 that I was able to be independent. This I appreciate
 very much. I was independent because I didn't de-
 pend on any dealer who said you had to do this or
 that. On the other hand, I have very modest tastes
 even today, and I am able to be independent.

SS / Do you think that's really important for an artist?

LB / Certainly. It's absolutely everything. The freedom
 to be yourself so that you do not hurt people and they
 do not push you back, so that you can circulate the
 way that you want, without objection, without pressure
 from others. It's a kind of equilibrium.

SS / You just mentioned dealers. What do you feel the
 best relationship between an artist and an art dealer
 is or should be?

LB / The best relation is if you expect nothing from each
 other. Dealers are only human, and artists expect
 much too much. A relationship is possible if it is
 so tenuous that it does last; it is tenuous, but it has
 to last. That has been my experience with dealers.
 I expect nothing from them. I don't mean they don't
 trust me. They do have trust in me, at the begin-
 ning, but then they lose that trust. At that point,
 instead of leaving and slamming the door, I say, "We
 didn't do too well this time, but I trust myself and
 I ask you to trust me the next time." It's not un-
 pleasant even though it's not very productive. But
 then in the end something does happen, something
 clicks, and it's your turn then to be on the art scene,
 and you're ready for it if you haven't expected too
 much. It's a very slow game.

SS / What advice would you give to younger artists coming
 along?

LB / I would say, please don't get the green disease and
 don't get the blue disease. The green disease is
 envy, and it is a disease that young people have to-
 ward older people. They are twenty-four, at the
 School of Visual Arts. Everybody sees themselves
 on West Broadway and a great success. If they
 could only be reasonable enough to see that this suc-
 cess on West Broadway usually is for those sixty or
 sixty-five and they are twenty-four, everything would
 fall into place. They are in danger of catching the
 disease of being so envious that they stop working.
 Green disease is deadly. You don't grow as an art-
 ist if you are envious. On the other hand, the blue
 disease is something else. The blue disease is young
 or old artists who feel that they are exploited. Well,
 they are not exploited at all. They are rather ig-
 nored, I would say. So those are the two dangers.
 Apart from that it is a rather nice road.

SS / It is really a lonely road.

LB / Well, lonely, of course.

SS / Don't you feel that if you count on outward acceptance
 and success, you're probably going to be discouraged
 because not very many people get that anyway? But
 you have to have success in your own work, and be
 happy with that. Isn't that the first step?

LB / You have to like your own work, right?

SS / I mean that's really what the greatest happiness
 should be, I would think.

LB / Right, that's the only one.

SS / Do you feel that you have ever had any problems with
 dealers or having shows because you are a woman
 and not a man?

LB / The men were treated as badly as I was. It's just
 that we artists are in a very difficult profession.
 The fact is that discrimination against women doesn't
 come only from men. In fact, I would almost say it
 comes mostly, in the art world, from women, be-
 cause it is the women who control the galleries. I
 wouldn't say control; I would say more galleries are

run by women. That there is discrimination against
women in the art world is absolutely true, but then
we can't blame it entirely on men. It is also true
that women are more difficult to sell. A collector
would rather not invest in a woman's work. So this
is not a mark against women artists, it speaks against
bad investment. It is not because of the feminine end
of it. It is because women's work doesn't sell so
well on the market.

SS / Do you think that's changing now?

LB / Well, some women charge very high prices for their
art, and some women are gifted and are going to get
good prices.

SS / This is the first century that women have experienced
this, don't you believe?

LB / In retrospect, Rosa Bonheur was laughed at for many
years even though she took herself very seriously and
was devoted to her own work. After being forgotten
for sixty years, the value of Rosa Bonheur's work
is coming out now.
 I have something to add, since we are dealing
with an interview. The whole morning I was inter-
viewed by someone else, and I was not able to stand
it. Video was there. The interview is a very hu-
man thing, and the interviewer has to be, in fact,
much more skillful than the subject.

SS / You think so?

LB / I do think so, definitely. That's what I have to say.
I add that the interviewers this morning did video,
insisted on photography. I detest photography myself;
it keeps me from thinking. The other thing is that
two interviewers came together. I was alone faced
with two interviewers, and I couldn't function at all.
Interviewing is a very delicate and interesting but
difficult work.

SS / I've done some interviews where there are two inter-
viewers and one person being interviewed. I don't
think it works.

LB / It's too much to ask for the person to be candid under

such conditions. I would like to add something else.
We all know there were lots of women artists in the
past. It is also true they were usually eldest daugh-
ters, in rivalry with their fathers, as a deep moti-
vation. A psychological study should be made of why
some women artists have such determination, where
it comes from, because they need it.

JUDITH BRODSKY, printmaker, was born in Providence, Rhode Island, in 1933. She attended Radcliffe College (B. A.) and the Tyler School of Art, Temple University (M. F. A.). A resident of Princeton, New Jersey, she served as the Associate Director of the Princeton Graphic Workshop, Inc. , 1966-68. Her work is in the collections of the Library of Congress, Washington, D. C. ; the Fogg Art Museum, Cambridge, Massachusetts; the New Jersey State Museum, Trenton; Princeton University; and others. Her exhibitions include Boston Printmakers, De Cordova Museum, 1971, and one-woman shows at Brown University, Rhode Island, 1973, and the New Jersey State Museum, 1975. She is Chair of the Art Department of Rutgers University in Newark, New Jersey.

Photo credit: Eve Shaw

SS / A good place to start would be your early years when you decided you might want to become an artist.

JB / I was drawing before I could walk or talk. My parents were very supportive and recognized the fact that I was interested in doing things that were visual. They sent me to Saturday morning art classes, and I had plenty of materials to work with at home. I just continued to draw for pleasure. It wasn't anything I was studying in school, because there isn't and wasn't any good art instruction in elementary school or junior high or high school. When I was getting ready to go off to college, my parents felt that since I had other skills and other areas that I was interested in it probably was not a good idea to go to an art school, but to go to a place where I could have a general liberal arts education and still be involved with art. I went to Radcliffe. There wasn't any major in studio, so I majored in art history, which I dearly love. As a matter of fact, I encourage young people, if they want to be artists, to go to colleges first rather than to art schools, and then to go to art school after that. They have to have some ideas, and it helps to learn about literature and about history and about art history, and then go on to get involved in their own work more fully. After I finished Radcliffe I started going to art school. We were living in Worcester, Mass., and I went to the Worcester Museum Art School for close to a year.

 This was back in the fifties, and then there was a lot of emphasis on home and children and all that. I had already married, and my husband and I both were eager to have children, and I had two children in quick succession. I didn't do anything with art for about five years. When they started school, I myself went back to school. By then we were living in Princeton, and I went to Tyler School of Art in Philadelphia; I did my M. F. A. at Tyler in the 1960s. The whole thing worked out very well. We'd all leave in the morning together, and we'd all get home from school in the afternoon together. I have a very sup-

17

portive husband, who was interested in my doing this;
I supported myself through Tyler because I had a
teaching scholarship. I was teaching art history at
Tyler while I was doing my studio work. I really
had very few years, about five years or so, when I
was not involved in a career. During those five years
I did other things.
 The year that I finished my M. F. A. , we had a
chance to go to Washington for the year. At that
time I was offered a permanent job at Tyler, but I
didn't feel I could take it at that point, because I
would have had to stay in this area, and it was a
nice opportunity to go to Washington. I was also
eager to be totally immersed in my own work, and
I knew myself only too well. I knew that if I got in-
volved in a heavy teaching schedule, I would meet
those demands first and I would not spend the time
in my studio that I needed to spend. The fact that
I would be going away for a year at that particular
point was very appealing, because I wouldn't know
anybody in Washington, I wouldn't have to get involved
in anything, and I could just spend all my time in my
studio. That's what happened, and it was a wonder-
ful year for me, and it was also the year that I really
started to exhibit actively. Because I wasn't teaching
and I didn't have those additional responsibilities, I
could go around to galleries, and show my work, and
get myself established. In retrospect, it was a very,
very good thing for me to have done. I had my first
purchases made by public collections that year; I
don't think I would have gotten off to such an active
start if I had continued teaching at that point. On the
other hand, it was very hard to get back into teaching,
because by the time I really wanted to, the whole sit-
uation had absolutely turned around, and there weren't
any jobs. When I came back to Princeton I was eager
to begin teaching again. I tried a few forays, but
nothing came of it for a year or so. I was geograph-
ically limited, because I wasn't willing to move to
other parts of the country. Then a teaching job came
along at Beaver College, and I was at Beaver from
1972 to 1978. I enjoyed it very much--a very nice
school. It wasn't a problem to go back into teaching
once I'd established my own routines and my own dis-
cipline as an artist. I've kept a very active exhibi-
tion schedule going during the years that I've been
teaching and I've also produced a tremendous amount
of work.

SS / Did you teach art history at Beaver?

JB / No. I taught studio. I teach printmaking. I teach
 lithography and silkscreen and etching and photography
 and the works, also, now that I chair the Art Depart-
 ment at Rutgers Newark.

SS / You said that you had been working in printmaking
 extensively for a number of years. When did you
 switch over to working on this solely?

JB / I didn't know anything about printmaking until I went
 to graduate school. I had been sure that I was going
 to become a painter or a sculptor, but I was required
 to take printmaking, and I fell in love with it, and
 I've been involved with printmaking ever since. How-
 ever, while I was at graduate school I was equally
 involved in painting. When I got out, I continued to
 paint as much as, if not more than, I did prints. I
 did buy a press very shortly after getting out, be-
 cause I discovered that you can't possibly be a print-
 maker unless you have access to a press, and there
 were no presses available in Princeton, where I was
 living with my family. I had to go either to Phila-
 delphia or New York to use a press, and it was to-
 tally unsatisfactory, so I bought my own. As a mat-
 ter of fact, I also got a lot of people started on print-
 making in the Princeton area at that time. I estab-
 lished a workshop for printmaking, which was the
 first serious printmaking workshop in New Jersey as
 far as I can tell. We taught a tremendous number of
 people to be printmakers, and since then, many of
 them have moved on to be active on the Printmaking
 Council of New Jersey.
 I also continued to paint, and I was showing my
 paintings. And then in 1971, my house and my studio
 burned down. I was very anxious to pick up instantly,
 and it was easier to pick up printmaking than it was
 to pick up painting. I did make an arrangement with
 Princeton University. By then they had an etching
 press, which they had bought from my printmaking
 workshop when it dissolved; we sold the etching press
 to Princeton University. So I used that press. There
 was then a big demand for my prints. I was showing
 my prints widely, and I had heard people's interest in
 new prints that I was doing. I was so anxious to get
 back to producing and exhibiting my work, and not let

the fire interfere with my progress--to continue my
momentum. It was then that I just started to produce
prints exclusively, and I haven't gone back to painting
since that time.

SS / Did you lose much in the fire?

JB / Lost everything. My paints ... I don't have any
paintings that I've done, except ones that were out.
Paintings don't sell the way prints sell, and so my
painting body of work was virtually destroyed. It
just doesn't exist.

SS / Do you have slides of them?

JB / The slides were destroyed. Everything was destroyed.
Fortunately, there were some photographs of my paint-
ings elsewhere. I was able to reconstruct a record,
to a certain extent, but not of the most recent paint-
ings I'd been doing, which I liked the best. It was
just a whole chapter gone out of my life, but it worked
out all right. One of the thoughts that I had was,
"Oh well, I don't have to bother with all that stuff
anymore. I can start fresh. Have a pre-fire period
and a post-fire period." All those art-school things
that you tend to save, all those got destroyed in the
fire, so I didn't have to worry about those, and weed-
ing them out, or anything. It wasn't so terrible. We
were OK, which was the most important thing. If the
fire had started in the middle of the night, chances
are that we wouldn't have been able to get out of the
house. We just felt so lucky.
 I'm now eager to move back into something that
isn't print, because I'm becoming more and more in-
terested in unique pieces, and less interested in pro-
ducing editions. Because my works are prints, I
can't sell them for the prices that one would sell a
unique piece for. I would like to keep going with
prints, but I'd also like to move into something that's
straight painting or straight drawing; it might be works
on paper and probably some photographic work. I've
been teaching photography and I've been considering
several photographic projects that I might do myself
that relate to my own work.

SS / Do you find it easier to show your prints because you
can show in many different areas, they're easy to

ship, and you can make multiples of them? Do you
think that's a good way for an artist to get known?

JB / It's a tremendously good way for an artist to get
known, and also for an artist to earn a living. There's
just no question about it; prints sell much better than
paintings do. Just in terms of survival, for anyone
who's a painter or a sculptor, I would really recom-
mend becoming a printmaker also, because it's such
a tremendous way to earn some money from your
art.

SS / There's been controversy in the last few years about
such very well-known artists as Helen Frankenthaler,
Louise Nevelson, and Robert Motherwell working with
printers at shops like Gemini and other print shops,
and then selling the prints for really exorbitant amounts
of money. What do you think of this? Do you feel
that this is ethical? After all, they don't do the
printing totally on their own; they oversee it.

JB / It's a very complex problem. And it's a very cur-
ious one, too, because in Europe they don't really
have this problem; they've always done prints that
way. Artists have always worked with printers. I
think we have a sense in the United States that unless
the actual artist executes every last bit of the work
down to whatever, then somehow it isn't authentic.
But I think it's fine for artists to work that way.
What I don't think is all right is for an artist just
to do a preliminary drawing, then to turn it over to
a master printer, who does all the transferring to the
stone or the plate and then just presents the finished
piece to the artist. I'm uncomfortable with that. But
I'm not uncomfortable with the idea of an artist hav-
ing a relationship with a printer where the artist is
involved with it all the way. I think the problem is
that there are so many printmakers who cannot afford
that kind of relationship, and so we all end up doing
our own printing, or having our students print with
us, or not printing our editions at all. I wish, as
good as the market is for prints, that it were even
better. I would judge a work of art--whether it's by
a printmaker who prints for himself or herself, or
whether it's by a Motherwell or Frankenthaler in con-
junction with a printer--on its aesthetic merits rather
than on the relationship of artist and printer.

I've done some talking about this with various people like June Wayne, who founded the Tamarind Lithography Workshop. She, of course, believes very strongly in the relationship between the artist and the printer. She also felt it gave jobs to printers, too. The printers themselves are often artists. It just opens up the ability for more and more people in the art world to earn a living through their art, rather than through other means.

I think it's too bad that prints by people like Motherwell and Nevelson and Frankenthaler are so expensive. I think the disparity between their work and prints that are done by artists who are primarily printmakers, who don't have a big name, who are doing their own printing, and who only get $100, $200, for each of their works versus $20,000 for a Motherwell or a Rauschenberg, is too bad. But that's a marketplace disparity. Actually I think that Nevelson, Motherwell, Frankenthaler, and Rauschenberg are some of the greatest printmakers of our century.

SS / There's a great intensity of color in your work. Would you like to discuss the relationship of drawing and color?

JB / I think that my involvement with color is probably an intuitional element in my art. I enjoy the color on a flat work. I don't think that my work necessarily has to involve color, but it does because that's my configuration as an artist. My work stems from a set of intellectual and aesthetic premises at the moment, and curiously enough, I'm not sure that color is part of those premises, but I think that's how they get visually expressed. The reason that I'm so involved in printing is that the medium itself is very satisfying to me, from a working point of view. I enjoy the metal plates themselves and I enjoy the resistance that they offer--I enjoy the manipulation of them. My working method is not spontaneous, it's additive. I start out with an idea, and I like the idea, I like to rework the idea as I go along. I think etching especially is very conducive to the idea of reworking. I think painting is, too, but I think painting doesn't offer that tactile involvement that metal plates offer. I think it's also the reason that I enjoy photography: because the kinds of mechanical manipulations in photography relate back to the kinds of enjoy-

ments that I have in printmaking. In both of those
media, I think, there is an element of surprise in-
volved. When you pull the print, no matter how you've
worked it out, no matter how much experience you've
had in printmaking, it still is different from what you
thought it was going to be. I think that's true in
photography as well--when you develop those films,
no matter what your experience is, it's still a sur-
prise to you, very often. And painting doesn't quite
have that, because you work on the painting and you
always know what's happening. But I like that ele-
ment of surprise.

To come back to color, probably in some ways
the color doesn't belong in my work, but the color
has to be there because that's me. I am very much
interested and involved in flatness in my work. That's
one reason that I've cut out all representation, be-
cause I do feel that I want my work to be concrete.
Color works into that aspect of my intellectual and
aesthetic philosophy very nicely. My color is flat,
and it's also very much involved in having the same
value. I use a tremendous variety of color in the
work, oranges and reds and blues and greens and
purples, but all of them are worked out so that they
have exactly the same value. When they're photo-
graphed they're horrible, because in black-and-white
photographs the colors all come out just gray; you
can't see what they are. Then I know that the work
itself is successful because I have achieved that flat
and equal value relationship that I'm looking for.

SS / Does the flatness have anything to do with the fact
that the etching process itself is very conducive to
a flatness of feeling and expression?

JB / I'm not sure that I agree with you there, because you
can take a Rembrandt etching and you get a tremen-
dous amount of space and atmosphere in it. I am
definitely using the etching as a flat means, though.
Even the drawing that I do in it, all the crosshatch-
ing that I do, is not used for illusionistic purposes,
but to make marks on paper that will enhance the
concreteness of the image on the paper itself. I
think I do use etching for its flatness, but I don't
think it has to be used that way.

SS / Perhaps you would like to talk about the intellectual
part of a series you have been working on.

JB / I call this particular series "Diagrammatic"; the name
 of the series and the concept behind the series is in-
 volved with my concern for the art object as being
 nothing but an art object, and not having any refer-
 ences to worlds beyond art. My theory is that any
 kind of artwork is a diagram. No matter how rea-
 listic the drawing, or how realistic the piece of sculp-
 ture, it's still not the same as the original, if you're
 doing a representation. Even a Duane Hanson, as
 lifelike as it looks, is still not the real thing, and
 of course that's why I think superrealists are success-
 ful. You go up and you touch the work and you've
 got the surprise thing going again. I feel that all
 art is essentially diagram. I don't want the diagrams
 that I'm using to come from anything but diagrams to
 begin with. In other words, a realistic drawing is a
 diagram of something beyond itself. But all the
 things, all the images that I'm now using in this dia-
 grammatic series, start as diagrams. They're the
 kind of things that are on the pages of Scientific Amer-
 ican or in the Encyclopaedia Britannica, where they're
 explaining electricity. I have a wonderful collection
 of those drafting stencils that architects use, that have
 circles and triangles and squares and little symbols
 for electrical wiring. I use some of those images
 in the prints. I have other diagram things that I've
 invented from leafing through magazines like Scientific
 American, and other things that are explanatory ma-
 terial. They come to life in the print, or I hope
 they come to life in the print, and they begin to take
 on activity of their own. They begin to do things
 within the print. But their life doesn't extend out-
 side the print anywhere. That's something that I'm
 very much concerned with.

SS / What about the fact that many of your prints are
 split into two sections?

JB / The reason they're split into two sections is that
 that's the way my mind works. My ideas never
 come out as holistic. They always come out as
 parts that add up to a whole. I've been working in
 sections within my prints for a long time. Very
 often there were more than two sections, there'd be
 three, four, or five. Different things would be hap-
 pening in those sections, which would then add up to
 the whole print. I'm working within a play back and

"Diagrammatic Dripping"
Intaglio, 30" x 24"

forth between the two spaces, and the two sections, and it's like two stanzas of a poem, where the idea develops from one stanza and then finishes up in the second stanza. Or else it's like a philosophic text, where an idea is developed and then there's a conclusion that grows out of the initial idea. Then the magic begins to operate within the spaces, too, because your eye must move from one space to the other in order to have the thought continue, and also the elements that are in the upper part usually reach some kind of conclusion in the bottom part of the print. There is a change that takes place in the print, and it means that it has to be read over a period of time, rather than being absorbed completely at once. I like that idea.

Also, even though they don't look sexy, my prints have to do with sex as the ultimate source of life. They multiply or they fertilize, or they attract, and they become a metaphor for me of what life is in the twentieth century. No one has to know any of this in order to look at the prints, but it is in my mind.

SS / They are very literary. Your father was a writer and you were very influenced by him. Do you think that this has something to do with the fact that your work is literary, and with your approach?

JB / Yes. And I think it probably also has to do with the fact that I do come out of a verbal tradition, an academic tradition, not only insofar my father is concerned, but my own training, and my own interests and ideas as expressed verbally. I'm convinced that creativity is transferable from medium to medium, and that I probably could have been a writer as easily as a printmaker. I think that's true of artists and writers in general. I do think it could work the other way around, too; there have been writers who could have easily have been visual artists, as well as being writers. I think that's one of the reasons I've moved toward conceptualism in my art; I've been looking, as so many artists have been recently, for an art form in which one can have visual-verbal crossovers without making a fine-line distinction between the two.

SS / One thing I find interesting to talk about is the whole

idea of feminist art and feminist imagery. You said
your prints were very sexual in a way. Do you feel
that there is a difference between men's and women's
work? I think in particular of the book From the
Center, by Lucy Lippard, where she says that women
have a particular centrist imagery in their art. What
are your thoughts on this?

JB / To begin with, we don't quite know the answer to that
question yet. I think part of the fun is in exploring
the subject and I'm not sure it's necessary to come
to a final answer in order to have new insights into
the art of women and into the art of men. I feel
there are very definitely women artists who are op-
erating with the idea of expressing their feminism,
or, I should say, their feminist sensibility. I don't
think they're necessarily being political directly, but
I think they're trying to express a feminist inner na-
ture in their work. I think there are others who
really are not interested in that especially. I would
find it difficult to say that women who are not inter-
ested in that are expressing something specifically
feminist, or feminine, in their work. Of course,
people like Judy Chicago are trying to do it in a very
conscious way. I think there are a number of women
who are trying to have feminism come out more
subtly, or to be part of the work rather than the
dominant theme. I've been very interested in this
in some of my art historical research, because I've
been doing research on women printmakers from the
sixteenth to the nineteenth century. Of course, in
the nineteenth century women were already involved
in suffrage, and were thinking about their rights.
I've run across women printmakers who wrote diaries
and books in which they talk about the fact that they're
women and they have to go through things that men
don't have to go through.
 As far as my own work is concerned, as busy
and involved as I've been in the Women's Caucus for
Art and the women's movement in art politically, for
a long time I've felt that my work was androgynous.
My work has nothing to do with my feminist sensi-
bility. I'm not so sure I feel that way any more.
As a matter of fact, I've always been conscious of
the sexual and sensual imagery in my work. I feel
now that because I'm conscious of it, it does relate
to my feminism. Maybe it didn't before when I felt

that my work was androgynous. I do think this is an
important aspect of the answer to this question. I
think women who are conscious of the feminist ele-
ment in their work are definitely involved in a fem-
inist sensibility. I'm not sure all women artists are
conscious of this.

SS / What did you think of the Brooklyn Museum show,
 Four Hundred Years of Women Artists?

JB / I think it was a fabulous achievement. I think that
 any woman art student is going to feel more confident
 as a result of that show. I also felt that the show
 itself was very interesting. I enjoyed looking at it,
 no matter who the works were by. I did feel that a
 tremendous amount of the work relates more to the
 period in which it was done, rather than to the fact
 that it was done by women artists. I think the show
 was very important from that point of view, that it
 proved that women artists were involved in main-
 stream art ideas in all those centuries, and I also
 think there are a few paintings in that show that
 point to an awareness by those women of their own
 gender.

SS / Do you think that the choices were good?

JB / The curators had trouble getting the pieces that they
 wanted. I think in some cases they could have had
 better examples of the work of some of the artists.
 They did in certain cases have to take the works that
 they could get, even if they were not the top works
 by those particular artists. If you saw pieces that
 were not top works by male artists, you would feel
 the same way about them.

SS / Do you think there's any possibility of a similar show
 of women printmakers?

JB / I've been working on one. And I've had preliminary
 talks with curators of print collections about the pos-
 sibility of doing a show, and I've had very enthusias-
 tic response from them. A couple of them even got
 involved with me to the extent of talking to other cur-
 ators and seeing what we could do. There's a prob-
 lem, which is that collections are very reluctant to
 lend works on paper. They're much more willing to

lend paintings, because paintings, for all their diffi-
culty of handling, are much less fragile. And works
on paper, as you know yourself, are so fragile. And
also the prints by women printmakers before 1900 are
so rare that we may run into lending problems. And
that would be the only thing that prevents that show
from becoming an actuality. It really would be a very
exciting show. The New York Public Library, you
know, has a tremendous collection of prints by women
from the sixteenth century on, and they have shown
parts of this collection from time to time, but not
really since the whole women's movement has been
going.

SS / Yes. The perspective is different now.

JB / And also, as much as those of us who are in the
print world know about the collection at the New York
Public Library, I don't think that their shows get the
kind of public viewing that I think it would be nice to
have. Of course, besides having a show of women
printmakers from 1600 to 1900, we should have a
show of women sculptors from 1600 to 1900. And
that's something that a number of us are working on,
too. So we'll see what happens.

SS / I was going to ask you, there have been some com-
ments on the fact that people are reluctant to collect
paper in general. What do you think about this?

JB / I think it's very unfortunate. I certainly think that
some of the big collectors have concentrated on paint-
ing and sculpture. I think it's very unfortunate that
prints and drawings are not considered quite as im-
portant as paintings and sculpture. What I'd like to
see is a revolution in the art-buying world where the
quality of the object becomes the most important
thing, and not the medium that it's done in. I think
that printmaking suffers from this more than it suf-
fers from people like Motherwell or Frankenthaler
making prints and selling them at such high prices.
The problem is that so many people don't consider
prints as being as important as paintings and sculp-
ture.

SS / Or as real.

JB / Or as real, yes. Or as valuable. It's very hard for
 a printmaker to have a one-person show at an impor-
 tant New York gallery. It'll be the print room of the
 gallery, and you get relegated to that, in the back!
 And probably the gallery makes its bread and butter
 through the print room. All the "big" stuff that's up
 in the front room, they're lucky if they sell one a
 year. But they just don't give prints the same con-
 sideration that they give painting and sculpture. The
 whole connoisseur world, the whole collecting world
 of prints, is a different world than painting and sculp-
 ture, and that I would really like to see change.

SS / Well perhaps this kind of show you're planning would
 help.

JB / Yes, I think so.

SS / Maybe it would be a good time now to move into talk-
 ing about the feminist movement, particularly since
 you have been the president of the National Women's
 Caucus of Art for several years. Do you think it's
 really beginning to make a difference, do you think
 that women are going to get an equal shot across the
 board eventually?

JB / Well I hope so! I think that the Women's Caucus for
 Art and other women's alternative art structures
 have made a tremendous difference in women's vis-
 ibility. In think we're much more aware of the num-
 ber of women artists who are currently working, and
 I think we're also much more aware of the quality of
 that work than we were before the women's movement
 in art started. And this movement really dates only
 to the early 1970s, so it hasn't been going that long.
 My feeling about women artists at the moment is that
 they are the most important artists around right now.

SS / I like that.

JB / It's almost like the situation that existed in New York
 after World War II, when there was the Tenth Street
 Club, and all the Abstract Expressionists got to know
 each other, and a whole art style that has influenced
 us ever since came out of that group of artists, who
 came together at the time because of geographic rea-
 sons. I think women artists are coming together and

formulating new ideas through the women's movement
in art. It's not because they're women, necessarily,
that they're the new doers in the art world, it's be-
cause something has brought them together and started
them talking to each other. I just know that that's
how new art ideas are realized. If you look back in
history, every time there's been a group of artists
who have come together for some reason, that's when
a new style has arisen. Take fifteenth-century Flor-
ence, with Brunelleschi, Ghiberti, Masaccio, and
others brought together by the Medicis; or take six-
teenth-century Rome, the first twenty-five years:
Raphael and Michelangelo and Bramante and all the
others are in Rome because the Pope is spending
money like mad to bring all those artists there; or
take the nineteenth century in Paris, and all the Im-
pressionists beginning to meet as early as the late
1850s in all those cafes. I am so very convinced
that it is the coming together of groups of artists that
results in new art ideas. That's why I think the art-
ists in the women's movement are the true avant-
garde at the moment.

SS / It's a pretty big group though.

JB / It's a huge group. I think that's good.

SS / Do you think that women have suffered more from
working in isolation than men have--until recently?

JB / Oh, sure. I think that women just haven't had the
confidence to show their work, to go out into that
horrible world, to make appointments with museum
curators, who have usually been men, to go see those
gallery dealers, who have usually been men, or even
to go see the women curators and the women gallery
dealers, who have been part of the male establish-
ment, not part of the women's establishment. I'm
still struck by it, when I go lecture at art schools,
and the classes are predominantly women, at least
at the undergraduate level, and the faculties are still
predominantly men. If you're a woman art student
and the only people you see in teaching positions are
men, how are you going to feel about yourself? You're
not going to feel as confident about yourself as if you
had women teachers up there. Your role models are
all male, and so you're going to assume that the only

people who make it in the art world are male. I
think women really do have a much more difficult
emotional and intellectual path to follow than men.
However, I think the women's movement in art has
given us tremendous support and encouragement, and
I think that that makes up for the fact that the studio
faculties are still mostly men. The situation is still
not a good one.

I think the reason that women have become so
visible in art is because of alternative structures,
and alternative shows that women have held, like the
shows that were put on in New York, Women Choose
Women, which was in 1972. That was the first great
big show, at the New York Cultural Center. There
are the Women Artist Series at Douglass Library, for
instance, and the Women's Caucus, we have now done
two national shows. We did one last year--a Works
on Paper show that had a hundred and fifty-seven
women artists from across the United States in it--
and it traveled to different areas, such as Utah, that
had never seen a women's show before. One year
there was a Women's Caucus show at the Boston Mu-
seum, featuring women who are working in metal,
fiber, and clay. We are not calling it a craft show,
because the point of the show is that people who work
in those media should not be relegated to second po-
sition in art, any more than printmakers should be
relegated to second position. The point of the show
is to reveal that one can create fine art ideas through
those media. Women who work in those media have
a tough time on two counts. First of all people say,
"Oh, they're just craft, and so they can't be high art,"
and then they think, "Oh, they're just women so they
can't be really good artists." So this show is to
really make visible those particular women artists.

The Caucus also did a show at the City Univer-
sity Graduate Center of women artists who are mem-
bers of the Women's Caucus for Art from this area,
from New York, New Jersey, and Connecticut. That
was a more standard show: painting, sculpture,
prints, some photographs. I know so many groups
of women artists across the United States who've
mounted shows in their various geographic locations,
and I feel that that has a tremendous amount to do
with the fact that we are aware of the names of so
many women artists today. The problem before has
been that there were so many women artists around
but nobody knew who they were.

SS / Do you think the professional aspects of the art have been kept up to standard in most of these shows?

JB / Oh, yes. I'm not for open shows, by the way. I do feel that even if you're wrong you have to make some kind of standard. If you don't, art shows will sink to the hobby level. Of course, I'm for changing standards, too, and for standards that are not sex-bound. But I'm not for compromising on excellence anywhere.

SS / Perhaps it's important for women to show together in order to get visibility.

JB / I think it's getting harder and harder to ignore women. But the statistics are still very bad. Take a couple of recent studies, as recent as last year, on prestige New York galleries. One-person shows still go primarily to men; only fifteen percent of them go to women. And museums are still very bad about showing or collecting work by women.

SS / What strides do you think have been made since you've been president of the Caucus?

JB / The directions that we've tried to work in have been, first of all, to increase visibility for women artists; secondly, to encourage more involvement of women in the academic and curatorial structure in the art world. And the figures are better. The number of women art historians who get jobs has improved tremendously over the last couple of years. The number of women who teach in studio departments has improved a little tiny bit, not very much. It seems to be easier to improve the direction of art history than that of studio. As far as organizations like the College Art Association, women have been very visible there. The Association has recently taken a stand on behalf of women artists and women art historians, which they hadn't taken before, so that they have become a force working to end discrimination. That wouldn't have come about if we hadn't been working in that direction. They have taken stands to support affirmative action, both within the organization and as far as colleges and university art departments are concerned, and they've actually been pioneers as far as protesting such things as the fact that academic women, when they retire, receive lower pension payments per month

than men. We feel that we've done a lot to move the
profession ahead in taking recognition of the problems
of women and working to alleviate those problems.
It's terribly important in the art field since fifty per-
cent of the professional artists are women, and fifty
percent of the people who get Ph. D. s in art history
are women, and fifty percent of the College Art As-
sociation are women. We have to get the larger so-
ciety working on behalf of women, and that's where
we really feel we've been tremendously effective. It's
not enough just for all of us to talk among ourselves.
We eventually want to be part of the larger world.
 We've also come out with a publication called
Anger to Action, which is a booklet on how to recog-
nize discrimination, how to begin legal proceedings
on behalf of yourself in a discrimination situation.

SS / I would think it would be very difficult for working
 artists if they went to a dealer. No dealer who's
 sharp at all is going to make it overt. And if they
 don't like the work....

JB / No, that's right. It's easier in an academic situation.
 And it's really kind of interesting, because art has
 really entered the academic world, and so many art-
 ists now earn a living through teaching. So many
 women artists do that in part-time positions, and
 there's so much discrimination as far as these part-
 time workers are concerned. Schools hire women on
 a part-time basis and then list them as part of their
 total faculty, and say, "See, we've fulfilled affirma-
 tive action." It's very difficult to try and do anything
 about discrimination as far as dealers or museums
 are concerned. But you can work it through any kind
 of paid job that an artist or art historian has.

SS / You know, we interviewed Alice Neel last week and
 she made a comment that she thought that women
 would stand up and band together as long as things
 are unequal, but then when they get equal they'll be
 just as dog eat dog as the way the world is now.

JB / I hope not. One of the things that some of us are
 interested in is to have an "old girl" system exist;
 men always help each other, and why shouldn't we
 do the same thing? If we all help each other, and
 someone says, "I know this position is becoming va-

cant; who can you think of?," we should all give each
others' names. That's already happening, and I think
that we feel fairly idealistic about it, and very opti-
mistic about it from a practical point of view, because
it is the way the world has always worked, and I think
we've got to start thinking in those kinds of terms,
too.

SS / Is there anything else you'd like to talk about?

JB / I think one thing that is true about women in art right
now is that there is a tremendous amount of energy.
I think it has to do with the women's movement in
general and the fact that women are coming into their
own, but I feel that art is one of the places where
it's happening most clearly. Maybe it's because there
are so many women who have been under the surface
in the art world, and so with this extra little push
that the women's movement has given them they're
rising to the top. I think it's very exciting being in-
volved in that right now. I think that energy comes
out in the fact that we all do multiple things. Here
you are, an artist, and you're doing the interviews,
and you're a painter, and you're involved in this proj-
ect, and I'm teaching and doing my own work and
being involved with the Women's Caucus, I think this
is true right across the board as far as women art-
ists go.

SS / Do you think this energy is showing in the work?

JB / Oh, I think it's showing in the work, tremendously.
I think it's showing in the changing of the structure
of the art world. The only thing is that I don't think
we can sit back. I think we're just starting. My
big fear, now that I've been optimistic, is that the
next generation is going to say, "Oh, well, we're
not interested in doing that, we don't need that help,
we don't have to think about those things." And it's
just going to come to a dead halt. And we're going
to have to just gear up all over again. Of course,
that's the pattern of the women's movement.

SS / If you look back at the forties, women were out work-
ing during the war, and then they had to go home.

JB / That's right, and it happened before that, too. There

was the great push toward women's rights in the nine-
teenth century, and then it just all sort of died away,
and then in the twenties it grew again, and then died
out.

SS / Perhaps, like many revolutions, you can look back
and see the pattern, but sitting on top of it, it's hard
to look at it objectively.

JB / Right. But it's not enough yet. We've got to keep
on going. . . .

RADKA DONNELL-VOGT, quiltist, was born in Bulgaria and lived for many years in the United States. She studied at Stanford University (B. A., 1954) and the University of Colorado, Boulder (M. F. A., 1963). From 1960 to 1965 she was active as a painter. In 1965 she began to make quilts and is now a well-known quiltist, whose work has been exhibited internationally. She now lives in Switzerland. In 1976, with a team of three other women, she organized the Boston 200--Bicentennial Exhibition of Contemporary Quilts, Quilts for 1976. Other group exhibitions include The Sensuous Eye, Boston Visual Artists Union Gallery, 1974; Frauen Sehen Frauen, Women's Art at the Städtische Kunstkammer zu Strauhof, Zurich, Switzerland, 1975; Antique and Contemporary Quilts, Da Gianza, Tokyo, Japan, 1975; and The New American Quilt, Museum of Contemporary Crafts (New York City), a traveling show, 1976-78. She has had one-woman shows at the Berner Galerie, Bern, Switzerland, 1973; the galerie object-Jurg Bally, Gewerbezentrum Zollikon, Zurich, Switzerland, 1974; Dana Hall, Wellesley, Massachusetts, 1975; Galerie-unip, art contemporain, Lausanne, Switzerland, 1977; and the Douglass College Library, New Brunswick, New Jersey, 1979.

Though not an interview, the following memoir was included because its tone and ideas fit so well with the book's concept and intentions.

When I was a child, in the early thirties in Bulgaria, there were no ready-made clothes. Every year, in early spring, a seamstress came to our house to do the sewing for everyone but my father; he had his tailor in the center of town.

I both loved and hated the times the seamstress was there. The children's room was turned into her workroom. The decisions about the colors and styles were made by my mother and sister, and I was allowed to have my say only about the collar's shape and other small details that did not matter. At the fittings my mother stood closer to me than usual and touched me, or, rather, handled the material next to my skin, in a sure way, as if in touching there were no problems ever. She came out of her usual remote and dis- tracted air, and half-peevishly, half-humbly submitted to the final judgments of the seamstress.

The seamstress was very quiet, dressed in black, and completely in charge of herself and the situation. She was a middle-aged widow, and this called for silence on everybody's part and made her work something to be respected on account of death. At that time I could not think of any single reason for her coming to work for us other than her husband's death. I did not know any other reason for women doing professional work.

She stayed a week or two working incessantly. She did not come downstairs to eat with us but ate from a plate on top of the sewing machine. She never looked up at any- one or at anything except her work, and left half-defiant, half-forlorn when she was done. In the room there remained afterward a faint odor of her sitting there and of ironed and singed clothes.

All this seemed close to a miracle to me, and she, a kind of a higher being. She cut the expensive materials without hesitation, never spoiling or wasting anything. She made patterns herself, just from looking at the French mag- azines my mother held before her with an unsteady hand, and everything fitted perfectly. As for my mother, she could sew in straight lines: she mended torn sheets, also made pillow cases and diapers, but nothing free or in the round.

39

No electric appliances existed at the time except the
radio, and the sewing machine was turned by hand. It made
a sound like a miniature train going places. I imagine this
was the first machine sound reaching me in the womb while
my mother made diapers as she was waiting for me, just as
she later did for my brother. The sewing machine's motions
and its sound I imitated in a bathtub, cutting the water into
ribbons that rejoined by themselves. I dotted seams with my
fingers across the surface and felt the tub water like a fluid
skirt that rippled round me but did not constrict me. My
mother rinsed me afterward with water that was regularly too
hot. I had attacks of fear that my body would be rinsed away
as the water rolled off and down the drain.

Bathing took place in the evening to keep the dirt from
getting into the clean bed, but, I suspect now, it was mainly
a substitute for the body contact my mother withheld from me
for lack of time, lack of interest, and for fear it would spoil
me. As usual in our prudish country at that time, she kept
nudity in front of children to a minimum. Whether for rea-
sons of class, or her own physical fatigue or inhibition, she
systematically unclasped my hands when I put them round her
neck and lowered them with a sweep loud enough to hear. To
give, to make a home for my feelings, any other material
was good enough but the flesh. Thus the feel of my clothes
against my body, the scrutiny of others' clothes for the bod-
ies beneath them, and the contact they promised or forbade,
occupied my whole childhood.

For reasons I shall never understand I was allowed to
accompany my father to the tailor's shop. There I was ex-
pected to be silent, and I watched all the more avidly, more
solemnly than in church, one man fit another man into new
clothes. The tailor was in shirtsleeves, and the tape measure
framed his neck and bobbed like a necklace as he moved. As
many others in his trade, he had a lame leg, but he hobbled,
kneeled down, and hopped up briskly as he adjusted the jack-
ets and pants being fitted. His face shone with something I
later recognized as love, but it ruled his hands in the form
of respect and skill, slowing down or speeding up his fingers
to straighten here, to smooth down there, and pin the material
next to my father's body. Materials in salt-and-pepper, in
herringbone design, in tiny English checks, pinstripes in dark
colors, he swirled off the wooden rolls and threw over the
shoulders of my father to look at in the daylight and before
the mirror for as long as he would have it. My father, who
generally was on the run, there took his time, took a long

time, and spoke to the tailor as an equal, as one professional
to another, both smiling and gesticulating.

All our clothes were cared for by our maid, who
washed them by hand in the cellar and ironed them in her
room. That was next to my parents' bedroom, and there
was a locked door between. She got up very early and fell
asleep before they did, otherwise she must have heard all.
My parents went out in the evening, or else they talked late
into the night, and this astonished me, as my mother other-
wise talked very little. How the maid figured out what to do
with minimum instruction is a mystery to me. She ironed a
whole day weekly, using an iron that was kept hot by coals.
She kept her back turned to me as I sat watching on her bed,
and when I held onto her as I had seen her boyfriends do it,
she shook me off by the force of her legs and did not stop
ironing.

She ironed her own things last and kept her best blouse
out on a hanger until her day off. When she took me along
on her dates I saw her clothes getting crumpled and parts of
her blouse hang loosely out in front. The back of her friend
as he hugged her blocked my view from where I was playing.
Before going home she pulled her clothes back into place,
pressing her hands over them, over and over, squeezing her-
self into place too, straightening everything, smoothing her
stockings, which had turned around.

When I was back at home and in bed, my bedcovers
fell as a curtain between what I had seen outside and myself
and kept in the warmth that rose in waves inside me. The
children's covers were flat, lightly stuffed, and quilted in
squares by craftsmen who also quilted mattresses, and more
elaborate comforters for adults that were a bit puffier and
had running designs with floral curlicues. All the comforters
I have seen in our country were done in apricot and rose
shades of damask or glazed cotton material and were called,
and still are called, yurgan.

They had enough body and thickness to be piled and
piled so as to give the illusion that there was someone under
the covers even when there was no one underneath. Thus
they were part of many games of hide-and-seek and acts of
disappearance. When as an adult I came across depictions
of burial mounds that contained the earliest known art objects
and artifacts (the mounds were referred to as Kurgan), my
feelings came full circle. The earthen piles on people's graves

that are flattened after a certain time had in my childhood
seemed to me part of other games with bedcovers, and now
I understood the Kurgan mounds as permanently covered beds.

The yurgans of our parents were covered with a fine-
meshed crocheted net to keep off the dust. On top of the
children's beds there were thin blankets, for, even though it
was forbidden, we sat on the beds and jumped up and down
until exhaustion. Since they were difficult to clean, the yur-
gans were never to be stepped on or sat on directly, and
once it gave me terrible pain to be pressed down on top of
one to be fondled. I thought of the yurgan all the time and
could not stop trying to puff it up again afterward even though
it was not even ours.

Unless I was late for a meal nobody at home missed
me actively except the maid, but I never spoke much to her.
I did cry when she left to be married. She cried only once,
when my father also embraced her after the wedding. She
was getting married to a butcher from out of town after hav-
ing taken care of my father's clothes for more than ten years,
after his fine pajamas, shorts, shirts, and handkerchiefs had
passed through her hands every week and come out immacu-
lately clean. It was clear to me that she was saying fare-
well to being close to him, closer than his children ever
would be.

How close my parents were to each other I could not
tell. I seldom saw them together except at meals and did
not understand what was exchanged. But I could watch my
mother making up her face. She first used a lot of powder
and lipstick and then patted them off, and plucked her eye-
brows lightly. I watched the side mirrors, which multiplied
her face and peopled the alcove in which her dressing table
stood with so many images of her that I got dizzy. It seemed
to me that I was being enveloped, stuck in the tight space
created by the play of mirrors round my mother, as I some-
times got stuck in my clothes not knowing which way to push
through my head or my arms while dressing. Later in life,
when I saw the broken space 'round Picasso's figures and
Marcel Duchamp's "Nude Descending a Staircase" it seemed
to me that Cubist space had happened in the dressing corners
of the women they knew and loved.

My mother was mostly quiet, her lips pursed, her eyes
darting moodily. In a family of seven children she was the
one in the middle, after the firstborn son, a brilliant sister,

a monumentally egotist second brother, and with twin sisters
and a younger profligate brother following her. She was es-
teemed and respected, as far as I could tell, but what her
childhood must have been as far as physical mothering and
attention-getting go, I dare not imagine. Her father was a
high-ranking officer, with two orderlies as part of the house-
hold, and two dogs, but only one maid. Her mother's time
was not her own, and my mother's time was not her own
either.

As she pulled and closed drawers, unpacked packages,
shopped, groomed herself and us, managed things in the kit-
chen, her eyes were always elsewhere than her hands, and
her hands looked out of place and never rested, but fluttered
on, in and out of bags, shopping nets, bags, gloves, baskets,
pots and pans. Even though she did not cook day by day but
only helped make the preserves and pickle vegetables for the
winter, she never stood still. I saw her rest only when she
watched the icon of the Virgin Mother, the mother in the icon
holding her baby boy sadly, sweetly, eternally, in a restful
hold such as my mother denied herself and me.

In the summer she took me along when she picked
mushrooms, and did this quickly, deftly, sighting them from
afar, letting me "discover" them and help pick them all. As
on her shopping trips, we seldom spoke. She seemed too
serious, and I did not dare disturb her thoughts. The only
thing we fully shared was silence. And this silence between
us, this silence we wove together, this is the cloth, the
ground, the canvas that supports what I have since learned to
see as the work of culture. Wound around each other but
only in our thought, she and I, yet not for each other, we
stretched into time, unconsummated yearning, the woman's
sacrifice that taught men to paint.

My father sometimes allowed me to walk a couple of
blocks along his side, and he did have a free hand to hold
mine. That is the only part of him I remember being allowed
to touch; on the inside of it it was gentle and warm and his
fingers were well padded and soft. I remember wishing to
touch my father's hair, which was curly and unruly, as I
wanted mine to be. His seemed to have a life of its own,
from the way he tried to hold it in place as he talked on
and shook it briskly. The horse hair that regularly stuck
out from the mattresses had the same sheen and spring.

My hair was the only part of me my mother touched

with comfort, seemingly having trouble getting it combed and
spending extra time to pin ribbons in it, which always slipped
off. I rolled and unrolled the ribbons until they would roll
back into a curl. My hair was straight and cut short, as my
mother considered plaited hair common. Only peasant girls
had braids. Even before I could read I had learned how to
knit, but my mother hated handknit clothes. She preferred
fine machine-knit English cardigans and screened my friends
on the basis of their woolens. I think she was afraid of pubic
hair, and this rather than class prejudice was the reason she
banned knitted woolens except socks and mittens.

The only person who had a body for me was my grand-
mother on my mother's side. She did all sorts of manual
tricks for me; she knotted handkerchiefs into mice that jumped
and rabbits that wagged their ears, she laid out cards and
taught me to play patience, and how to knit before learning
to read. She let me fold and unfold her linens and polish
the leaves of her rubber plants. She fell asleep in my pres-
ence and snored something like little tunes. She put her arms
around me.

She had no dressing table in her room but kept her
things on top of a dresser, arranged as on an altar. In the
next corner there was an icon and around it the photos of her
favorite son, his decorations, and poems he had translated.
All the corners were furnished with symbolic objects and were
thus defined. She and her maid, like all women when I
watched, kept moving between these special places, corners,
niches, alcoves, dressers, drawers, tables, stoves, with
shopping trips in between, and did not go on larger travels
as my father did. Our farthest trips were to the park, where
I dug in the sand, made mud pies, and built sand castles.
My best girlfriend actually became an architect later, when
Bulgaria became a socialist country and women there got an
equal chance professionally. But in my girlhood, to design
whole buildings, free standing in space, to traverse space in
every direction, to own the recessional three-dimensional per-
spective and change it, that belonged to men.

For me the question of why there had not been many
women painters was tied by my experience to the question of
why women were not allowed to be architects, why they con-
trolled and fashioned and furnished such limited areas as they
did. Into the full depth of the world they could extend only
in their fantasies and move only in their words.

The Eastern Church, even though Protestant in denying
absolute hierarchy and the Pope, was, and still is, committed
to the primacy of the male. This was inscribed in my life in
a thousand ways, but one is most vivid in my mind. As part
of the ritual of Easter, on the Saturday before it, Christ was
laid out in effigy on a table high enough to walk under bent and
crouching, and women and children brought flowers, piling up
a whole hillock round him. Then they passed under the table
--decended into hell and rose again. As a child I got scared
under the table, since it was draped over and very dark under
there. Ever since, I have had to work my way out of this
kind of world, out of this kind of predicament. This is why
I am interested in covers and in uncovering.

But first I did a lot of hiding, covering up, and melting
into covers. Not yet ten, I often drew the covers tight around
me letting my eyes rove between waking and sleep, watching
the regular patterns round out or draw together over my body
rising and falling like the landscape of the day behind me, the
order of the seams running into disorder, always new, always
different, and taking on the shapes of dreams. Crawling out
of them in the morning I left them lying there, like the snake
skins I ran across in summer in the woods near our house.
The scents and tangibles of summer layered round my body
as I ran, fell, and scrambled up those hills. All I saw fil-
tered through the order of disorder close as my limbs in the
play of shapes, between the covers of the world outside, and
myself. Many years after, as I made the beds of my daugh-
ters when they were small, I meditatively received their life
from the disarray they left, the unmade beds welling up with
shapes and feelings, and the covers finally settling as a float
on uncertain currents. Thus we learn to recognize in the
rendering of cloth in paintings the artists' feelings, which
can be as strong there as in the rendering of a face.

The scintillating summer air of my childhood shines in
my memory as radiantly as the winding sheets in paintings
trailing the resurrected Christ into heaven, the cloth a meta-
phor of the personal in human feelings and the connectedness
of all persons. Blinding white in summertime, our sheets
lay spread out on the grass to be dried and bleached by the
sun. Grasshoppers landed on top, and I had to keep chasing
them off before they left their tiny droppings. Paraskewa,
my favorite of our maids (I can call her now my alternate
mother), assigned this task to me. She also took me and my
friends along to gather kindling wood and help pile it up against
the house, shaping the wood piles into textures, into orders of

near geometric perfection, which we slaved over with artistic
abandon, getting to keep the bark for carving. Picking up
sticks for kindling meant looking out for snakes, and there
were many around; if we ran into one, then sure enough there
was a second one near.

These snakes were mostly harmless, and the mountain
people were not given to killing them. There was a fruit ven-
dor who lived with a whole group of them, with a whole set of
dishes of milk left outside his hut. This huge bearded man
used to bring us the sweetest pears and apricots and tangiest
wild plums in baskets carried by a donkey. There was also
a woman supplying us with berries, which she picked with her
little son and carried in round baskets made of wood shavings
balanced on long sticks over their shoulders. Her hair was
totally white, though she must have been in her thirties, and
her face terribly contorted out of shape, permanently, making
her speech unintelligible. She had been raped by a group of
village toughs and driven almost out of her wits, the beautiful
boy born out of this her one recompense for all to see. The
berries, raspberries and wild strawberries, were arranged in
beautiful rows all down to the lowest layer, not just above to
fool the eye. Oh, then my mother gave--that is, she over-
paid--her cheeks darkening with color! The berries we ate
silently, undoing the mosaics this pair had created, piece by
piece, tasting mother love, feeling it all the way down, the
scratchy fuzz of the berries slipping past fear down our throats.

There was no way our mother could stop us from
roaming in the woods and getting lost in the thickets of black-
berries. She kept thinking of safe tasks like picking walnut
leaves right by the house to string and soak until a black brew
collected to be used as a bath, a homemade sun lotion. We
were also sent to get spring water from a nearby spring along
with Paraskewa.

It was all the effect of the setting, our mountain site
opening spectacularly, getting us all mixed up in nature, na-
ively, in a nineteenth-century way. The Balkans were irre-
sistible, rising in billows above a vast valley that cupped out
and merged in a bluish tremor with the sky. Smaller valleys
tucked into the mountainsides stretched out into cultivated land,
and some valleys down from us lay the famous fields of roses,
too far for us to sense the smell, but in imagination wrapping
the whole area with perfume to fill the whole world. Actually,
the global feel of the summer heat was punctuated by the scents
of herbs and grasses. As the colors of the day changed into

dark the scents too changed, getting more intense and hover-
ing in the sheer expanse of the sky, adding to the spangles
of the stars their sweet breath and bringing them down closer
to the touch. The miracle of summer, turning the world out-
side into one vast interior, since it was traced in the floral
curlicues of quilting, thus held us warm in winter with dreams
of total continuity, the unforgettable utopia of the best of cli-
mates.

The craftsmanship that captured this sensibility I then,
of course, did not appreciate consciously, though in school
sewing and embroidery were stressed as much as the literary
skills, and even my sister struggled with needle and thread.
Her interests were mainly social; all school subjects came
easily to her, as for me too. This left time for games: hop-
scotch, the simple version and with a ball being whipped along,
and, most of all, handball. Drawing the squares of the game
"Getting into Heaven" with chalk on the street still forms the
invisible matrix for my quilt patterns, as do the actions of
Cat's Cradle, done by hand or in rope jumping. We played
until my ears exploded with excitement.

I spent hours watching workmen lay bricks as they
were building the house next door, and street pavers lay out
cobblestones and pound them, and the repairmen of our fence,
and this made my mother suspect that I loved the "lower
classes." I did. They had smells and louder voices, and
looked me right in the eye. I studied their hands as they
worked slowly, their necks crisscrossed with wrinkles like
the lines of tic-tac-toe. I longed to touch them.

When I was about five years old, my parents suddenly
went overseas, taking my sister with them for a year and a
half to the United States. My father had received a string of
grants, a great distinction, the call to further science and the
national economy. They left me alone at my grandmother's.
Much later, by a combination of circumstances, I got to live
in the Boston area while my first marriage dissolved. There
I began to live down the myth of male supremacy in the very
place where my brother had been conceived. For, after my
parents' return from the U.S., he was born, and at the side
of my happy mother I basked in her new warmth and felt
equally loved.

After one of the many moves in my later life I came
across an American quilt, when a friend of mine who was also
moving gave it to me to hold while she and her husband were

carrying a cupboard to the truck. Our children are now in
college, and I, instead of only holding, only using quilts and
painting pictures, started to make quilts and to reintegrate
myself.

My experience of loss and transcendence, my fate as
an immigrant and a woman, led me to quilts as to a home
ground. And after twelve years of making quilts I now come
to the question about their value as instrument of liberation
and the danger of their being the ultimate placebo. Perhaps,
it is only for myself that I can settle these questions, knowing
well their place only in my life, what they did for me, and
what I have done for other persons by making them and en-
dorsing them as works of art. Yet my own studies of art his-
tory and my work as a painter, as well as my pursuit of psy-
chological insights and my experiences of the political nature of
of all issues, have now given me new points of reference for
my views about quilts.

My first step of self-emancipation was painting. After
my two daughters had reached school age I went back to col-
lege and got a master's in fine arts. I had the basic skill of
drawing, as in Bulgaria drawing was taught from the first
grade on and up through high school. Having this skill saved
me from deliberating too long about whether I had talent as
formulated conventionally. I also had family examples, as
my sister had started to study art at one time, and of the men
in the extended family two had deviated into painting. The
one, a first cousin of my mother, reached brief eminence as
portraitist and died in his thirties, and the other, one of her
brothers, kept tinkering all his life at his studies of law,
putting his energies into doing aquarelles and caricature with-
out becoming a professional. The impact on me of the gigantic
portraits painted by my mother's cousin was tied to his having
defied his family of military men. Goschka Dazov's self-
portrait filled a whole huge wall and dwarfed his surviving
father, who as retired officer did the food shopping and the
cooking, terrorizing the household thereby but living well into
his nineties claiming that his longevity was due to the effect
of honey and yogurt.

Few paintings were to be seen in Bulgaria as I was
growing up, easel painting being a new art after the liberation
from the Turks in what had been a country all along adverse
to image-making. In the Eastern Orthodox Church body repre-
sentation is extremely stylized, and holy faces the subject of
most icons. In church these are arranged so as to form a

separation between the altar and the faithful, rising in tiers
almost all the way to the ceiling in the iconostasis--a glow-
ing, mystifying, hypnotizing wall. Witnessing the icon's power
to immobilize all persons of authority I knew instilled a deep
respect for paintings in me, but as I felt disciplined and
scared in church I also had the impulse to pull down the icon-
ostasis or run away. My later painting efforts thus vacillated
between dissolving the wall and creating visual structures that
hold the gaze of the observer as long as possible. My abstrac-
tions foundered on this double aim, incompatible with pure
painting.

In quilts I found a surface that was not a wall and that
could hold more than purely visual structures, a surface that
could accommodate plenty. For the reductionism, the asceti-
cism, of male painting at the time repelled me, frustrated as I
was as a person, moving physically too much during my chores
yet too circumscribed by the limited woman's role I still clung
to. The double function of quilt-making, to help collect one's
thoughts and provide an image of spatial integration that does
not freeze one in one place as the observation of stationary
paintings, was essential in giving me a base for exploring my
situation as a woman and as an artist. Quilts as a commem-
orative art helped me to focus on my history. Making them
became a devotional activity that did not extend into a too-
elusive sphere, as in religion, or a too-ethereal precinct, as
in the fine arts, sequestered as both realms are by mystified
intentions.

By contrast, quilts became for me a reconfirmation
and restatement of women's toils in child-raising, of the phys-
ical labor in the cultural shaping and maintenance of persons.
The seeming simplicity and "poverty of spirit" in male paint-
ing visible in the mid-sixties appeared to me a guilt-ridden
hypocrisy on the part of the powerful, renouncing the fullness
of reality produced for them by the work of the actually op-
pressed and exploited, by women. My upbringing had left
me short of physical handling and physical warmth, yet on
this small allowance I managed to give whatever I could of
these to my children, while at the same time being led to
believe other accomplishments were more important. Making
quilts, I was retracing this too little and too much, the double
limitation of the woman's sphere. In part the quilts were a
continuation of all the physical work of moving objects, tidy-
ing up, handling laundry, folding, stretching, smoothing cloth,
dressing and undressing children, making beds, scheduling the
days, keeping everything moving, and managing, making do

with the time and leisure left. There I was making an inventory, a permanent sign of what went unnoticed as an effort otherwise, and I found recognition at last: the easy sharing of praise among women and the realization of our common lot.

Quilts brought about a change of attitude toward my work. They have done this for many women, and the revaluation of established forms of art on a vast scale as it is taking place now is largely the result of this changed attitude of women toward their work, with little help from men. The artists and critics among my male acquaintances and friends visibly liked my quilts but had trouble with them intellectually. Only women painters "traded" pieces with me, but only few without the sense of an "unequal" deal. They are right, for, with all due respect for women painters anywhere, quilts are in a class by themselves among objects, above paintings perhaps.

In their geometry lie undeciphered the record of women's struggle to affirm their anatomy against all cultural odds. And as I got pulled into this struggle and lived it, my eyes began to read the evidence and I could not help adding my own. The guiding impulses of family example had run out for me, my children were growing up, yet I could not step into a wider context, half-finished, reduced, or stunted as I was as a person. Beginning to make quilts changed not only my attitude toward work and art, it changed my self-image, as it focused attention on my body and my sexual identity, at first without my noticing and then unmistakably. Finally, I saw the quilts as the bliss and threat of the womb made visible, spread out as a separate object shaped by the imaginative wealth of women's work and body experience.

The complex nature of the quilt as a sheltering object yielding warmth and cover for the body, involves it in the history of shame about the body and its sexual parts, and in the social stigma peculiar to those. For what it is worth, Sigmund Freud's view that weaving was invented by women to cover their shame-provoking parts has a positive side. It confirms the production of cloth and covers as primary technology. We can surmise that human beings first took care to cover their bodies and then made architecture, one in the image of the other.

For me this is borne out by the history of the "Log Cabin" quilt pattern, which I had seen before coming upon it

in quilts and which added one more piece in the puzzle. In
Bulgaria children's diapers had the shape of long rectangles
and were wrapped around the baby to produce a pattern that
I met again in the quilt block "Greek Cross." In my studies
of art history I had seen the patterned swaddling of the Christ
child in many renderings, the most striking being the medal-
lions outside the famous "Foundlings' Hospital," by Brunel-
leschi in Florence. Then, in the British Museum, I saw
mummified Egyptian cats, dogs, and birds, swaddled in the
Log Cabin pattern. Later I saw many wooden doors in En-
gadin, Switzerland, also in this pattern. Adding this together
and assuming that women did the swaddling of the dead just
as they swaddle infants, I came to the following conclusions:

The Log Cabin pattern, as built up by the continuous
strips wrapped round the mummies, produced on the two-
dimensional surface an isomorphic projection of the pyramid
shape. When this is read projecting up as in the pyramids,
then it has a phallic aspect; when it is read as a depression,
it refers to the vaginal opening and the womb. It is a uni-
versal convertible bisexual pattern protecting the union of op-
posites in human beings and securing safe passage from one
world into the other, from day to night, from life to death,
from three-dimensional existence into the extension of infinity.
Swaddling, doors, quilts, thus mediate in the dichotomy of
inside and outside, that is, in the problems of physical, psy-
chological, and social boundaries. Before the invention of
glass and hinges, pieces of cloth were, and still are, inter-
changeably used as doors, window curtains, rugs, and blan-
kets, as those who have traveled in the Middle East can eas-
ily confirm. This convertible, flexible, many-sided aspect
of quilts responds to many different needs in our relation to
objects.

When I first exhibited my quilts in a gallery, the
Municipal Gallery of Bern, my work had to be approved by
a panel of city men. They did so, unanimously, but at the
opening viewed the quilts running quickly past all of them,
or stood next to one a long time, poking at it with a slightly
disturbed expression. The most unlikely older people, respect-
able and staid men and women, fingered good-humoredly va-
ginal triangles, pearly crosses, structures of abandon and
tenderness, and the most unlikely people bought my most
sexually revealing quilts. I was completely surprised by this
reception. After starting to make quilts I was kept going not
only by my own needs but by the actual urging of nearly every-
one who saw them. I heard words that had never been part

of my experience before: you must continue! make more!
they are beautiful, beautiful! I want one! I want one like that!
look at that! I want them all! make one for me! mine is the
most beautiful! they are too strong! they are too beautiful!
I want to make one too! keep making them! don't stop! The
most unapproachable and hardened city women and the sternest
grandmothers out in the country suddenly were cordial. I
laughed and cried.

I piece my quilt tops by machine and have them ma-
chine-quilted by a wonderful woman in Kansas, who also quilts
material for upholsterers and asks less for doing the quilts.
If I had to quilt them by hand, I would never have developed
a whole body of work expressing the different issues that have
occupied me, nor would I have reached so many people with
my work. I feel sociable in my art. I simply cannot view
art as a response to some hidden formalist logic. To me it
seemed one more frightening piece of male hypocrisy to have
done away with the complexity of objects in painting, which
was during the heyday of Abstract Expressionism, Abstract
Impressionism, and Op, while the male technologies were
filling the world with dangerous, totally destructive objects.
In the quilts I had found good objects--hospitable, warm, with
soft edges yet resistant, with boundaries yet suggesting a con-
tinuous safe expanse, a field that could be bundled, a bundle
that could be unfolded, portable environment, light, washable,
long-lasting, colorful, versatile, functional and ornamental,
private and universal, mine and thine. Making the quilts was
technically easy, physically rewarding, and socially liberating.
I made a quilt called "Good-bye Mr. Klee" and parted ways
with the fearful, esoteric, and cryptic in art.

Broken down by the demands of the excessive male
role, my husband struggled toward creative regeneration, and,
even though suffering, he showed a kind spirit toward my work
and approved it. My marriage was dissolving, and I had to
start supporting myself. For three years I was able to make
my living by making quilts. Then assisted by odd jobs and
the support of my sister, who encouraged me to go on and
helped me to sell my quilts privately, I tried to exhibit them
on equal terms with painting. But this became a painful strug-
gle, as I insisted that they should be viewed as bedcovers
AND appreciated as art, and not be "cleansed" from their
functions in daily life, which for me had changed all elements
of design into a code for feeling. I was made to realize that
this was getting too close to home, to the battle of the sexes,
to be welcomed on the male-defined art scene. I have con-

tinued trying to change all that. Having changed first small portions of my life and developed, by piecing and laying out the quilts, the skill of deciding for myself, I progressively gained more courage to face the public world and now am studying to become a therapist.

The resistance to my quilts came, among other things, from the fact that for this art form, as in other fields held down by the name of "crafts," its value in the mind of men and women is associated with excessive and time-consuming effort. I have tried to r educe this effort, but the excessive demands on the time of women still extend into what is expected even of their art. For my part I find that the question "How long did it take you to make one?"--a question apparently intended to measure a value and dedication otherwise uncomprehended--is plainly sadistic, a sign of disregard for the lifetime of women generally. These excessive demands, I find, also drive some women to use canned preassorted quilt-kits and guessproof "how-to" prescriptions, which plainly trivialize the whole issue of self-expression in quilt-making. Quilt-making is in a way a prisoner's art, a nomad's art, a convalescent's art, and the question of time, with which these aspects of a women's life and art enter into the making of quilts, displaces their appreciation, as do all questions about production time in a world with unequal, sex-based division of labor.

This reality threatens to make quilt-making now a mere flight, a mere distraction, a compensation, and how can an equitable reward be assigned to these? Thus to one side part the hobbyists, to the other those who extract from quilts only the visual graphic design elements and either degrade them to mere gimmicks by transferring them to commercial design of patchwork prints in plastic, linoleum, and textiles, or elevate them into Art. We see, for instance, a single element of the quilt design "Baby Block" enlarged and monumentalized as a painting by Ellsworth Kelly, or Lucas Samaras using the piecing of material to solve such problems of painting as the rendering of depth as approached by Cubism, thus devaluing both the historic achievements of traditional quilters and Cubist perspective. Can a man, other than being an exception, make a quilt worth our while? For, apart from presenting this or that formal design aspect, quilts have been rallying points, platforms, banners, for the neglected and self-forgetting persons, for women. Mere semblances of quilts for art's sake, quilts for quilts' sake, are dictated by self-alienation and therefore never will speak to the heart.

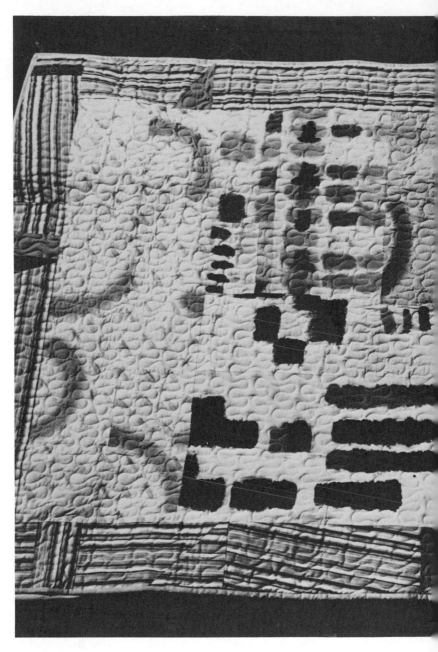

"The Palette of Joy" (1979)
Patchwork quilt
Photo credit: Toby Atlas, Salem Art Colloquium

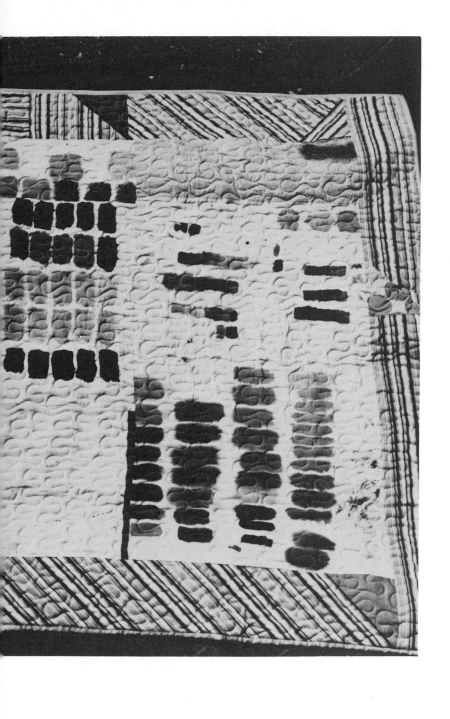

The quilt is first of all a speculum by which a woman looks into herself, and when she finds her unknown and disregarded beauty, she can find also the courage to prevail along with others for her share in the world.

DEBORAH S. FREEDMAN, painter, was born in New York City in 1947 and educated at the University of Cincinnati, the Art Students' League (in New York), and New York University (B.S., 1970). She presently lives in New York. Her work has been acquired by Fisher Price, New York State Facilities Corporation, Texas Gulf, and other corporate collections, as well as by private collectors. She has also been featured in Heresies #5, September 1978. Writings about her work include Ellen Lubell, "This Could Be the Start of Something Good," Soho Weekly News, September 21, 1978, and Peter Frank, "Reviews," Village Voice, January 3, 1978. Her exhibitions include Contemporary Issues: Works on Paper by Women, Women's Building, Los Angeles, 1977; Electrostatic Art, Tim Blackburn Gallery, New York City, 1978; Alternative Imaging Systems, Everson Art Museum, Syracuse, New York, 1979; Electroworks, Canadian Center of Photography, Toronto, 1980; and solo exhibitions at the Douglass College Library, New Brunswick, New Jersey, 1978, and the Sarah Y. Rentschler Gallery, in New York, 1979.

Photo credit: Maurice Freedman

SS / Can we talk about when you first became interested in art, when you decided you wanted to be an artist?

DF / I was always interested in art. My father had art books around, and I think that it was the first thing that I liked to do in school. I was good at it. Other things didn't come easily, but art just did. It was a pleasure from the start.

I think I didn't decide until college that it was a profession. It's true, I identified with artists all my life. But identifying with Kandinsky when you're fifteen years old and a girl doesn't really get you into the fantasy of being an artist. It may subliminally, but it's not a conscious thing.

As I got older and left home, I realized that people were actually going to art school and deciding to do what they wanted. That was what I thought art was: it was making a commitment to doing what I really loved to do. I didn't make the commitment until I was about nineteen, and I just keep recommitting myself. Even now.

SS / Did you think about that at the time you were nineteen and you went to N.Y.U.? Did it bother you that you didn't have any role models that were women?

DF / That wasn't conscious then. That took a long time for everybody to realize. I always admired Georgia O'Keeffe, but I knew her more from the photographs of her in the museum than I did of her art. I knew that she was an artist, but I was familiar with her through Stieglitz's pictures that were always up at the museum. And Mary Cassatt. It's just a handful of women. I identified with women in other professions who were great beings, but there weren't that many women artists, painters, sculptors, to identify with.

SS / Were you pleased with your training at N.Y.U.? Was anybody in particular helpful?

DF / Yes. Audrey Flack was a teacher of mine.

SS / I like her work.

DF / That "Macarena" silkscreen over there is hers. The
Madonna. She was fabulous. I really can't say enough
nice things about Audrey. We immediately connected.
She was teaching anatomy then, and drawing. I took
anatomy with her. I was really not interested in be-
coming a figure painter, but I wanted to know how to
draw. She was an incredibly inspired teacher. She
taught me how to see things I just never had seen.
She helped me with problems I was having, visual prob-
lems. I didn't have binocular vision, and she helped
me see that I didn't, and there were all sorts of fab-
ulous discoveries for me at that time. She was some-
body for me to identify with. I took her class three
times. The same class.

SS / What artists have influenced you in your work? In the
development of your work?

DF / I don't know yet which living artists affect my work.
Much of the effect on me has been from art of the past,
Oriental, Tibetan art, tantric art, Chinese landscape,
mandala painting, Indian sculpture. It skips from there
to nineteenth-century painting. Cézanne, and nineteenth-
century American painting, really influenced me. And,
as a child, Picasso let me do that, make those kind of
marks and use paint in that way. I think that was
pretty profound, his influence on everybody. O'Keeffe,
too, was an influence. I can't remember when I saw
her work for the first time. I do remember the im-
pact it had on me. Something else besides just what
it was, in terms of flower painting. She liberated me,
seeing it. She really did what she wanted to do. I
think there was a message there.

SS / She's primarily a landscape painter of a different sort.
Do you consider your work abstract landscapes in a
sense?

DF / Yes, I do. I think landscape painting can be a vehicle
for different kinds of experiences, psychic experiences.
Different landscapes create different psychological states.
It's not just about describing a place that you've seen.
I think O'Keeffe's work has that for me. I don't like
to interpret it as a feminine imagery. I think that's
really overdone. But her sensibility and her sensitivity

and love for something that really is so small, making
it so big--that had a very big impact on me.
 The influence of Oriental painting on me had to do
with learning how to look at something in total. Not
a landscape in the traditional sense, even though nine-
teenth-century landscapes had an effect on me. The
importance of looking at Oriental work for the first
time for me was central imagery, which I had never
experienced in looking at European art. Central imag-
ery also combined with landscape, imagery that had
nothing to do with anything tangible but was about the
mind. Well, what a mandala is is a vehicle for look-
ing through something. When you look at a mandala,
you have a visual experience that goes far beyond the
page; you're not just experiencing looking at a cup on
a table. You have a change of brain-wave patterns,
change of breath; it is physical. I'm very involved
with my body, and my body in space, one's sensations
in the world, one's experiences. When I first started
doing these paintings, I wanted that feeling of making
a painting that one would look at and actually travel.
The viewers would actually go someplace different from
where they had been before they had seen the painting.

SS / Would you like to talk a little bit about your technique?

DF / It's a marbling technique, the way old book covers
 are done, the insides of old book covers. It just at-
 tracted me. The first time I did it, it was a very
 pleasurable experience for me, and it felt right, to
 do that. I didn't want to make endpapers. But I did
 learn how to do it and I found out the way the Chinese
 and the English do it. I loved the freedom of painting
 on water. It's different. You don't paint on a hard
 surface; you're actually painting on something soft.
 I make a painting on the water, then I reverse it by
 putting the paper over it and then when it comes up,
 the image is reversed. What the painting is, is flip-
 flopped from what is actually accomplished.

SS / It's like a monotype.

DF / As soon as I did this oil floating on water, I knew
 that it was a way for me to express something that I
 wanted to express. And I kept doing it. Then when
 I moved to this loft, I hadn't done it for a few years.
 I was dripping paint and staining canvas, not really

knowing where I was going. I didn't like using brushes;
that was a big part of it. It really felt very restric-
tive to me. Then a friend of mine saw a certain book
and then saw the work I was doing, and asked, "Is
there a way for you to get that thing together?" That
was eight years ago. I did it; I got a pool and I
started making bigger paintings. Then the problem
was the paper, or canvas: how to get something so
minute and so detailed and so fine onto a surface to
make it look like something. It took about two years
to do that. The reason they became collages is that
the paper I was using, which was the best, the most
efficient, in terms of the marbling, didn't come any
larger than thirty inches by twenty-two, so I started
cutting them up. I had all these papers that looked
the same and I thought, I have to make a painting some-
how, so I started cutting them up and making a paint-
ing by pasting them together.

　　Pollack was an influence on me. His work had that
movement to it, overall.　He worked on the floor, too.
The thing about working on the floor and working in
the pool is that it's a tremendously integrated physical
experience. Painting from the arm down to the brush
is not enough for me. I do come from a dancing back-
ground. When you're dancing, you're using your en-
tire body, so for me a visual art form had to do that
too.

SS　/　Have you experimented with different papers, or just
　　one particular type of paper that works out better?

DF　/　I tried everything. I tried etching paper and I tried
　　hundred-percent rag. The only other thing that's as
　　good as this paper is etching paper, because it's very
　　heavy. But the problem with a rag paper is that it
　　absorbs all the water and it buckles, so that you can't
　　put it in again and have it look the same, whereas this
　　paper, because it had glass in it and even some asbes-
　　tos, never wrinkles. You can saturate it; it never
　　stretches, never shrinks. It's not real; it's not paper.
　　It's only partially paper, so that I can put it in the
　　water over and over and know what's going to happen.

SS　/　That leads me to ask you another question. Some
　　people work on paper with oil paint, but it is not a
　　particularly lasting technique because the oil makes
　　the paper rot. Because of the fiberglass content in

this paper, do you think that your work will last longer?

DF / I worried about that for a long time. It took me a long time to find out what was actually in the paper, because the paper company didn't want to tell me. I've only known for a year that there was asbestos in it. I knew that it was partially fiberglass and partially rag, paper fiber. Now that I know it has asbestos, I realize that I may die before it does. But it's not going to rot. I even stopped worrying about covering it. And if thirty percent of it, since it's thirty percent paper, doesn't last, well, it might be interesting.

SS / Look at the Chinese scrolls. And the Oriental pieces that are on paper. Hundreds of years old. Do you think that there has been a trend toward a very transitory type of work on paper and different media that are self-destructive?

DF / Yes.

SS / Do you think artists have a responsibility to tell people that?

DF / Oh, sure. I think that if you're going to make something that isn't going to last more than ten years and somebody buys it, they should know that it's going to disintegrate in front of them. And that's part of the work.

SS / Do you want to talk about your use of color?

DF / Color is not something terribly important to me anymore, though it looks like it is. The color at this point is a vehicle for something else. Creating the space. I used to be very into color, very beautiful, rich color. I think I went through a great many color possibilities that were exciting to me. Now color doesn't interest me that way.

SS / Do you have a limited palette?

DF / Well, it seems to be getting limited. It's getting grayer and whiter.

SS / More monochromatic, you mean?

DF / It's becoming monochromatic, which might be from
 living in the city. I noticed that the paintings are
 looking more and more like what I see when I look out
 over the city. If I were out West, I probably would
 work in those colors. But I don't quite know why this
 is happening. I have a feeling it's because I've spent
 myself on color. I'm more interested in the geometry,
 in what the painting is expressing, than the color.

SS / Do you want to talk at all about the feminist movement
 and its effect on your work or on your life?

DF / It's had a very big effect. I feel like it's gone in
 two stages. The first stage was the initial 1970 con-
 sciousness-raising group with the heavy political fem-
 inist activity that was going on. I was involved with a
 group. That was the initial getting in touch with anger,
 and feeling men have ripped me off, and society, all
 that stuff. I saw that injustice. Feminism has also
 gotten me very much in touch with realizing that I had
 always identified with men. Especially in terms of
 success. The part of me that would be a successful
 person was identified with my father. I chose to be
 like him in that way. Except that it didn't feel like
 me, it felt like being somebody who I wasn't. I didn't
 really integrate those parts for myself. I'm still
 struggling with those things. I really didn't identify
 with women, and feminism helped me to see that. I
 started liking women during that period, not feeling
 separate from them, because if you don't identify with
 what you are, then you don't feel part of the group.
 There was a time when I didn't think I wanted to
 have any children, and just wanted to be a professional
 person. Then I forgot about feminism for a while and
 really concentrated on my work completely.
 Now I'm involved in Heresies, the feminist political
 art publication. I'm again experiencing feminism with
 regard to being an artist, and my personal struggle,
 and all women's personal struggles with regard to
 their being artists. Heresies is really about just being
 a woman in this society. Being an artist is terrific
 if you're a woman.

SS / Do you think it's harder to be taken seriously?

DF / It's harder to be taken seriously, but it's hard in any
 field. I think the support that most women are giving

each other now is what excites me most. The incredible feedback, the interest women have in each other's work, the lack of jealousy. There's somehow an underlying nonthreatening feeling that's going on, that's never happened before. People have just been scared all the time about showing their work, sharing information, any of that. I think that's a big problem still, even with feminism. There's not too much to go around, so everybody's saving their little bit. The other thing that's interesting to me is the eclectic nature of the work that's going on, by women. There's something very rich happening with women's work. I don't know why, but I think it might have to do with the support, where people are saying it's OK to do what you want to do. You don't have to be an abstract painter, you don't have to be like Jackson Pollock, you don't have to be a photorealist, you don't have to work in steel if you don't want to. That to me is very rich. I'm very opposed to every woman's art being interpreted as a feminist image. That really bugs me, and it's been bugging me for a while now.

SS / Like O'Keeffe's things, you were saying. She flatly denies any female imagery.

DF / Yes, she has an absolute right to deny it. As far as she's concerned, that's not what it's about. I mean if you want to look at it and see that in it, then that's your business.

SS / Do you think men's and women's art are at all different?

DF / Sometimes yes, sometimes no. I know men who relate to my work very, very strongly, and women who don't. I know some men whose work I greatly admire, and other men whose work I have no identification with. I know women's work I don't identify with. I don't know if it matters.

SS / Did you ever have anyone look at your work and say you paint like a man?

DF / No, I've never had that happen to me, although I've had other things said to me in that way, about myself, that I had that kind of strength. No, my work has been sometimes interpreted in a too-strongly feminist way.

"Pond" (1977)
Oil on paper, 66" x 90"
Photo credit: Chris Kraemer

I wish it weren't so much interpreted as female, al-
though sometimes I like it. I'm not too consistent
about this issue.

SS / Have you had difficulty getting shows and showing your
work?

DF / Sure.

SS / And what do you think about alternate space for women?
Is that important?

DF / I think it's very important. That's part of the support
that I was talking about. But, I think it can be danger-
ous to get so identified with feminist shows that that's
all you're in. Then critics start looking at the work,
and thinking, "She's a feminist, a woman painter."
Then you're back to that again, that separatist thing.

SS / Women have to show together first in order to get
some space, and then later....

DF / Yes, I think it's a matter of just making up the num-
bers. I think women should have shows, just because
they haven't shown enough. There's a lot of time to
make up for. So I look at it that way, more than as
a separatist issue. It's very important to devote space
and energy toward showing women's works. I'm not
a radical feminist.

SS / Are you a member of the Women's Caucus for Art?

DF / Sure. I think that the injustice is real. I think that
the lack of curators, the lack of women exhibiting in
galleries, is incredible. I've had male dealers say
things to me that were just abominable. Especially
when I was pregnant. They just couldn't relate to the
work; they were just totally involved in the pregnancy.
They would say, "The work is beautiful, but it's not
tough enough. You enjoy it too much." At the same
time, I was pregnant, so here I was, and they were
saying to me, "Your life is not worth it."
The women artists' movement is very healthy; it's
very, very good. The quality of the work is good.
It feels to me like an incredible rebirth. I have an
image of the girls that I knew when I was growing up
and what we were all like. We were very unfocused.

We weren't driven, we weren't ambitious. We weren't
ambitious for ourselves, in terms of achievement other
than grades. There was some vague reason we were
supposed to get good grades, which had to do with
pleasing our parents. But there wasn't any kind of
goal.

SS / Some people say that the only real artistic energy, par-
ticularly in New York right now, is from women's art.
Do you think this is true?

DF / That's ridiculous. Although I agree that things in the
art world are really messed up. It's very cliquey and
masturbatory. And it's without vision, it's very aca-
demic. God, the lack of heart, the lack of soul in the
writing in the art magazines is enough to put anybody
to sleep, and nobody understands it. The art world is
extremely hostile. There's a tremendous need for art
critics to say things that they know people are not go-
ing to understand, to intimidate them into thinking that
the work is something only critics can understand.
 That part of the feminist movement I think is healthy,
that there isn't that kind of obscurantism going on yet.
There isn't the need to interpret. The most important
thing is to produce and show the work and communicate
what is going on. But I think that there's a danger for
feminists who get into that "we're the only thing that
matters." That's just going to turn around on us in
a backlash. I think it's about the same thing that crit-
ics do. Elitism. I'm here and you're over there,
and I won't relate to what you're doing.

SS / What about the fact that New York is obviously the
center of the art world and has been for quite a while?
Do you think it will remain that way, or that art will
become more dispersed throughout the country? Or
will another country pick up the main force?

DF / I can't tell much about other countries. I haven't been
abroad for awhile. I always wanted to be in New York.
I still do. However, people are doing shows out of
town, and a lot of things are happening, and I think
it's terrific. People being intimidated by New York--
that's decreasing. I don't know if it will all shift; I
have a feeling it won't. There's something here that
doesn't have to do with art as much as that everything
else is going on here. You need that kind of tension

to make art. I know if I go to a beautiful place and
I'm very relaxed, I tend not to work in the same way.
I work wherever I go, but there's not that same kind
of edge to it. New York is such a struggle to live in.
I really don't know if it's for everybody. Still, there
must be a reason that we all live in these lofts.

The shows that are going on out of town are very
important for artists for many reasons. First of all
they're important for people in the places they're hap-
pening, which I think is most important, because art
is not only happening in New York and is not only un-
derstood by people who are only in New York. Another
problem, even in New York, is that people with very
good educations and sophisticated minds are so intim-
idated about art. Their education has been nil, in art.
They have not been trained to look at anything in their
lives. It's a result of the nonvisual education of those
older, middle-aged people. That is an indication of a
society where art is not integral. The lack of integra-
tion is encouraged by the system in which we are liv-
ing. You build a building; you then commission an art
piece after you build the building.

SS / That's starting to change.

DF / Where art comes from, what it's about, what people
are doing in art--in our society, these are afterthoughts.
Art is not part of our religion, that's part of the prob-
lem. We're a diverse country; we don't have religious
art. Where people have religious art, there wasn't a
thought about doing their art. They just did it. They
needed to do it. Here, it's not integral, it's ornamen-
tation.

This is a power-dominated industrial society. It's
very technological. There's a lot of potential that is
not used, that is not recognized and used for people
and the richness they could experience in their lives.
People have nothing to do with art, here. In Italy a
paper bag, or a vitamin bottle, can be the most beau-
tiful thing you've ever seen. I'm not advocating that
everything be designed beautifully. I'm just saying
that the reason artists have to live in New York and
the reason they have to separate themselves from the
rest of society is because of that real hostility toward
what they are doing.

SS / But don't you think it's true that in other cities the art
world is always very small no matter where it is?

DF / Yes. But it's really great that people are looking at
art more than they used to. The problem is that they're
trained in television, so they're very impatient. They
don't want to sit and look at something for a long time.
They really want something very fast.

SS / There have been people who have said that painting
will become obsolete and that we will use video and
other media instead. Do you think this is a possi-
bility?

DF / No, no. That whole thing passed for me. That whole
"painting is dead" movement, remember that? I know
there's a whole theory about that, that the evolution of
art is necessary for other experiences to take over,
and I think that for some people that's true. If they
don't need to paint anymore then they shouldn't paint
anymore. I would like to express what I have to say
in other ways besides painting, but that doesn't mean
that painting is not valid for me. I understand where
that theory is coming from, but there's something about
painting that is not going to go away too fast. It's a
very integral part of our unconscious. It's a process
that's been going on for thousands of years.

SS / Also, I just don't think you can get the effect in other
materials, other media.

DF / It's just one way to make art, that's all. When you
talk about the question "Is painting dead?," the whole
thing about painting is that it was dead. The reason
it was dead was that it was on the wall, and if it's on
the wall, it's separate from the viewer, and it's an
object, and the viewer is not involved with it. I said
no. Painting can give the viewer as much experience
of totality as a work of sculpture, because if you learn
how to experience a painting you don't have to have
that limited vision of color and line.

SS / Do you actually have an eye for the viewers, how
they're going to react? Do you feel like you're writing
a message?

DF / Yes. Of course, I paint for me. There's no doubt
about that. I paint because I have to paint. But
there's an interest in me about what the painting's
going to be. I think that's true for everybody. I want
to communicate something. I want to change people in

terms of the way they see. I want people to have an
experience they never had before. I really want to say,
"Look here!"

SS / You were talking before about how you like to paint on
the soft, the water's soft, and also there's a different
space going on with the water.

DF / When I first started doing this work, and I'd be in my
studio and it was a hundred and ten degrees, I'd really
get hot. I felt like I had been there and done this be-
fore. I don't know what it was, but I had a sense of
familiarity, that déjà vu. The paint started to be ex-
pressions of places that I had actually seen, in my
dreams, seeing them flying over spaces, airplanes.
The work is about consciousness, where your conscious-
ness can be in one place and your body in another.
That's what astral flying is about: you go to sleep
and you dream and all of a sudden you're flying over
Greene Street. I have dreams of flying over the beach,
flying over the desert, flying over the mountains. I
was interested in having that feeling in my art.
 Also, I like to break up space. I like to take the
painting and divide it into three parts, because the
traditional thing is, you know, one. When I first looked
at Oriental art, I saw you could take a triangle and
make it into eighty-three triangles, and each one would
have a different meaning. These newer paintings with
the triangles divided up into nine parts have something
to do with each square having a different story; you
could look at the painting and experience a shift. I
took these little triangles out from each corner and
changed them around to say: Here's this little story,
here's this little twenty-two-inch by thirty-inch story,
but in the corner is a different story. And I'm going
to borrow a story from that corner and put it in this
corner.
 It's like life. Things happen to you a long time
ago, and all of a sudden in a little brain-wave pattern,
that thing will appear again, and give you some kind
of information you didn't have yesterday. But you
experienced the original thing fifteen years ago.

SS / Your interest in Oriental philosophy, and time and
space and layers of consciousness might have something
to do with the layers in your work.

DF / Definitely. I love the veil. I don't like flat art at all.
I don't like acrylic paint for that reason. Acrylic
paint has no light coming through it. For me, time
and space have to do with light, and depth, density,
being able to see through something. If you're exper-
iencing yourself and you're conscious in those ways,
you're seeing through yourself and your art experience.
I love that kind of experience, and I like a painting to
do that, where you can look, and then you look again,
and there's more. You can go back to it.

I don't seem to make portraits of people as much
as I do of places, or of the experience of a place that
I have. This piece I did after my son was born. I
felt my body was a tunnel and the baby came out of
it; it was an open, cavernous, fabulous feeling. And
that's what I painted.

FRANCES KUEHN was born in New York in 1943 and educated at Douglass College (B. A.) and Rutgers University, New Brunswick, New Jersey (M. F. A.). A resident of New York City, she is represented by the Max Hutchinson Gallery in New York. Her work hangs in the J. B. Speed Art Museum, Louisville, Kentucky; the Weatherspoon Art Gallery, University of North Carolina; the Power Institute, Sydney, Australia; the Allen Memorial Art Museum, Oberlin, Ohio; and in private collections. Her painting is discussed in Phyllis Derfner, "Frances Kuehn," Art Spectrum, February 1975. Her exhibitions include the Whitney Museum 1972 and Biennial; Contemporary Portraits by Well -Known American Artists, Lowe Art Museum, Coral Gables, Florida; Selections in American Realism, Akron Art Institute, Ohio; 1974; and one-woman shows at Douglass College Library, New Brunswick, 1973, and the Max Hutchinson Gallery, New York, 1973-75.

SS / When did you decide you wanted to be an artist?

FK / I think I first began thinking of myself as an artist
when I was in my next-to-last year at Douglass College.
My instructor at that time was Roy Lichtenstein, and
that was also a time when Pop Art was just exploding
in New York. There was an extraordinary sense of
excitement at living at school and among the people
who were students with me. I think it was at a cer-
tain point I started to realize that how my paintings
were going was the most important thing. I was study-
ing a lot of things, and I was a good student; I cared
about all the things I was studying. But it struck me
that my art was the most important thing that I cared
about. That year I was acquainted with George Segal
and with my brother-in-law, Gary Kuehn, and other
graduate students, and the seriousness and the directed-
ness of people who are older made it seem possible
to be an artist. I was for a long time fearful that
this was not possible for me. And knowing these peo-
ple made it seem more possible. In my senior year
at Douglass I continued to work, I continued to get a
good response from the department and the people who
were there. I was married in my senior year and
found that it was possible to combine art and marriage.
My husband, at that point, was studying art history.
It was possible to be not just a student but to see ahead
to the future, to see some kind of way of life that
would give me a chance to do my work. Dealing with
the practical realities of survival was not that fear-
some either.

SS / Do you think that the fact of being a woman had any-
thing to do with the fact that it seemed harder?

FK / I don't think so. My mother was a science teacher;
she was an example of someone who was very much
a professional, and who was competent, and who was
always an example. It never occurred to me that be-
ing a woman would be a limitation. In my family,
while there was always a great respect for the arts,

75

doing art was something that was far out, it was not something that regular people did. You had to be tapped on the head by a magic wand when you were a baby and that would make you a real artist. It was not something that one went after in the same way that one went after other professional accomplishments.

SS / Maybe society's at fault. I think that society has this kind of image of artists that's not necessarily true; it's kind of idealized.

FK / Yes, yes. I think so. Maybe that's part of the appeal, too, though, especially to very young people.

SS / You say you studied with Lichtenstein. Is he an influence, a prime influence on you?

FK / Yes. A very definite, important influence, although actually in thinking back over the years, I don't think that he was what I would call a generous instructor. I don't think he really gave of himself. I think his ideas, when he chose to express them, were always provocative, and I respected him enormously. But I don't think that as a teacher he felt a great need to draw upon all his reserves. Because Douglass was associated with the graduate school, the atmosphere of excitement was more valuable than what was specifically gained from one person or another, even the instructor.

SS / Were there other people then at Douglass who were important, who had an effect on you?

FK / I think George Segal was an important influence. Although I always feel a little strange, as though I must explain that to cite someone as an influence is not to give them the blame!

SS / Segal is a portrait artist in a sense, too, even though he's a sculptor.

FK / Figurative.

SS / Do you consider yourself figurative, and was your figurative work important early in your development?

FK / At a certain point when I was at school I was painting

abstract pictures and I was drawing from the figure. They were two separate things. At the same time I was doing the abstract pictures I was working instinctively. I didn't have a very solid background in contemporary art history. I was drawing from the figure and sensing too much of a division between my drawing and my painting. At some point (I guess it was in the spring of 1963) I started drawing, doing the drawings on canvas and basically using flat color and using the drawing, the figurative drawing, as a means of dividing picture space, in a way that I think was influenced by Pop Art. There was a clear relationship to a piece that Wesselman was doing at the time, but it was also influenced by Matisse. As the work evolved the figures became less flat, and over a number of years I began to do a more naturalistic kind of modeling.

I began to work with photographs, largely to solve a practical problem of finding models. I found that I really liked working from photographs; the photograph was the same every day. There was no difficulty of coordinating my time with the model's time. I began to work much more closely and much more specifically from the photographs. In about 1969, 1970, the way that I was using the photographs was so explicit that in effect I was making portraits of the models. There was something about that that disturbed me at the time, in the sense that where the nude had traditionally been considered an idealized form, these were definitely specific individuals and were indeed portraits. I began to think about what a portrait was; in any case, I began to make portraits. What I remember thinking about was that something you declare to be a portrait has some kind of relationship to the truth, or how you see the truth; whereas, if you just say it's a model, it's a figurative painting, it could be anyone. Say a portrait, and it seems that you're defining something true.

SS / And about a particular person, too.

FK / For a while I was doing more things with the rest of the space in the picture, since this gave additional information about the person, and enlarged upon the portrait truth. Last spring I started thinking about painting nudes again. I started thinking about the tradition of the nude as one that is close to the portrait tradition, and I felt that I wanted to expand the range of

my work. I also wanted to think again about what the
nude was all about. I was floundering with the diffi-
culties of finding a model, and then finally I did find
one. As I was working on these two paintings so far,
I think they express rather different attitudes about the
nude. I'm planning some pastel drawings that may be
more focused on the nude as a more abstract source,
a source for abstract form.

SS / It seems that you're coming around in a circle.

FK / To me, the two paintings that I've done so far look
quite different. But I'm not sure if they will look that
different to other people.

SS / They look quite different to me. One is very specific
and the other is not. One is really a portrait of a
person at a particular moment in time, and the other
one does not have that momentary effect.

FK / I want to work with the male nude, too.

SS / I was going to ask you about that. Do you have a
preference for painting women, and do you think that
you treat them differently in your work?

FK / When I was painting the nude years ago, they were
almost all female nudes. With portraits, I painted
men and women, and my daughter; the only child I
painted was my daughter. I felt then that I didn't
have a preference. Coming back to the nude after
a number of years, I found it easier to get back to
the female figure. I feel a little bit more shy about
finding a male model and posing him. I'll get over it
after I do it once, probably. My husband posed for
me some years ago, but he doesn't want to do that
any more, and I can understand that. Male nudes are
something that I've put off for a little while. When
I hire a model, I can take lots and lots of photographs,
and it will keep me going for a while.

SS / One sitting will do you for quite some time.

FK / Yes.

SS / I know that you work from the photograph in the grid
fashion. Do you consider yourself a photorealist?

FK / Yes, I guess so. I'm not particularly enthusiastic
about the category, because I think that for some peo-
ple it implies a kind of sharp focus, mechanical sur-
face, air brush. The surface and the touch in my
work are more traditional than other work that has
been called photorealist. Some people call me a paint-
erly realist.

SS / Labels are always like that. Nobody really likes them,
but they're useful for art criticism.

FK / I don't mind being called a photorealist, because other-
wise it would seem to be evading the fact that I do
work from photographs, which is different from work-
ing directly from life. That's not a source of embar-
rassment; I don't want to deny that, but it's just the
implication of the category "photorealist" that's a
slicker kind of thing than what I do.

SS / You know the one painting that you were just showing
me, the reclining figure, seems like a traditional
Venus, in a sense; but she's on a contemporary chaise
longue out in the yard. Did you feel that way about it
at all when you painted it?

FK / Yes, I think so. There's a group of contemporary
painters, of whom I guess Pearlstein is the most em-
inent, who handle the figure in a way that suggests
that the figure is like a special still-life object. It's
in the studio; it's examined, minutely examined, beau-
tifully examined, but there's a lack of responsiveness
to the spiritual realm or the content of what a human
figure is.

SS / Pearlstein's figures are very empty.

FK / They're beautiful, formal, and in the last paintings
I've seen, the color has become more and more re-
fined; they're wonderful paintings, but there is a kind
of feeling about the painting that I don't feel.

SS / Impersonal.

FK / It's not what I want to do. On the other hand, in what
I think of as nineteenth-century handling of the figure,
in an intimate setting, something like Bonnard or Dégas,
there's something a little dishonest. It suggests an

intimacy with a woman's life, but it comes out of a
romantic feeling about these women, who were painted
by men. There is something that would be too stagey
about my handling a female model in that way. I
started thinking about the most natural way to use a
nude figure in a way that is not stagey, not forced.
I thought about the sunbathing nude. We have a yard
with privacy and open spaces beyond where the trees
are. I had this model come, and I had the chaise,
and I took many reclining poses and some sitting up
poses, which might suggest someone preparing to lie
down. What I was thinking of was a contemporary mo-
ment. Then the relationship of the figure to all the
natural foliage and everything started. I started think-
ing, "There's something else I'm thinking about also,
something more mythical." The way the figure came
out is very sensual. The towels and the chaise were
painted last. I wondered if that would snap it into a
more specifically contemporary look, but I'm not sure
it did. It's a painting I just finished not too long ago;
I'm not entirely clear what it means.

SS / In six months it's clear, I know.

FK / It becomes a little bit more clear.

SS / There's a feeling, in most of your work, of the catch-
ing of the moment.

FK / Well, that's what a photograph can do.

SS / But they're genre scenes, too, in that they do have in-
timate spaces sometimes, and settings.

FK / Yes, yes. In the painting I'm working on now there's
that momentary glance. In fact I have the next frame
on the roll of film, in which I stepped back a little
further to get a little more of the background, and it's
amazing to compare that photograph with the one that
I'm using. In that instant the interest in the face has
just gone blah. In one instant only the eyes are shift-
ing to the side--and it's fascinating to me.

SS / That momentary thing is very important in your work.

FK / I've begun to understand what a photograph is by using
them. I think the first thought about using them was

just that I needed a model and it was easy. And then
the more I became involved with making the photo-
graphs, the more I began to understand what potential
the photograph could give me.

SS / You were saying that you think you might go into ab-
stract things.

FK / When I say abstract, I mean not really very abstract.
I'll bring out another picture. As the fragment of
a larger image, there's a choice based on more ab-
stract problems than content.

SS / Even though it's a chair, it's very abstract, and it's
quite close up.

FK / I've been thinking about using pastels and conte crayon,
and I just bought some beautiful colored papers last
week. That's what I'm thinking of doing next. Not
abstract in the sense that the figure becomes unrecog-
nizable, but less focused on humanistic content and
more on the figure as a source of form.

SS / Most of your work is very large. Do you like to work
large, rather than small?

FK / I'm starting to work smaller. The painting I'm work-
ing on now is less than four feet by six feet, which
is pretty small in comparison to some things I've done
in the past. It is nice in the sense that it permits me
to move more quickly. There is something about a
great big canvas. A very big canvas isn't necessarily
a big idea, but it does have a special presence.

SS / And the figures become almost life-size.

FK / The figures have tended to become smaller. In my
very earliest paintings, around 1970 to 1973, the fig-
ures were twice life-size at least. Now they're com-
ing more toward life-size; in fact I think that some-
times they look like life-size even though they're about
one and a quarter times life-size.

SS / Do you think that the background elements have become
more significant than the abstract forms in the other
paintings, since the figures are smaller?

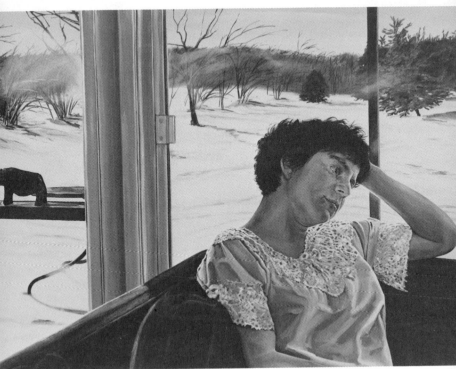

"The Student's Vacation" (1977)
Acrylic on canvas, 46" x $69\frac{1}{2}$"
Photo credit: D. James Dee, © 1978

FK / In many of the recent pictures I've been using foliage
 --working with figures outdoors and using complex
 foliage backgrounds. I think finally in this picture I'm
 working on now I'm pleased with the way I've handled
 the foliage, because it's been a problem how to ap-
 proach it, to get a sense of the very rich complexity,
 without exactly painting each segment of each leaf. I'm
 pleased with what I've done in this painting. In fact
 maybe that's the reason that in a painting that I think
 will follow the pastel drawings, I'm going to be going
 back to the interior.

SS / Do you want to talk about color in your work and the

effect of the light? Do you use natural light or fluo-
rescent light when you work?

FK / I use fluorescent light. I've worked from black-and-
white photographs because the drawing and the patterns
of light were more important to me than color. But in
the past few years I've become more concerned about
color; I've changed the way that I'm painting the skin,
which is a very complex problem, a very difficult
problem. In some of the paintings where the color
has gotten stronger than it was in earlier works, it's
surprising to me, and I suddenly realized one day
that it's because I'm working from black-and-white
photographs, which are essentially patterns of gray,
as my sources. When I look at them and then look
at my paintings, the paintings seem so intense. The
colors particularly seem so intense, though they're
really not.

SS / Your palette seems limited. Is it purposely limited
in the sense that there isn't a great variety of color,
of intense color in your work? It seems to be more
tonally equal. Some people do that on purpose.

FK / I think in this last painting, the completed one that I
showed you, the big towels that she's lying on were an
opportunity for me to use color decoratively, more ar-
bitrarily than I've used it in the past, and that was
exciting. I felt that I didn't want to use color to be
colorful, in the past, but just wanted to use it func-
tionally. If you're painting foliage, you must paint it
green; it needs to be green. I'm thinking about color
a little bit differently in the sense of not only wanting
there to be more variety in suggesting skin tone, for
example, but also thinking about color in its abstract
possibilities, too. A painting is a problem in abstract
color relationships as much as it is anything else.

SS / There are some people who think that all artists are
abstract artists. What do you think about that? Do
you think that's a possibility?

FK / Oh, yes, I think so.

SS / Yes, because you break most paintings down in that
way. Have you ever worked from color photographs?

FK / No. I don't like color photographs because the colors

are never right. Color photographs always look like
Kodachrome color; the colors don't move enough.
When I work from black-and-white photographs, I feel
that I trust the information that is there. I think of
them as very detailed drawings. And then the way I
handle color, you know, I can always refer back to the
subject.

SS / Is there any other aspect of your work that you'd like
to discuss?

FK / I could tell you about the way that I paint. I do most
of my pictures in a technique that is generally called
indirect painting, in the sense that the problem of the
patterns of light and shade is separate from the prob-
lem of color. There is an underpainting and glaze,
which the use of photographs is very congenial to,
because the underpainting can be quite directly derived
from the photograph, and the modeling can be done in
the underpainting. This is something that came about
quite early. It seemed a very comfortable thing to
get into, and I didn't even know when I first started
doing it that that was what Venetian painting was. In
the early paintings that have the flowers I used to paint
the flowers with watercolors. If I painted a flower with
red watercolor, when it was finished it didn't look like
a red flower, it looked like a pink flower. In looking
at and using the flower catalogs, which were my source,
I noticed that for a picture that looked like a red flower,
there was just a solid red and then there was a black
stamped on it, in two layers. That's what gave me
the idea of doing the underpainting. What I would do
is do the underpainting in watercolor in black and then
paint with oil (I was using oil at that time), paint the
red over it. When I began to use acrylics, and I
started using the gel, I started reading a little bit
more, and finally I understood that this was quite a
traditional painting technique.

SS / Do you use both acrylic and oil now?

FK / No, only acrylic.

SS / Sometimes artists use acrylic underpainting and oil
glaze. Do you?

FK / No, the gel works quite well. The thing that's very

nice about acrylics is that they dry so fast. I work
quite thin and I work sometimes with the paint almost
like a wash, for the modeling, so that it can dry and
then I can start the next layer.

SS / Do you work on one painting at a time?

FK / Yes.

SS / And you work up, as opposed to on the floor; you work
on an easel?

FK / Oh, yes. When I first began to think about painting
the nude again, I was preoccupied with the question
"What is painting the nude all about? What does it
mean?" I made the photographs. I take one picture
at a time, and my thoughts about the pictures change
as they go. I think it's possible with certain kinds of
work to be much more clear about intentions from
start to finish, but I feel as if I don't know what my
paintings exactly imply for a long time. And that's
very exciting. Therefore I don't feel that I can make
absolutely firm statements about what I'm doing.

SS / It changes all the time. It's a growing process. I'd
like to ask you about your feelings about the feminist
movement and how it's affected your life and your
work.

FK / My first awareness of the feminist movement was in
about 1971. At that point my daughter was in kinder-
garten. The year that she went to kindergarten I went
back to school to finish my M.F.A. That spring Judy
Chicago and Miriam Schapiro came to Douglass as
part of a tour. I was very much put off by the ideas
that they presented about women's imagery. I felt that
I didn't like anyone telling me what women's imagery
was. I had at that point been married for seven or
eight years and felt that marriage and motherhood were
not incompatible with my personal goals. I had re-
solved personally many of the problems that the wom-
en's movement was raising. I felt that I had already
gone past that step, and I think I felt rather distant
from the movement. I think I still do.
 I think it's very hard to be an artist. It's hard for
men to be artists and it's hard for women to be artists.
As women, it's hard for us to cope with the mixture of

expectations that we have of ourselves. The traditional
roles are very important, and to combine them and the
image of ourselves that those traditional roles give us
with our more active, competitive, self-proclaiming
roles as well is a special problem for women that is
not a problem for men. The most important focus of
the women's movement needs to be how women sort
all this out in their own minds. Less emphasis on
problems of dealing with the outside world, but more
on how we sort this out within ourselves and can re-
main in harmony with expectations that we have of our-
selves and of things that we want to be.

SS / Do you think it's possible to do it all, then?

FK / I'm not sure that anything is possible. I've always
wanted to do it all.

SS / Do you think that women have been discriminated against
in showing their work, and in getting recognition?

FK / It's very hard to generalize. My own experience has
been pretty good. I've been helped by men. In fact
one of the things that makes me wary of feminist state-
ments is this realization that I've been helped by men.
It would be a betrayal of that help if I said women
don't have any chances; nobody helps them. The at-
tention that the women's movement has had, particularly
in the last couple of years, has in fact made more
special opportunities for women. I've heard grum-
blings from men who feel that these special opportun-
ities are in effect discriminatory. I haven't made a
study of the whole scene; I'm not sure that I can make
any more of a statement than that.

SS / Do you think men and women's imagery are different?

FK / For all of us, our imagery comes from ourselves, and
it comes from art history, which is something we all
share, and it comes from individual differences, which
may be more significant than the differences between a
man and a woman. I'm not prepared to make any gen-
eralizations about women's imagery or men's imagery.
Obviously being a woman or being a man is certainly
a significant ingredient in one's identity, it must affect
the work in some way, but I am not prepared to be
specific about that.

SS / Do you think the fact that art history is a male-
 dominated field, and the fact that women have not been
 shown in museums, are of any significance? Do you
 think that it's changed? Do you think that women are
 getting more equal opportunity now to show in galleries,
 and museums?

FK / Definitely. The situation now compared with that twenty
 years ago is dramatically different. Another way of
 interpreting your question, though, was part of my
 thinking when I started working on these nudes. My
 sense of the tradition of the female nude in art is one
 that comes from my knowledge of men's handling of
 that subject. Art history, the sense of tradition, is
 important to me, more important perhaps than it is to
 other artists. But if it in effect comes all from men
 artists, maybe it's a prejudiced outlook. My sense of
 what traditional painting is is painting of previous cen-
 turies by men. The power of role models and how that
 influences one's aspirations are something to think
 about. To have the temerity to declare oneself an
 artist might be easier if there were more women art-
 ists well represented. In a certain way it's more par-
 ticularly hard for men to be artists, since our society
 values money-making by men, whereas women can be
 aesthetically inclined.

SS / But yet they're not taken as seriously?

FK / Maybe not, but then when the men do go into art, it's
 a little bit different. Men are maybe more discouraged,
 but if they finally make the decision, they are more
 likely to pursue it with vigor and with seriousness,
 whereas women may fritter around.

SS / Do you think that that's really true? Historically,
 women have been looked at as dilettantes.

FK / I think the possibility of being a dilettante is more
 open for women. Being an artist is considered a dopey
 thing in our society, and men are supposed to do con-
 crete real things and make money and be powerful and
 build businesses. Art is not considered a manly under-
 taking.

SS / That's interesting. Would you consider yourself a fem-
 inist or not?

FK / I think that any woman who sets goals for herself and takes her own life seriously and moves to achieve the goals that she wants as a person in her own right is a feminist. Therefore any woman artist is a feminist, whether or not she toes an exact political line that is described by somebody else.

SS / There is a problem. If women don't take themselves seriously enough, sometimes it's because their culture doesn't take them seriously enough. I think that men could be dilettantes just as easily.

FK / But most of them can't afford to be.

SS / I have friends whose husbands are artists, and these men are very protected; their studio is out there somewhere and they are never bothered with the children. Mommy takes care of the children.

FK / This has never been what we've done. My husband's and my own careers have run roughly parallel. He has worked, basically making a living for us, full time since his graduation from college. I've always worked part-time. When our child was small, he always shared the responsibilities, he still does, although at her age it's not so much specific kind of caring, but it's transporting and attention. I think he's an unusual person. I know a woman who is quite a bit older than I, who has three children, and whose husband felt that the children were her responsibility, which I think is very unfair.

SS / One thing the women's movement will do is to reshape those expectations a little bit. Most of the younger husbands that I know tend to be more sympathetic and more helpful and have a closer relationship with the children when they're little, aside from the art world.

FK / I think that this is something that we started before people were talking about it.

SS / It was before it was popular.

FK / That is why I felt that the movement didn't have that much to do with me. I'd already been through it. To both George and me each other's goals are as important as our own.

SS / It must be nice to be able to share your work and be able to talk about it.

FK / I consider myself very lucky.

SS / If you had to give some advice to a young artist, specifically a young girl, what kind of advice would you give?

FK / Equipping oneself to make a living is very, very important. When I was a student, I had fantasy ideas of what being an artist was. I never came to grips in a practical way with what it would mean to make a living. I had the M. F. A. , and I just assumed I'd get a teaching job at some point, and I've been teaching part time for a couple of years now. I'm looking for a full-time job, but it's taken a long time for that to happen. There aren't that many teaching jobs, too, so people have to be aware of this. You have to be able to do other things. When you're in school, even if you're not that attracted to photography, you should learn photography. You should learn everything. You should learn how to cut hair, you should learn how to do carpentry, you should try to learn everything that can help you to survive. I'm so much aware of the importance of having skills to survive by.

SS / I think it is a real problem, and I blame the schools in some ways for this, that they don't impress upon students the fact that if they, for example, go for an M. A. in art education or an M. F. A. in painting, the jobs will be scarce. Students will always need jobs, and there are many people with these degrees. I don't know how it can be different, but I think the schools should help students take photography and commercial-art courses in order to survive.

FK / The realizations that you have to eat and that at a certain point you don't want to live at the minimal level anymore are important. There's a romantic mind-set about that. I'm in my mid-thirties, and I find that I feel impatient with thoughts about pensions and retirement and life insurance, and one day my husband reminded me that I have the same old romantic attitudes that I had when I was a student. I just thought I'm going to be an artist and live on air. I was so sure,

because I deserved it, that the paints would come, and the brushes and the canvases.

SS / The basics of life are a little tedious, but it's important to keep them in mind.

FK / Obviously being able to pay your studio rent, for your materials, your food, is important.

SS / It takes money to survive.

LORE LINDENFELD, weaver, was born
in Germany and was educated at the Art
Academy, Dusseldorf. Later, after com-
ing to live in America, she studied at
Black Mountain College (1945-48); the
New School for Social Research (1948-
49); the Forstmann Institute (1949-50);
Rutgers University (1977-79); and Prince-
ton University (1977). She has worked
as a designer for the textile industry; at
Kanmak Textiles in New York she started
a handloom sampling department for power-
loom production. She has taught both tex-
tile design and weaving at many places,
from the Haystack Mountain School of
Crafts (1970) to Middlesex County College,
where she currently teaches. She lives
in Princeton, New Jersey, and is a board
member of the Princeton Adult School.
Her articles have appeared in American
Fabrics and Craft Horizons. Her hand-
woven and embroidered textiles have ap-
peared in many exhibitions, including 10
Women Artists, Douglass College, New
Brunswick, 1971; the Contemporary New
Jersey Artists' Series at the New Jersey
State Museum, Trenton, 1972; New Jersey
Designer Craftsmen, Mason Gross Grad-
uate School of Art, Rutgers University,
New Brunswick; and a two-woman show
at the American Craftsman Gallery (now
Hadler) in New York.

Photo credit: Jon Daniels

SS / We should begin by talking about your development as
 an artist and when you first became interested in being
 an artist.

LL / The time that made the greatest difference in my life
 as an artist was the period I spent at Black Mountain
 College. This was several years after I had come to
 this country from Germany, and I was older than the
 average student. This helped to make it a particularly
 important experience for me in terms of my life as an
 artist. It was an opportunity to meet people and to
 become part of life here, which I had not had before.
 The way in which Josef Albers and Anni Albers, who
 were my teachers at Black Mountain, both viewed their
 particular areas brought a unity not only to their art,
 but to life; they made it possible to look at things from
 a fresh point of view, as if you were the first person
 to discover whatever it was that you were looking at,
 or that you were going to pursue in its various forms.
 That quality of teaching has really stayed with me
 throughout my work regardless of where it is and how
 it is applied.

SS / Tell me more about the Alberses and their influence
 on your development and teaching as an artist.

LL / My own area of specialization became textile design,
 not because I had planned to become a weaver, but
 simply because looms were there. I had the curiosity
 to explore the possibilities of weaving, and looked for
 opportunities to apply principles of color and design in
 a more concrete way. Anni Albers's emphasis in this
 area was to prepare people to work in industry as a
 way to influence contemporary design and society more
 effectively than would be possible in individual work.
 This seemed to be a very worthwhile endeavor to me.
 It was in this spirit that I later tried to find jobs in
 industry and worked as a designer for ten years in the
 fabric industry, designing fabrics for women's wear.
 I just realized, also, as I talk about that time,
 what made that time so exciting for me was that my

93

eyes were opened not only in the area of textiles at
Black Mountain College, but that there were also
courses for contemporary architecture, music, dance,
painting, within the context of contemporary life. It
was a time in which my interests were broadened and
in which I received inspirations that have added a great
deal to my life.

SS / What made you want to become a weaver in the first
 place?

LL / It was really just the fact that on my way to one of
 the art studios I would pass through the weaving work-
 shop, and saw looms standing there and decided after
 my first year that I would try to set up a loom and to
 explore what could be done. As a matter of fact, set-
 ting up was so tedious it took me the better part of that
 summer. I felt since I had invested so much of my
 time and effort just in the mechanics of setting up the
 loom that I now should really see what it was that one
 could do with it. I must say it opened up a totally new
 world to me. I very much like the combination of free-
 dom that exists in the choice of color and materials
 and the discipline of the technique of weaving itself,
 which suggests certain shapes, certain uses. I find
 that this combination works very well for me. I would
 find it very difficult to be a painter, to be confronted
 with an empty canvas.

SS / It seems as if a tapestry or a weaving builds like a
 building, in the sense that it's not like a blank canvas
 or a sculpture.

LL / Of course the inspiration can come from various sources.
 It can come from the technique itself, and the tools you
 use, or it can come from things you see in the world
 around you that you translate into the medium of weav-
 ing. I like either one of these possibilities. In indus-
 try I of course had the opportunity to use my ideas and
 at the same time to function in a very structured en-
 vironment. I find that the very discipline of it is
 something that is very helpful in one's life. Some-
 times one rebels against it, but structure is something
 that makes you do a great many things, and out of the
 many things there are some things that are worth pur-
 suing and developing. It is because it really forces
 you to have that commitment and to develop your ideas
 further.

SS / And to produce a lot of work.

LL / A lot of work, so that just by the sheer volume of it,
 there are things that lead to the next step.

SS / One thing leads to another. You end up with more
 choices that way.

LL / Yes, I don't have that pressure at the moment in my
 own work and I sometimes miss it. It takes a great
 deal more self-discipline. One way to achieve this is
 to set up a show.

SS / Then you have to get ready for it.

LL / Yes, absolutely. That is certainly a great help, when
 one has a goal of some kind.

SS / We talked earlier, and you told a very interesting
 story about how you wanted a particular loom when you
 were working in industry; I would like to talk about
 that.

LL / I remember this particular story in connection with the
 fact that when I worked as a designer in industry, the
 making of samples on a hand loom for power-loom pro-
 duction was a pioneering effort. There were very few
 women who were trained artistically and technically to
 pursue this profession. I remember getting a job in
 one of the fabric mills and wanting a hand loom for
 sampling. The technician was called to come from
 North Carolina to New York in order to purchase an
 inexpensive hand loom. A whole fleet of people got
 into a car and we drove out to Long Island to see the
 man who made these looms in his basement. It had
 to be approved and okayed by the technician from the
 mill. Of course the loom was purchased, but it needed
 that kind of endorsement at the time.

SS / Do you think that was more true because you were a
 woman than if you had been a man in the same posi-
 tion?

LL / There were two factors that entered into it. One was,
 of course, because I was a very young woman, and also
 it was a new method of designing fabrics. The usual
 thing was for someone to make a drawing and for these

Photo by Jon Daniels

drawings to be interpreted into the technical possibilities
by people in the mill. However, that process elimi-
nated many of the new ideas, because in that method
the artist could not work them out herself and could
not see them and give instructions for something that
was not imagined by people who had gotten into a static
routine. It is that hand-loomed sampling element that
contributed to the changes that have taken place in
woven design.

SS / What you draw with a pencil or paint is totally differ-
ent from what you'd come up with working on a loom.

LL / As a matter of fact I was often told by the people in
the mill, after they received my instructions, that it
wasn't possible, that this couldn't be done. Since I
had particularly good technical training in my job at
the Forstmann Woolen Company in raw material and
manufacturing, I saw every process from the raw ma-
terial to the spinning, dyeing, and weaving. I was
able to give instructions for the power loom. I would
simply go and stand next to that loom and have it set
up in such a way that it would do what I had suggested.
That was only possible because I was familiar with the
processes.

SS / Did you have trouble when you went into the big plant,
telling people how you wanted it done? Did they give
you a hard time?

LL / Once I was there it was an endorsement from above.
They had to deal with me. It was not their choice
anymore. I was simply sent by the office in New York
to supervise this project and so it was accepted, may-
be reluctantly. I tried to be as easygoing about it as
I could.

SS / Are you familiar with a tapestry company that makes
tapestries, rugs, and hangings from drawings and paint-
ings of famous artists? Have you seen any of those?
They're very interesting. What are your feelings about
them? I have seen exhibits where they show the small
drawings and they show the finished tapestries.

LL / Yes, I am familiar with the tapestry workshops in
France, such as Aubusson and Gobelin. I have visited
the Gobelin workshop in Paris. I saw the translation

of a Chagall painting into weaving. What was very
interesting to me at the time was that the weaver does
take a certain amount of freedom to interpret the paint-
ing or watercolor sketch into weaving. It is of course
translating one medium into another, and it can never
be the same. It should not be. One of the more in-
teresting tapestries that I saw being translated into
weaving was a very bold watercolor sketch. I don't
remember the artist anymore. But it was a very free
brush stroke in blue suggesting circular movement.
That design of course gave to weavers a much greater
amount of freedom in their interpretation, and those
who worked with it enjoyed that. I admire the skill
rather than the idea. I would prefer the original paint-
ing, the original watercolor, to the translation in weav-
ing. I think there are some drawings and some paint-
ings that lend themselves better to the translation into
weaving; the flat Calder or Miró paintings I think can
be very successful.

SS / I was thinking of them or Appel. I saw one of his.
His translate very well, too, with the bold colors and
simplicity of design.

LL / I think they are successful because weaving does not
change the image. It changes the texture of the sur-
face and that is not so important; it can even enhance
something. It can make it even more interesting.

SS / On the other hand, I saw a Robert Motherwell that was
translated. I thought that it was altogether lost.

LL / When people think of tapestries in the traditional sense,
they do think of translation of painting into weaving.
In the beginning of this century, with the explorations
that were done at the Bauhaus, to use the shapes that
come out of the technique of weaving itself as subject
matter for tapestry, there was a new approach. There
is a return right now, not to the translation of painting
into weaving, but to depart somewhat from the linear
elements of the loom itself.

SS / You were saying that you worked on your loom at home.

LL / I did most of my work at home. I continued with my
job in industry when I had my first child. I found it
very difficult to combine the work with bringing up chil-

dren without the possibility of having very good help
for the children. By the time I had my second child
I decided to give up my work, which I regret in some
ways now, because I think I spent too many years
away from my work, feeling that there was no good
solution to bringing up children and doing my work.
Today even partial involvement and continuation of work
seems very important to me.

SS / It's much more accepted now.

LL / I think it would have been accepted, too, at the time.
There were not always very good solutions, and I'm
not sure they exist today. Looking at my children
today, I think they're fine. They probably would have
been just as fine if I had not spent, and very reluct-
antly at times, so many hours with them, when they
were small.

SS / I think it's important to be with them, but you don't
have to be with them twenty-four hours a day. You
could take off four hours for yourself.

LL / Absolutely, I would never do it again. I think it was
a mistake, because it took a great deal of effort, then,
to get back to work, to reestablish myself.

SS / You mean after having been away from it.

LL / Yes. I think the only positive thing I can say about
this is that it made me reevaluate my work and ask
myself whether I wanted to go back to work in industry
or to explore another aspect of weaving. Since I had
a limited amount of time, I began to explore weaving
in the areas of tapestry. I enjoyed the freedom that it
provided, because it didn't have to serve a particular
function except the aesthetic one. I was able to become
more playful, and I think that freedom is reflected also
in the work that I'm doing now in that I don't feel to-
tally tied, in terms of design, to the structural ele-
ments, the loom itself. During the last few years I
have explored the possibility of bringing a feeling of
movement into the design and I have very much liked
the contrast for textures that I provided by combining
plastic yarns with wool or with nylon netting, both in
weaving and in wrapping. I have enjoyed the possibil-
ity of creating hangings that could be transparent, that

are not entirely solid areas but combine open spaces
with solid areas. I think I myself have not felt the
need to do things that are three-dimensional. I have
been very much interested in the work that has been
done by other people, but I feel there is still so much
to be explored in two-dimensional surface and to give
it a kind of three-dimensional quality through the use
of design rather than the actual, physical three-dimen-
sional shape.

SS / You have to limit yourself in some ways when you
start out, too. I notice you use a lot of metallic
yarns.

LL / They are not metallic; it's actually plastic raffia. I
have used the plastic raffia because it does not become
brittle and it keeps its color. It doesn't fade. I do
like the shininess of it.

SS / It has a very metallic look. Do you want to talk about
this piece? I remember it was inspired by a dance.

LL / This particular piece was inspired by a dance of Judith
Jamison's; I think it was called "Old Man River." She
appeared in a costume which was like a black leotard.
It had a curved shape that went diagonally across her
body. As she moved, this costume would emphasize
the movement itself. In the back of the stage there
were panels of cloth that were moved to suggest waves
of the river. In this weaving I tried to capture the
dance movement.

SS / It's quite lovely. In these pieces that you can see
through the transparency almost gives another dimen-
sion, too. You could put it in the center of a room
and divide rooms.

LL / Some people have. There are some pieces that are
hanging in the middle of a room. I find that our house
doesn't lend itself to this sort of arrangement because
it would block off an area. I rather like that contin-
uous open space. But it could work that way.

SS / Have you ever worked with a clear material, like an
acrylic thread that you could see through? So you
would get sort of a window?

LL / You can see through this when it's against the light.
 I have some weavings that even have a quality of stained
 glass, because the shapes are in very bright colors and
 outlined. Should I speak about my teaching?

SS / Yes. I think that's important. I think we would want
 to talk about that. Do you want to talk about how you
 got into teaching?

LL / I had not thought about teaching myself, because it is
 one thing to work in an area and it is another thing
 to talk about it and to verbalize and to motivate people
 to do the things that you are interested in. I was ap-
 proached fifteen years ago, by the Princeton Adult
 School. I was asked to offer a weaving course. It
 was held in a high school. There were no tools, no
 workshops of any kind. I was confronted with finding
 a way for people to weave on looms. I thought of ex-
 ploring very simple frame looms; I tried out a number
 of them that seemed to be available at a very inexpen-
 sive price. I chose one and tried to find out what it
 is that one could do on a two-harness loom. I dis-
 covered as I worked on the loom myself that the pos-
 sibilities were really very great, from weaving open
 spaces to various textured surfaces with knotting and
 tapestry techniques. I built a course on the possibil-
 ity of using this loom. It helped me in realizing what
 goes into the development of ideas for weaving, not
 only into the technique, but what it is that would in-
 spire people to think in terms of shapes, in terms of
 textiles, what one could bring to weaving that would
 make people more aware of the physical world around
 them, and in turn inspire them in things that they are
 doing. It was on the basis of this course that I even-
 tually approached Middlesex County College and started
 a weaving department, years ago, which has since de-
 veloped into an important part of the Art Department.
 There is a possibility there to work with students and
 to teach some of these very fundamental, but exciting,
 aspects of weaving. I'd like to develop ideas further
 into areas that might be related to architectural struc-
 tures and to things to wear. Within these areas there
 is always the possibility of looking at how people live
 today, what physical environment one has created, where
 a woven piece would fit in, in terms of shape, in terms
 of size, in terms of material. If it is something to be
 worn, there is a possibility of looking at garments that

are worn by people in Japan and Africa and asking,
are they wrapped, are they buttoned, are they assem-
bled out of various pieces?

SS / Because a garment is like sculpture in a way. It is
a skin for a sculpture in a sense.

LL / One can even question the necessity for symmetry.
Even though the shape of our bodies suggests that
things should be the same on both sides, there is al-
ways the possibility of denying or playing against that.
I find it very interesting to look not only at textiles
that have an applied use of this kind but also at civili-
zations in which things are still made by hand to be
used, and to see how people work within the framework
of a medium. For instance, there are the narrow
looms which are used in Africa, on which small strips
are woven and then assembled in order to create one
large piece. There is a necessity for finding a solu-
tion in design that does not really force a person to
have to match each strip. The checkerboard design
that is very often a result of this process is an out-
come of assembling things and at the same time not
having to worry about matching.

SS / Almost like a patchwork.

LL / It is. In Mexico many of the dresses are assembled
in terms of vertical strips, two or three, because
again they reflect the size of the loom, and the way
in which the strips are joined becomes an element of
design. By looking at textiles of various countries it
is possible to be inspired to combine the techniques
of weaving with embroidery, with macrame, with others.

SS / You said in the beginning of the interview that Anni
Albers influenced you a great deal when you were a
student. Do you use the Alberses' ideas when you are
teaching, or have they influenced your teaching?

LL / I must say that in my own training the courses that
Josef Albers offered in color and design were funda-
mental--the whole idea of using color as a subject
matter in itself. I find that it is still a very inter-
esting possibility, but only if eventually it can be ap-
plied to something that gives some purpose and mean-
ing to these very fundamental concepts. I do not find
them interesting anymore for their own sake.

SS / Would you like to talk about the difference between
 what is called the "lesser arts" and the "fine arts"--
 in other words, between weaving and ceramics, and
 sculpture and painting? Today they seem to be amal-
 gamated into one whole, but historically they were
 separated into the "decorative arts" as opposed to the
 "fine arts." What are your feelings and your thoughts
 about that?

LL / There are pieces done in fiber that are artistically on
 the same level as paintings or sculpture. They can
 be enjoyed for their own aesthetic value and are in
 every way in the category of "fine art." The only
 question is whether you also want to call those objects,
 that are meant to be functional, art objects.
 The New York Times in a recent article showed
 some very beautifully designed jackets that were printed
 and quilted as "art-to-wear." What it boils down to is
 that, if a thing is on an artistic level beyond the purely
 useful level and can be very beautiful in itself, too, it
 is certainly acceptable.

SS / That barrier has broken down in recent years.

LL / The only time I would question or would see a division
 is in pieces that are rather mediocre in terms of work-
 manship and in the concept of design. Outside of that
 they can be enjoyed in the same way as one would en-
 joy sculpture, painting, or whatever.

SS / Do you have primarily women students or do you have
 men as well?

LL / I have men as well, but I have more women students.
 There still is a kind of stigma; it takes a certain
 amount of courage on the part of a boy to want to join
 a weaving class. Those who do have absolutely no
 qualms about it. But I think that in order to have the
 freedom to join a class that offers a subject matter
 that is still in many people's minds associated with
 the work of women takes courage.

SS / But many of the leading people in the field are men.

LL / And some of my best students have been boys.

SS / What advice would you give to young students getting
 out of school today or still in school? What kind of

training should they have and how would you suggest
they proceed from there?

LL / It is a very good question. I wish I had the answer.
I would say, first of all, in order to go into any of
the areas of art you have to be excited about what you
are doing. I think you have to have the feeling that
this is what you want to do more than anything else
and that you can do it well. Because you have to be
able to stand the disappointments and the trying times
that are obviously to follow. It is a very stimulating
environment in which you find yourself while you go to
school. Once you leave that environment there is of
course a much greater isolation. You have to be able
to function by yourself. You have to be able to find
the motivation and the inspiration, and you have to
find a place for your art, where it will be used. None
of this is very easy. If you have built up a great deal
of momentum--and I hope, for each person who goes
through college, that school is the kind of environment
that allows that kind of excitement--this brings people
to a point where they have a feeling of competence and
a feeling of doing something that will give quality to
their lives. You need a great deal of momentum and
stamina. It is worthwhile. I hope that the training
that people get both gives them the artistic inspiration,
and the environment in which things can be explored.
I hope it also gives people the tools to work with tech-
nically. Both the technical and artistic aspects really
are very important. One doesn't work well without the
other.

SS / Would you like to talk about the feminist movement and
if it has influenced you, and your thoughts about it?

LL / There are certainly some very positive factors in it,
since it has made women aware that they are capable
of doing things. There are areas in which we could
function better if the doors would open wider. I admit
it is very worthwhile working toward that goal. Even
today we still live in an environment in which many of
the major decisions that allow one to function, on an
economic level anyway, are made by men.

SS / Economic power is a powerful tool. It is very impor-
tant.

LL / It is a very important one, because without it one

cannot be very effective. That is the area that is
probably the most sensitive one, in which there are
barriers. There are limitations and frustrations. I
do feel that in that area it is worthwhile for women
to make their words heard. I'm sometimes repelled
a little bit by the women's movement when it loses its
sense of perspective in the relationship with men. It
is important to retain that relationship and to retain
that balance. I still find it very important to be able
to live with men.

SS / You said that when you worked as an industrial de-
signer you sometimes felt prejudice against you, but
you think it was because you were young.

LL / I was young and I was also working in an area that
was a very new one for women to work in. Not as
designers, as I described them before, people who
made sketches on paper, but people who at the same
time also had technical training and wanted to super-
vise the technical execution of the design; that was the
part that was new. I came across an issue of Made-
moiselle magazine in which there was an article called
"Jobs Looming." It was about all kinds of women who
at that time were involved in weaving as a profession.
Most of them were people who were working in indus-
try. It was written in order to make women aware
of new possibilities in job training. And, I hate to
tell you, that was in 1953.

Photo credit: George Malave © 1978 CCF /CETA Artists Project

CYNTHIA MAILMAN, painter, was born in the Bronx, New York, in 1942 and was educated at the Art Students League, Pratt Institute (B.S., 1964), the Brooklyn Museum Art School, and Rutgers University. She lives in Staten Island, New York. Her work is in the collection of the Prudential Life Insurance Co., Newark, New Jersey. She was commissioned to paint a mural by Citywalls Public Arts Council, Staten Island, 1977, and received a CAPS (Creative Artist Public Service) grant in painting in 1976-77. Her work has been reviewed in the Soho Weekly News, Arts Magazine, and Art News. Her exhibitions include The Eye of Woman, William Smith and Hobart College, 1974, and solo shows at Soho 20 Gallery, New York, 1974 and 1976, and Douglass College, New Brunswick, New Jersey, 1976.

SS / When did you decide you wanted to be an artist?

CM / I always was an artist. When I was quite young, my
parents were interested in all the arts, and I had an
interest in all arts at an early age. Whether that was
because art was in the home--my parents encouraged it,
sent me to cultural schools--or because I had a natural
propensity, it's hard to know. By the time I was ten
years old I had taken dancing lessons, piano lessons,
singing lessons, art lessons, drawing lessons. When
I was in junior high school, I was going to the Art
Students League Saturday mornings, getting up early,
taking my portfolio, drawing from live models. The
other kids thought it was funny that I was drawing nude
men. It didn't mean anything to me. I thought of it
as a doctor would. I used to think, "I'm like a doc-
tor. I'm just looking at the form."
I was different from the other kids because I was
going out of our Bronx neighborhood, I was going into
Manhattan, I was drawing. And my parents were poor;
we had no money. Everybody else would go shopping.
I remember going to a friend's house and seeing pros-
perity. I went home and said to my mother, "Joan
has all these sweaters and all these blouses and all
this ...," and my mother said, "You know we don't
have that kind of money.... But don't forget, Cynthia,
we send you to dancing lessons every day, we're spend-
ing money for the Art Students League, and you have
all the art supplies you need." And it was true. I
realized that we just had different values.
I always pursued art. I was always making things;
I was never bored. I used to sit around and build
castles out of toothpicks. I was always very good with
my hands. In fact I thought I would be a sculptor, or
go into crafts. When it came time and I knew I had
to make decisions, I tried out for the professional high
schools. My father did not allow me to try out for the
High School of Performing Arts, which was for drama
and dance. My mother said, "Look, Cynthia, you're
very young, you can go to an art high school, you can
learn a trade of some sort." I tried out for two high

schools: what was then called High School of Industrial
Arts and is now called Art and Design, and High School
of Music and Art, which was for the fine arts. It's
been one of the greater disappointments in my life that
I was not accepted to this school. But maybe this dis-
appointment strengthened me. I had that feeling, "I'll
show them!" I started collecting the names of all the
great artists and famous people who were turned down
by Music and Art.

I did go to the High School of Art and Design, the
school that my parents wanted me to go to. It was a
vocational school, and, although you could go on to col-
lege if you wanted to, it prepared you for a career in
the advertising arts. My parents being poor, I felt
that I had to be able to take care of myself.

I lived way up in the Upper Bronx and the school
was at Fifty-seventh Street, and then Seventy-second
Street in Manhattan. I traveled the subways, became
cosmopolitan.

SS / Out in the world, yes.

CM / Out in the world. I met derelicts. People tried to
feel me up in the subways, I had my wallet stolen,
and I had to confront people. I got home late, I
couldn't be with the kids in the neighborhood that I
had grown up with. All of a sudden there were Puerto
Ricans, there were blacks, there were Chinese, and
life was wonderful.

I went to that high school, and at some time in that
period I decided that commercial art wasn't for me. I
was a very moral person. I felt that if a company
said "Sell this," and I didn't think it was good, I didn't
want to sell it. I didn't want to push products. At
that time I thought I was a socialist; I was anti-materi-
alist. The idea of being paid to sell something was not
what I wanted. I had decided that I didn't want to go
out onto Madison Avenue, so what did I want to do? I
had to do something. I applied to Pratt Institute. They
had me scheduled for a personal interview at Pratt,
but they had already said, "You didn't do well enough
in high school for us to take you." In the interview
the admissions officer looked at my portfolio and said
the work was nice, and that he thought Pratt would
take me anyway because I had shown I had the ability.
He asked me very good questions. Lo and behold, I
received a letter of acceptance! I was thrilled. I had

promised the interviewer that if Pratt admitted me, I
would do very well. And I did.
 I earned a Bachelor of Science degree in Art Edu-
cation from Pratt. By this time I was very involved
in fine arts: going to museums, always painting. Pratt
was very high-pressured artistically. I was not one of
the greatest. Interestingly enough, many of the people
at Pratt who were the big stars, except for Nancy
Grossman, have never been heard from again. I used
to tell myself, "Cynthia, maybe you did well because
you had to work at it, you had to use your will." I
find to this day that when things are too easy I just
don't do them.
 After I graduated, I had to get a job. All I could
do was draw and paint, and I needed a job. So even
though I felt that teaching wasn't for me, I decided that
there was no choice. I would give it a try. I taught
in a junior high school in Brooklyn for four years,
after which time I was fully aware that it wasn't for
me, although I did extremely well at it.
 After the first year that I taught I got married and
moved. In looking for a new place, I insisted on studio
space. My husband, also being an artist, was com-
pletely sensitive to that need. Even though I taught
for another three years in the junior high school, I
had my own studio. I would come home every day
and paint. By the end of that period I was very en-
grossed in painting, and I said to my husband, "This
is it. I cannot do the teaching and the painting and
it's the teaching that must go."

SS / The teaching, did it drain you?

CM / Completely. It's not that it drains me creatively, it
just drains me psychically. I would arrive at the
studio at 4 pm feeling that I had already given most
of myself, and the better part of myself, to those kids
who didn't want it, that I had to become selfish and
maintain myself. That's the beginning of my art ca-
reer. After leaving full-time teaching I did substitute
work; we moved to California for a few years, where
I developed my artwork, and I came back East with
developed, mature paintings and felt that I had to do
something with art. What I did was earn money. I've
always liked to earn money, to feel that I am inde-
pendent, which must come from having had a poor back-
ground and feeling that I must support myself. That's

also why I decided I needed another degree, the M. F. A.,
and I've always maintained different jobs. Now I'm do-
ing commercial artwork. It's interesting that I'm doing
work that I put aside years ago, but it's good for a
buck. I'm able to do it, and I'm in a position where
I don't have to advertise things that I don't want to.
I've always maintained my teaching license and done
substitute teaching over the years. I used to go in
two or three days a week, and that's how I've main-
tained my part of the deal with my husband in terms
of money.

SS / Let's talk about your work and the influences on it.
For example, your commercial art training. How does
that influence your work, assuming that it does at all?
I know you work very flat.

CM / In high school, when I was studying commercial art
and illustration, I used to look at Japanese illustra-
tions and I was very affected by them. When I look
back on my work, even when I was ten or eleven
years old, I can see that I always worked flat. I
don't know why, but I always had trouble with forms
being round. I do think that being in commercial art
had something to do with a basic push toward design,
composition, impact, color, all elements that are part
of my work, rather than the painting. In illustration
you don't really do things in a painterly way, it's more
hard edge, more splashes of color, how you frame it,
how you put it together.
 My style also results from the way I see things.
I do tend to see things the way I paint them. When I
had my first show, a critic, Peter Frank, in the midst
of all the commotion and excitement of a first show,
asked me a question: "Do you first see it one way
and then paint it this way, or do you first see it <u>this</u>
way and then paint it this way?" I didn't know the
answer at the time; I've thought about it again and I
think the answer is a combination of both. I see things
in different ways depending on what I'm looking for.
I remember as a child always seeing things in patterns.
I used to count patterns and I used to do something
that I have since discovered is a form of meditation,
where I would focus on one area and let everything else
blur out and become patterns of color, which would then
move and become psychedelic in character. When I
look at things, I tend to see them as my paintings

are, just the flat patterned areas, and I tend to like
certain kinds of days and types of light in which you
can see lots of shadows. I'm interested more in the
gray, and I love those gray days more than anything
else. I don't know how much that has to do with the
psychological implications of it not being a sunny day,
of being a gray day, or overcast, or not seen clearly.

SS / The color is very muted.

CM / I'm not a gray person; I'm a colorful person. I dress
very flashily. I wear bright red lipstick and bright
red dresses and purple nail polish and gold high-heeled
shoes. It's always interesting for somebody who has
only known me as a person to see my work. Several
of my friends who had never seen my work over a
period of time, who then came to the shows said, "I
can hardly believe that you are doing this work, Cyn-
thia."

SS / Because it was so controlled?

CM / Yes. I feel there must be an aspect of my life in
which I am very controlled. I think, in different parts
of your life, you are able to express different things
in different ways. This is the way I express one im-
portant part of myself. There is within myself a very
calm, satisfied person. I do have a very happy life.

SS / I would like to talk about the layered effect of your
imagery; there are some scenes from a window open-
ing to the outside, and your series of road paintings
with mirrors.

CM / Let me try to talk about that. I was doing paintings
of different things without any particular idea in mind
of the meaning of the things themselves. My husband
and I were living in California. The heat was oppres-
sive one day, and we decided to go out for a ride so
that we could get a breeze. We had no air condition-
ing and it was very muggy. We were just riding along
and I saw water towers in blue haze, and the road was
blue haze. I was struck by it. I believe in being in-
spired by things. I can just be struck by something;
I see it and say "This is a painting, this is something
I must put down, must express." I started thinking,
"Look at the water towers. Very much a part of our

society; every town has a water tower. It's an ancient
form of getting water to the people." It's technolog-
ical, but it's not. And it seemed to me to be impor-
tant. I decided I would do a painting incorporating the
water tower with a natural environment. There was
a water tower that looked just like the trees, just like
the sky. It seemed always to be at the end of a road.
I stopped the car and did a series of road photographs
with water towers. That's how I did the first painting
I showed you, called "American Highway Scene #3."

I don't know how important this is, and sometimes
I don't like to mention it. Possibly a year before that
trip when I started doing paintings from photographs,
I had begun to try psychedelic drugs, which were very
exciting at the time. When I first took LSD, I had a
visual experience. Being an artist, I was struck by
the visual effects of LSD. I had read The Doors of
Perception, by Huxley, in college, and I had taken psy-
chedelic drugs at the time. This was way back, there
was no LSD, but there was mescaline. After reading
about these kinds of experiences, and being an artist
and always striving for psychic experiences within art,
I tried LSD. During the experience I saw all the ele-
ments in life as being one. This is very traditional,
like a Buddhist concept of the oneness of nature and
life. I'm not a religious person, but this was my re-
ligious awakening in a certain sense. After that my
painting started changing radically.

I was going to the Brooklyn Museum Art School; I
was teaching, but I decided that I wanted to go to
some art school just to get back to learning. I liked
having a live model. I always was a realist, though
at Pratt I did have to play around with abstract work;
Abstract Expressionism, Pop Art, were very much in
my background. God, at that time, was Greenberg
and his whole school of abstract work, which looked
down upon the figurative work I did all through college,
in spite of the pressures favoring abstract. While go-
ing to the Brooklyn Museum Art School, I had the sud-
den understanding of the oneness of everything; two days
after I had taken LSD I went to class, and my work
had changed radically. My work was very Japanese;
I stopped trying to do any kind of shading. I did a
few paintings that related almost directly to my trip-
ping. I had been on the floor and I saw a chair, and
its design, with the negative and positive spaces, and
I started doing paintings that were brightly colored,

flat, decorative almost, design paintings. When I was
struck by the water towers, I was struck by the one-
ness, and it flashed through my mind that everything
was composed of the same molecules, and it was just
the arrangement of molecular structures that made one
thing a tree and one thing a stone, but that really we
were all one. That was what I was trying to say in the
early paintings, and to this day that is something that
I am striving for. It took me over two years to com-
plete that water-tower painting. I had several false
starts, which is why I call it "American Highway Scene
#3." I like the painting very much, although I did no
more roads for a while. I did strengthen the way I
was working from photographs. I had started project-
ing certain images small, and developing a way of
working in which I would do a small painting first,
working out all my detail small. I did this because
the other large painting had taken me two years, which
seemed a very difficult way to work. I wasted time,
paint, and energy, and I became frustrated because the
paintings didn't move. Even working on one painting
for a year is a very frustrating experience. So I de-
veloped a way of working in which I did small studies
and scaled them up.

Matisse always was my favorite artist, always. I
liked his later works much less because they tended
to be more abstract, but I loved the earlier paintings.
Not the very realistic ones either, which I didn't care
for. I was not immersed in art history. I never
really liked looking at old paintings. Nothing really
interested me until the Impressionists. I was not big
on the Cubists; I did not relate to abstract paintings,
although I did have a heavy background in abstract work.
The reason I like Matisse is that he was a realist
while being very involved with abstract ideas of paint.

SS / Your road paintings with the mirrors have abstract
qualities.

CM / I think so, too. I think all my paintings have abstract
qualities. I did several paintings directly from Ma-
tisse's work. For instance, I did a painting that I
called the "California Painting," which was a direct
takeoff from Matisse's "Decorative Figure on an Orna-
mental Background." I did a door-and-window painting,
which I later called "View from the Kitchen While
Watching My Husband Doing the Dishes," which was

"Texas Winter" (1977)
Acrylic on canvas, 49" x 72"

again directly from Matisse. Many of his paintings
that really interested me were these views through
windows. I loved the inner and outer idea.

I came back to New York with a large body of work.
I joined Soho 20 Gallery. I came back in touch with
the New York art world, which hadn't really left me,
because I was only gone for three years. There was
new work around. While I had been out there in Cal-
ifornia there developed a new concept, New Realism.
I had never heard of it, but I decided I was a New
Realist. I hadn't known it; I didn't know any of the
people involved in this concept or anyone else who was
working with photography. I felt I had developed it
myself and yet there was a group of people doing it.

When I came back to New York, I wanted to show
the work, but Soho 20 had a busy schedule and couldn't
show me for another year. I decided I'd do a new
group of paintings. I didn't know what I was going to
do. I had done a lot of traveling with my husband in
our VW van. In California I had become very involved
with nature. I became a bird watcher. I joined con-
servation groups. I had gone out to San Francisco and

tried to clean oil from the beach. I had spent so much
time in the VW van, traveling, that I'd become a road
person. We had done camping. I went everywhere.
I went to Washington State. I just traveled along the
Pacific coast highway all the way up and down, saw
all the national parks. That is how I began the road
series.

Also, I went to visit friends in Canada who pointed
out to me the situation there with the dying elm trees.
I decided to do a painting called "Dead and Dying Elms."
I took photographs and did studies, and noticed that the
elm trees were always at the side of the road. When
I came back to the studio and started doing sketches
and studies for the painting of dead and dying elms,
and I remembered the painting "American Highway
Scene," I felt reaffirmed in the value of the oneness
of life. What was more important was the road we
were on, rather than the elm trees, the fact that the
elm trees were dying because our society didn't care
about trees; it cared about roads. That was the road
we were on.

When I was doing the elms, looking at trees, a shot
I had of two roads going off in different directions
came to my attention, and I remembered the poem by
Robert Frost, "The Road Not Taken"; I felt reaffirmed
in the idea that the road less traveled by makes the
difference. I had always felt that I had taken the road
less traveled. I was not on the road of all my friends,
nor on society's road. I was on my own road. That
became very important, and I decided that would be
what the painting was about. So the painting that had
originally been about dead and dying elms now became
about society and the road we are traveling. I did a
whole series on that concept, and somewhere in the
middle there I decided to put the windshield in. I felt
it incorporated another aspect, it put you and me on
the road. It created an implied passenger. And thus
we were seeing the road in the way in which we are
used to seeing it--through a windshield.

SS / That's the way our society sees it. Through a car.

CM / That's right. From a purely artistic point of view,
the windshield interested me, because of my interest
in the inside and outside. The window, the in, and
out, the contrast. Pictorially, it added a complete
dimension and became a more exciting painting. The

fact that I had the windshield and wipers close in made
for a very deep space, which I was always interested
in. I did a series on that. And somewhere at the
end of that series, I took a ride looking for paintings,
which I rarely do. I don't normally look for anything
special; I just look and am struck by things. In this
instance, though, I went out purposely looking for in-
formation, studies, sketches. I went out to a section
on Staten Island where there are container ships, a
big container port. There I saw a beautiful red con-
tainer and a piece of my car, which was red. I tried
to get a good view of it through the windshield, and I
couldn't. I pulled up and looked through my side win-
dow. I could see the red container with all the grays,
with New Jersey way out in the distance.

SS / In the mirror?

CM / No, not in the mirror, just through the window, the
side window. All of a sudden, as I was looking and
doing drawings and sketches, and taking pictures, I
realized that the mirror was there, reflecting the whole
car, which was also red. I did one painting with a
small mirror and that was the end of that series. That
was the only painting with a mirror in that first show,
but it was a premonition of what was to come. I was
interested in the mirrors because painting is about re-
flections. Painting is a reflection of myself and a re-
flection of my society. A mirror is of course a re-
flection, and it enabled me to see what was in front of
me as well as what was behind me. And the mirror
opened the picture plane to quite another dimension,
created an even deeper, more interesting space.
 Then we went traveling around New England, and I
did a whole series of mountains. I did the White
Mountains of New Hampshire, and the mirror kept on
getting in there, and became more and more important.
I had one painting that I called "It's Nice to Know
Where You're Going, but It's Good to Know Where
You've Been," which epitomizes how I felt about mir-
rors, that it's important to know where you're going
in life, but it's also important to know your roots, to
know your history. Where you've been is equally im-
portant as where you're going. Pictorially, I loved
the reflected space, the past as well as the passed.

SS / They're visual puns in a way. What painters influenced
you?

CM / Tom Wesselman, of the Pop movement, was an influ-
ence on me. His "Great American Nude" is very flat,
and I think that had an influence. Photorealists like
Richard Estes had no influence on me at all, because
I had never seen their work until I was already de-
veloped.

Having done the New England series, I felt I had
done the East Coast, but that I hadn't dealt with the
larger climatic and geographic environment. It wasn't
until I was on the way back from California that I re-
alized I had gone from a beautiful winter, from that
warm sun, into a really icy cold environment. It was
frightening in a way, all that cold and ice and snow.
I wanted to make a statement about the climate, about
various climates, about the frightening aspects of the
cold as well as the beauty that was inherent in every
environment. There was a throwback to a very im-
portant movie in my life, called Woman in the Dunes.
It's about a man who is trapped in a terrible environ-
ment all of sand, but he grows to love it, because it
is his environment, and because there is beauty in
everything, even what we think of as being desolate or
ugly. I've always had a different feeling about beauty
than other people, in that I do see beauty in everything.
Sometimes it's frightening to me that I see beauty in
pollution, I see beauty in factories spouting black
smoke.

SS / Artists, when they look at things, are not moralisti-
cally judging. They just look at things as shapes.

CM / That's right. It is a problem that in my paintings I
am trying to make a comment about society, and yet
I'm making it look beautiful. I like to think that the
way my paintings bring together the road and the land-
scape and the houses, all are living a peaceful co-
existence in paint. It's very important for our society
to realize the road we are on and to come to terms
with the fact that we are just another part of the en-
vironment. If we don't learn to live within the environ-
ment, it is no longer going to support us. I'm so-
cially conscious, and it's a little hard, because I've
chosen to be an artist rather than a political activist.
In a way, doing my art is hiding my head in the sand,
because I'm not involved doing things for society.

SS / But you are. What about the women's movement, and

your involvement in the Sister Chapel, which is a
very political movement? Tell me your feelings about
the women's movement and how it's affected your own
life.

CM / The women's movement has been important to me be-
cause it's given me the opportunity to exhibit my work.
There has been an opening of minds to women's work,
and to looking at all people's work, not just men's.
There is an opening up in the society. I'm now taken
seriously. As I grew up, it was a real problem being
a woman. I wasn't aware of it's being a problem, and
that's why it was a problem. I would say things and
people wouldn't listen. I thought it was my fault, but
it wasn't, it was because people don't listen to women.
It's only recently that women are taken seriously. I
used to think that I was a very domineering person,
but I'm not; it's just that women aren't supposed to be
as outspoken as I am. Over the years, through the
women's movement, meeting other women with strong
personalities, and realizing that they have all gone
through the same problems, has certainly strengthened
me. It's given me wider outlooks and it's given me
another standard to judge by.
 I wasn't aware of the women's movement until I
came back to New York in 1971. By that time I was
an older person, my painting was developed. It's not
the women's movement that has made me an artist.
I have always been an artist. But the women's move-
ment certainly protected me, has helped me immeasur-
ably in my career, in giving me strength to carry on,
and to feel that what I'm doing is important. It has
really helped my career tremendously, although maybe
not me personally, as much.

SS / You were an individual before the movement came.

CM / Yes. And I think that it's important that I was a
daughter in a family with no sons. There are other
aspects of my life where the women's movement, not
specifically but generally, has helped. I've been mar-
ried thirteen years. I have a very happy relationship
with my husband. And I feel that the women's move-
ment has helped me with that, helped me understand
who I am. There are many ramifications of the wom-
en's movement. It's not just about art, or any one
area. I do feel strengthened by the knowledge that

there are now many women who, because of the wom-
en's movement, have grown in their careers. They
are there for me to meet, for me to be strengthened
by, and for me to help.

ALICE NEEL was born in Merion Square, Pennsylvania, in 1900. She studied at the Philadelphia School of Design for Women (1921-25) and the Moore College of Art (Honorary Doctorate, 1971). Her work hangs in New York City's Museum of Modern Art and Whitney Museum; the Dillard Institute, New Orleans; the Graham Gallery, New York; and others. She lives in New York, and is represented by the Graham Gallery. A selected bibliography of writings about her work includes Ted Berrigan, "Double Portraits," Art News, January 1966; H. Crehan, "Introducing the Portraits of Alice Neel," Art News, October 1962; and Jack Kroll, "Curator of Souls," Newsweek, January 31, 1966. Her exhibitions include retrospectives at the Moore College of Art, 1971, and the Whitney Museum, 1974.

Photo credit: Maurice C. Blum
(Painting: "Kitty Pearson")

SS / Do you ever do self-portraits? Have you ever done
any?"

AN / No. Oh yes, I'll show it to you. A skull.

SS / A skull?

AN / Yes, I'll show it to you. In 1958. I'm a realist, you
know. Even though I don't copy from photographs.
How do you like this stuff? Look at all the figures.
I did that completely from memory. I decided to de-
velop my memory. I could, in those days, do anything
that I had set out to do from memory. For twelve
hours after I could do it.

SS / Twelve hours, that's good.

AN / Yes, that's a long time, isn't it? My eyes have been
driving me crazy, so let's hope these glasses do some
good.

SS / I hope so.

AN / Then I have other glasses, too; I can't remember what
they're for. Oh yes, one, this one, is to paint with;
it covers about seven feet. It makes it a little bit
clearer. Oh, I can use this today, I have someone
coming.

SS / We were talking about how you strip people bare psy-
chologically.

AN / Well, that's psychological insight.

SS / Do you think that you treat men and women differently
in your work?

AN / No. At least I'm not conscious of it. I don't care
about any of those things. You see, I think we're all
members of the human race. I'm women's lib, be-
cause I think women get pushed down. I always was

123

women's lib long before it became popular. You know,
do you know my picture of Joe Gould? Yes, well you
see, that was done in '33. I guess it was first shown
in '71, at the Philadelphia School of Design. That was
the first showing.

SS / Yes, they would have found it very shocking in '33.
Sometimes your people seem very frightened.

AN / Well, after all, you know what Cézanne said? (You
know I was amazed to find this.) Cézanne has a lot
of psychological insight in his people. They once had a
show of figure things at the Metropolitan, maybe ten,
fifteen, maybe twenty years ago even. And Cézanne
said, "I love to paint people who have grown old na-
turally in the country. " But I'm just the opposite. I
love people who are ruined by the city, psychologically
and every other way. They're under this terrible strain
that modern life imposes. I love to show the results
of all that.

SS / Has women's liberation affected your life and your
painting at all?

AN / No, the only thing is, I like its defending women, but
it also has encouraged a lot of women with very little
talent to paint. Now you don't have to say this, but I
think some of them are just frightful. But you know
what I said in that address (and you better not put that
in because they won't like it) in Philadelphia, in that
doctoral address. I said, "Now you girls who are
graduating (it was a school just for girls) will be able
to do up and above board what in a sense I had to do
underground." But I said, "Don't think that'll make you
a good painter. Because to be a good painter you have
to work very hard, you have to take it seriously; it
takes much more than women's lib to make a good
painter. " Now women's lib to this extent will help:
it will give a show sooner; it'll give attention. There
won't always be this discrimination between men and
women that there always has been.

SS / Do you think that's going to change?"

AN / Well, I think it has to. But just the same, it doesn't
make a bad artist a good one. Art is art you know.

SS / Do you think that women have been at fault partially for

not taking themselves seriously enough? Do you think
that some women artists have not worked hard enough?

AN / It isn't that. There are very few artists. Out of
twenty students you may get one.

SS / That's true.

AN / Sure, so it isn't anything they do. You see, there's
a life of art. Well for me art is everything (even
though I have these sons and everything else); instead
of buying clothes I bought art materials. Art for me
was the important thing. Now when I was on the
W. P. A. , I was in a group, seven men and me. So
you see, I was already a very good artist. And this
was 1935. Hilton Kramer gave me a very good review
on the W. P. A. shows. You know why? I could not
just do those standard paintings. I never could be in-
fluenced that much. I never wanted to be. Because
you have your own road and you have to go along it,
even though it's hard. You see, there was no figure
work in the forties and fifties. None at all.

SS / In your paintings you put so much emphasis on the head,
and I also noticed the hands.

AN / Well, you know, if you know anything about nature or
medicine or anything else, the head contains most of
the senses. You feel all over, but you hear, see,
smell, and taste with the head. You also think with
the head. It's the center of the universe, really. But
I don't know that I do that. I don't put any more em-
phasis than I think should be there. "

SS / Andy Warhol was probably the first major portrait
painter of our era. Do you think that the great por-
trait artists reflect their era in different ways than
other artists do?

AN / You know what I try to capture when I paint? Not only
the person but the whole zeitgeist, the spirit of the
age. So that my paintings of the various decades ex-
plicate the decades. You see this painting to me is
very definitely the thirties. I was in Spanish Harlem,
but I was never a tourist, you know. I was married
to a Spanish man.

SS / Right, and you lived there.

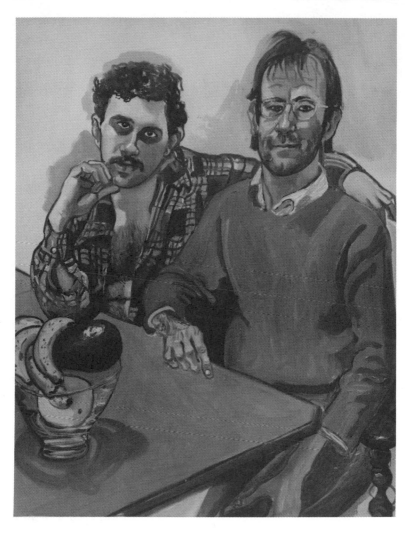

"Men from Rutgers" (1978)
Oil on canvas
Photo credit: Eric Pollitzer

AN / And I lived there for twenty-five years. Now I've lived here for sixteen, and before that I lived in the Village. I think a good portrait always tells more than the strictly personal. But I wouldn't know how you'd go about explaining that. It's amazing how your work changes and you're not even conscious that it's changing, because they're other times. You know what it is--other days, other ways.

SS / Do you think that you're really an intuitive artist, specifically, rather than an intellectual artist? Some artists have lots of theories.

AN / I don't think, I don't believe in those categories. It's like chicken in parts. I don't believe you can cut up the whole process like that. As for me, looking at the art of today, I say, thank God for a bit of intuition. You see, whenever I give a lecture, I tell the audience I still have feeling and I believe in psychology. Those things are right now out of fashion. This copying of photographs is very much in fashion. It's noncommittal, cold, shows really no faith in humanity even though it depicts humanity. I know that's not as much the fashion as it was five years ago. Then it was absolutely in the saddle. A person with feeling was just crossed out.

SS / You feel that you are a strictly intuitive artist?

AN / No, of course not, I'm very intellectual. I know an awful lot. I'm even well read.

SS / Of course, but I meant in your work.

AN / Look, you know what I do? I know all the theory, I read all of it, I understand it. When I work I think of nothing but what I'm doing.

SS / That's what I mean.

AN / I don't consider that just intuition. I consider that the sum total of your whole scope, plus your immediate reaction. But I hate things that look as though they're figured out to be this or that. I don't like that; I think it's mechanistic art. I don't think any good artist ever painted like that.

SS / No, no I don't think so either. But some artists have
 a lot of theories.

AN / Yes, I know. Right now art is theory-heavy. You
 know why? It's easier for those colleges to teach
 art to historians than it is to teach artists. It's eas-
 ier, less messy, and just a regular brain can be a
 good art historian, but out of twenty people to whom
 they teach art, there will be one good artist, maybe.
 So it's a much better thing. You see, my sons had
 all these great girls from Smith and Wellesley and
 none of them taught art itself; they all taught art his-
 tory.

SS / That's true. What did you think of the show at the
 Brooklyn Museum, <u>Four Hundred Years of Women Art-
 ists</u>?

AN / Well, I was in it, you know. Tom Hess said they
 picked unfortunate centuries. But I think it was a
 great show really. It brought certain people to light.

SS / So then you were pleased pretty much with that show,
 and felt that it was an important one?

AN / Oh well, I feel it was a very important show, of course.
 It helps women's standing. Certainly. Of course.
 Still, the fact is that it concentrated on an era where
 there were a lot of still lifes and fairly sappy paintings
 like the one on the catalog cover even, those peaches.
 Especially when we know Cézanne.
 Now, I did this painting of Ethel Ashton in 1930.
 Now you see, the outline is there, but not quite as
 obvious. I think this is an important painting. This
 should have been in that women's show. This was
 painted in 1930. The curator took up to 1950, and
 all she took of mine was that TB case in Harlem.

SS / That's a fantastic painting.

AN / Isn't that wonderful?

SS / I think that would have been good for that show.

AN / It would have established something. But nobody ever
 came to see me. You see there's frightful rivalry.
 When women finally get liberated, they'll do the same

that men do--dog eat dog--that's what our culture is.
That's the theory of our culture. Not cooperation but
assassination. Women will cooperate until they attain
certain goals. Then one will begin to destroy the other.
Just like the men do.

SS / Do you think you would have been a great woman artist
even if you'd had no teaching?

AN / Oh well, I really don't know that. I wanted to go to
art school, and I learned a lot in art school; I even
believe in the kind of training that I had. I think that
draftmanship is almost the discipline of art. Now Pi-
casso, he's a marvelous draftsman. He just forgets
it, he throws it out the window, because he shows de-
struction.

SS / You know, your women always seem more vulnerable,
like this painting.

AN / They are. Look at her, she's women's lib already,
although that's 1930, and Joe Gould is 1933, and that's
women's lib. You see, you have these beliefs all your
life. I never fought the fight out on the street, but
when I was in my studio I didn't give a damn what sex
I was. Nor did I feel I couldn't learn from any male
artist either. I thought art is art.

SS / Were there some other things you wanted to say?

AN / No, I've said all I wanted. Don't you think that's
pretty thorough?

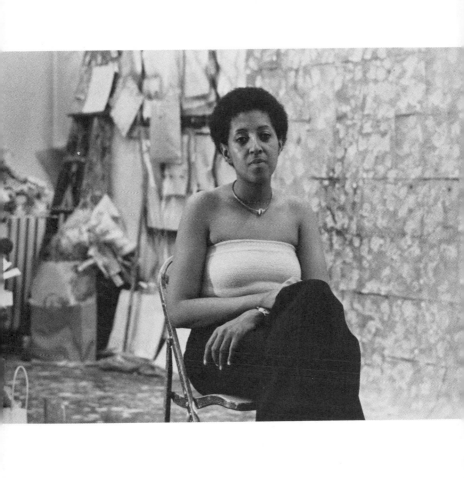

HOWARDINA PINDELL, painter, was born in Philadelphia in 1943 and was educated at Boston University for Fine and Applied Arts (B. F. A. , 1965); the Cummington School of Arts; and the School of Art and Architecture, Yale University (M. F. A. , 1967). Her work hangs in the Museum of Modern Art; the Fogg Art Museum, Cambridge, Massachusetts; the Neuberger Museum, Purchase, New York; and the Whitney Museum in New York City. She received a National Endowment for the Arts grant for 1972-73. Writings about her work include Françoise Eliet, "Five Americans in Paris," Art Press (Paris), April 1975, and Carter Radcliff, "The Paint Thickens," Artforum, 1976. She has served as exhibition assistant, curator's assistant, assistant curator, and associate curator for the Museum of Modern Art in New York. Among her exhibitions have been Young American Artists, Museum of Modern Art, Stockholm, Sweden, 1973; Fogg Art Museum, 1973; Five Americans in Paris, Gerald Piltzer Gallery, Paris, 1975; and Vassar College Art Gallery, 1977.

SS / To start with, let's talk about when you decided you
 wanted to be an artist, your schooling.

HP / I always wanted to be an artist from the time I was
 very small. My parents had put me in a school for
 so-called gifted children. What was good about this
 particular school was that generally the teachers were
 very liberal and the classes were not any one ethnic
 group. It was a mixture of Chinese, European descent,
 African descent, Jewish. We observed all the differ-
 ent holidays; even if we didn't stay out of class, we
 learned about them. It was a very open school in
 terms of appreciating people's differences and simi-
 larities. It meant the teachers were very open to the
 students. If they saw a student had a special gift,
 they would call the parents in and tell them. I re-
 member my third-grade teacher called my parents in
 and said, "Your child has a gift and you should really
 cultivate it." Then they started sending me to the
 classes that were given at a place called the Stoddard
 Flasher Art Memorial, downtown South Philadelphia.
 From there my parents kept me in academic schools,
 and then they would send me out on Saturdays. I went
 to Saturday classes at the Philadelphia College of Art,
 and then at Temple University; they also had Saturday
 courses.
 Then my parents sent me to a special girls' school
 after I went to elementary school, then to a junior high
 for two years. Then I got into a school for gifted
 women, Philadelphia High School for Girls, which to
 me was like a prison. I hated it. It was very, very
 conservative and very narrow ethnically. If a kid was
 in any way different from the general student body,
 there was a certain amount of ostracism on the part
 of the teachers and some of the students. During that
 time I still went to the Saturday courses.
 My parents then decided for me that instead of going
 to an art school they wanted me to take an academic
 program, at least get a college degree. I chose studio
 courses. My parents wanted me to do commercial art,
 but I refused. I had worked one summer in an ad

132

agency where there was a woman who was the only
black to own an ad agency. They were training me
to take over the business. I was just bored to death.
Then I rebelled and started working in a factory dur-
ing the summer, and I nearly cracked up because it
was so boring. But the people in the factory were
very supportive. They were mostly blacks or Puerto
Ricans. They said, "Get your education or else you'll
end up like us; here we are putting lids on and we're
forty years old." I remember there was one woman
who was twenty-one who had been in the factory five
or six years. The drudgery was unbelievable.

I went to Boston University after Girls' High. I got
a Scholastic Art Achievement Grant or Fellowship.
What I found in the girls' school was that they didn't
particularly like their black students so they wouldn't
recommend us to go to college. Knowing that they
wouldn't give us the advice they gave the white stud-
ents (they would always hook them up), I just went on
my own and I applied to Boston University. I got in
on early admission because I was graduating in a Jan-
uary class.

I started college January 1961. I was the only
freshman on campus. That was wild. I was in a
dormitory called Towers, which was a real "rah rah"
sorority environment. Talk about culture shock! For
four years at Boston University, starting in September
1961, I was hooked up to a class in fine arts. I stayed
with that class until I graduated in June 1965. It was
basic academic stuff, drawing from the model, painting
from the model, no real interest in the substance of
paint. In one class we had a woman teacher; that was
rare in those days. We had to put a piano in perspec-
tive and a cube in perspective. That was sort of in-
triguing. Our design courses were boring.

The most moving instructor that I had was Walter
Merch. He loved the students. His work had integ-
rity, so that he didn't envy a good student. He wasn't
jealous of someone's having more talent, because he
had a lot, but he also was a very centered person.
He gave a lot to his students, and he also gave a lot
to his work. There was a wonderful balance there.
The other teachers seemed mediocre. I remember
there was one teacher, Sidney Horowitz, who tried to
be very supportive.

Then I applied to and was accepted at Yale. At B.U.
they got really pissed off. You couldn't leave the fold
once they had brought you in and trained you.

SS / They had you in their grasp.

HP / Right. You could draw an egg and you had made it.
 And drapery, folds of drapery. Yale was another form
 of culture shock almost as great as going into the so-
 rority atmosphere of Boston University. I went to
 Yale in September 1965. There were two or three
 women in the class. The best teacher I had at that
 point was a man named Nicholas Corona. The most
 devoted teacher in terms of being very concerned about
 his students as people was a man named Bernard Chape
 and also a man named Lester Johnson. Al Held was
 there and he made fun of the women. He got angry if
 a woman used certain colors in her work. (A guy could
 use white mixed with red, which is pink, but if a woman
 used it he would go into a tirade.) There were no
 women teachers at that time--except that Helen Frank-
 enthaler was invited to come in. She would never crit-
 icize work that was figurative; she said it was done in
 the Renaissance and she wasn't interested, and at that
 point I was still doing figurative work but not anywhere
 near what I had done at Boston University. It was
 getting flatter and more geometric.

SS / Did you like any of your teachers' artwork? Particu-
 larly, was any of their work a model for you?

HP / No, I didn't like any of their work. What I liked was
 the intellectual atmosphere, and the rapport with the
 students was wonderful. With the support and the lack
 of support, it was more like the real world. I enjoyed
 being exposed to the architects and being exposed to
 filmmaking. Emshwiller brought in a film that he had
 just begun, so that we would see things in process that
 other artists were doing. Red Grooms brought in part
 of one of his incredible extravaganzas. It wasn't the
 supermarket; it had to do with fire engines. We would
 see other artists' thought processes. John Cage came
 in and talked to the students. We were with very vital
 people, which made quite a difference.

SS / A lot different from Boston University.

HP / Right, much different. I think the course that I learned
 most from, besides Nicholas Corona's drawing course,
 was Albers's color course. I learned about color ab-
 solutely, no two ways about it, just in using Albers's

concepts of all color as relative, dependent on the
quantity of the color and what's next to it. You can
take the gray and make it a green or a blue or a
purple just because you surround it with vast amount
of some other color. At Boston University I didn't
have any sense of one color being heavier than another
or lighter. Albers had it all worked out. We didn't
actually have Albers because he had left by then. We
had a man named Sy Soame. He taught us about how
you could take a gray and make a lighter gray. How
to really read color, lighter, heavier, forward, back.
It was incredible. I know I wouldn't have gotten that
at Boston University.

SS / After you got out of school, what did you do?

HP / When I was a graduate student, I was taking art his-
tory as my minor. I was working with a professor in
art history who was head of the Garvin Collection at
Yale. He asked if I wanted a graduate-assistant assign-
ment to work with Yale's British collection. I took
it, which gave me some experience. When I was out
looking for a job, people kept saying, "What do you
have experience doing?" I started working for a mu-
seum, and I still work for them.

SS / We were talking about how you enter museum work.

HP / In a way, it's a field that has notoriously underpaid
women, but it has hired women. I just ended up there,
because it was there that I had my experience.

SS / You moved away from the figure when you were work-
ing at Yale?

HP / At Yale, it gradually happened, but I didn't really move
away totally until 1967 or 1968. I found myself work-
ing basically with points and grids.

SS / Do you think that the fact that you use a circle is
meaningful? I'm sure you're familiar with Lucy Lip-
pard's work.

HP / I try not to read too much. Tell me about it.

SS / She has a theory about the circle being used by women
as a reminder of women's center in their art, seeing
the use of a circle as a feminist influence.

HP / I thought of the circle in other terms. To me it's the
 simplest form. Our eyes are round; we don't have
 square eyes. Somehow it's primary form for me.

SS / The grid, is that modern civilization?

HP / I'm not sure. Look at a map with longitude and lati-
 tude: those are points, and where they cross are
 points of energy. I don't know enough about physics.
 I've tried to read to understand if there are some con-
 nections. But apparently there are points of power
 and lines of power that have to do with just pure old
 natural energy. The earth is round. It's not square.
 When gravity works, you get a mass that's circular,
 and somehow points along the mass are designated by
 lines drawn from A to B and they intersect. Someone
 once mentioned to me that my work sometimes looks
 like a map, like a bird's-eye view, someone flying
 over, that topographical sort of surface.

SS / That's interesting.

HP / I think my ideas are based more in looking at natural
 things. My father, who was trained as a scientist,
 always took me on little nature walks, or he made
 sure that I felt myself to be part of nature. He has
 a real respect for nature. I remember being sent to
 the Y, in a camp situation where we were always out
 studying birds and plants. I think my attachment to
 the circle is more from nature than it is from a theory
 about a woman's way of seeing, but then one could go
 beyond the nature and say, "But that would therefore
 reach back to women who traditionally worked with
 agriculture." Maybe it reaches farther back to some
 archetype. I was always fascinated by the fact that
 the sun is round and the stars are seen as points of
 light. I see everything as energy represented by little
 circles that move at a certain velocity. You don't see
 square protons and square neutrons.

SS / I was thinking that the way you use the glitter as well
 as color is like the stars, and picks up light.

HP / I'm interested in that concept, although I'm not inter-
 ested literally in astronomy. When I was a kid, I would
 look in the other direction instead of the heavens. My
 parents bought me a little microscope. I was forever

looking at a microcosm like drinking water under high
magnification. I was saying, "Mama, look what's
moving around in the water." One can look at the
work and see the minute quality about it even though
it's on a large scale. It could come from that.

SS / It's also made up of square or tiny things put together.

HP / What I do is take pieces of paper and make drawings
on the paper and then destroy the drawings by punching
holes. It starts with something larger and it's reduced.
Also I might even have more drawings on one little
surface. I know a critic who got angry at that and
said, "Oh goodness, how many Lord's Prayers can you
get on the head of a pin?" He was putting it down as
being excessive.

SS / You use the written word and your dots. Why do you
do that?

HP / I'm not really sure. The work splintered at a point.
When I started using the circle, it was in paintings
where I had punched holes in paper and sprayed through
the holes and saved the dots. The dots became the
pieces that are numbered. The piece behind you is all
circles with numbers on them. I did one primed can-
vas where I would spray dots and layer them and layer
them and layer them. So you would get veils of color
instead of literal pieces of color.

SS / This is more like a collage.

HP / The other was like the paint was sinking into the can-
vas and this is coming out.

SS / Was Frankenthaler any kind of an influence because of
her layers?

HP / Maybe she was; maybe it was her use of staining.
However, I didn't like her or her work. I remember
she was so callous with the students. Maybe it was
a class thing, or she probably saw these students as
just another glut on the market. I remember a lot of
guys in the class got off on making mini-Franken-
thalers. Then she would come in and say how wonder-
ful the work was and she was so glad to see they were
changing in the right direction. She could be easily

"Untitled" (1975)
Ink, spray adhesive, thread, 15" x 15"

conned, just by being shown the same thing that she
does. I didn't have that much respect for her, from
an artist's point of view, and I did not appreciate the
way she treated the students.

SS / Did you feel when you were an art student that people
didn't respect you the way they did the men students,

that they thought you were just diddling around, that
you weren't really serious?

HP / They didn't. I think Chape and Lester Johnson re-
spected their students. I think they, as people, were
devoted, interested in other people. Held was into
making it. I remember a lot of the male students
would buddy-buddy with him, because they knew if they
got friendly with him they could attract certain jobs
and certain gallery shows. The guys were awfully
ruthless. They knew they could make certain connec-
tions and make it through these connections.

SS / That's why they were there.

HP / That's why they were there. In fact I remember a
student who had a show in a major gallery and had a
teaching job before graduating. He got it just by pure
brown-nosing. 1 often wonder, in that case, if the
person really knows what his work is, because his
work has been produced in order to please a market
and to please the teacher. As a woman, one is free
to do your own work.

SS / Nobody cares.

HP / Right.

SS / When you were a student or later in trying to get a
job, or with your work, have you ever encountered
double prejudice because you are black and a woman,
too?

HP / It's something that I'm becoming increasingly aware of
now with the women's movement and also the black
movement. The women's movement has effected change.
There are women who are being shown that perhaps if
we had said nothing, no one would know. But with
blacks, it's like a brick wall. The men are beginning
to show now in the white galleries. I can think of two
or three, which is a small percentage. But with
women they're already pre-prejudiced by your color
and also by your being a woman. The feeling I get is
that the dealers are willing to take on a number of
white women and maybe give them shows. But with
a black they're afraid that if they take you on, it will
look like a political statement on their part, that they

are saying they are pro-black or that they are saying
to the other dealers that this is a challenge: "I am
doing this and look at you, you're not doing this." It's
not just taking on another artist for them.

SS / They're afraid to do it.

HP / They're afraid to do it. And then when they do it, as
when I was showing, with Rosa Esmond, she refused to
list my name as being in the gallery, even though she
would list other people in that three-person show as
being in the gallery. She asked me for an exclusive
contract, in writing, where she would sell the draw-
ings because she knew she was making money off me,
selling drawings. But she would not give me a show.
My feeling is that she didn't want to attract other blacks
to the gallery. She didn't want blacks to think she was
sympathetic to them and therefore they would come with
their work, maybe come in when she happened to be
selling a piece to someone who was white--as though
black artists would ruin her real-estate value, like
living next door to her. She was very rude to me.
 With other places, what has happened is that people
bring your work in if a client comes in and says they
want a black artist's work. Then I'll get a call from
a gallery where they suddenly want to send someone
down in a panic. They have this client with a lot of
money who wants to buy work. They want to make a
good showing and they send the work back as soon as
that client has bought what he or she really wants.
So they don't take you into the gallery as someone they
are interested in. It's just the "queen for a day" syn-
drome. Faith Ringgold's having a show; that's the only
black woman I know of who has been showing, and
Betye Saar. What I've also found is that often the
dealer will deal with you if your work is political.
They won't deal with the white artist whose work is
political. It's as though, if they are going to make
a political statement, they may as well make a com-
plete political statement. If your work is neutral po-
litically, then that's somehow a very nervous-making
thing for them. If they take you in the gallery, that's
ambivalent. They feel they're making a political state-
ment, but your work isn't.

SS / In a way Betye Saar's work looks as if a black artist
has done it. With your work people wouldn't know
that you are black unless curators put a little note on it.

HP / Exhibitors feel they have to tell.

SS / They want to get credit for it.

HP / They either want to get credit or they don't want to
 sell work to someone unless they tell them that you're
 black. An artist whose wife is a critic said to me,
 "Oh, Howardina, I see we're in the same collection.
 I wonder if the owner knows you're black." I don't
 know if he knows I'm black. I don't even know him.
 This artist said, "I bet he wouldn't have bought the
 work if he had known you were black." Now this guy
 thinks that's a sympathetic thing to say. He's saying
 in an undercurrent, "I'm white, and I don't have to
 worry about race, and we're in the same collection."
 Was he expressing his distress that maybe I was low-
 ering the value of the collection because I was in it,
 or was he on face value just saying, "Interesting that
 you're in the collection"? I didn't think the collector
 particularly liked blacks or had anything to do with us.
 April Kingsly wrote an article about it in the Village
 Voice, not about this incident but about how there are
 black artists whose work is on the artistic level of
 white artists who are showing in good galleries and
 no dealer will touch them.
 I don't use my job at the museum to push myself.
 I don't think that's right at all. I try to help other
 artists by being an advocate for the living artist where
 I work. Believe me, the living artist needs an advo-
 cate.

SS / You have to die to be appreciated.

HP / Right, you have to be dead. I cannot push my work
 on my job and I wouldn't. What I find interesting is
 that there are whites who also work in museums whose
 girlfriends or boyfriends are artists. Those girlfriends
 and boyfriends are picked up immediately by galleries
 who think that they can get into a museum, because
 gallery owners think that girlfriends or boyfriends who
 work in a museum will come to see their work, thus
 giving the dealers access. Well, I haven't found that
 to be true. The opposite has happened to me. No
 dealer has approached; they know that I'm very ethical,
 which probably turns them off. I'm not going to make
 any deals; the fact that I am above board might be a
 deterrent, because the business isn't a very clean busi-
 ness.

SS / It took me a long time to figure out why the artist is
 the lowest on the art totem pole, even though the whole
 system is based on the artist.

HP / It's based on keeping the artist down, too--all of
 us, black and white alike; I guess it's because it's a
 profit system.

SS / Do you think that this situation will improve?

HP / In my lifetime? I don't know. I've shown work in
 Europe and I haven't had the same problem. I'm con-
 sidering going to Europe and showing there. I've ap-
 plied for grants to do that. I'm also showing mainly
 with black dealers, who function with the same handi-
 caps. At least I'm showing the work when I can, show-
 it at Just Above Midtown. I'm showing with a guy in
 Chicago who will be opening a larger space in Septem-
 ber. He shows both black and white artists. He's
 not limiting himself to any one group. Also he is
 very open to the women's movement. Whenever he
 goes to different cities, if there's a women's show or
 a conference, he always brings back some material for
 me. He's very supportive as a person. I think he's
 the best dealer I've ever had any contact with profes-
 sionally, and in terms of his interest in me as an art-
 ist. It made me see what it's like for a white artist
 dealing with a white dealer, if there's a personal inter-
 action just how supportive it can be.

SS / It's that they believe in you.

HP / I always felt an adversarial relationship with any dealer
 that I've met in New York who is white.

SS / Let's get back to your work. I know you just work
 small in a three-dimensional way and then you work
 very large.

HP / When I first came to New York, I struggled with the
 figurative, trying to figure out what to do. Then I
 started doing large paintings with the holes that were
 sprayed, sprayed dots. Then I started numbering at
 that point. That would be around 1970. I came to
 New York in 1967. The real struggle was around
 1967-68. By 1970-71 I started numbering. Someone
 said to me as a joke, "What did you do with all those

holes? You've punched out all those holes; what did
you do with them?" I said, "Oh, I've saved them."
He said, "Well how many have you saved?" I said,
"I don't know; I'll number them." So I started num-
bering them. I remember it was my first show at
A. I. R. , and I was in a limbo period. I knew when
the work came back I would have no room in my studio,
so I tried to think of a way I could work small. I had
this bag of spots, which I numbered. At work they
have the insides of the mats. When they cut the win-
dows, there is this beautiful one-hundred-percent rag
ivory mat, which they throw out, the center. I asked
the frame shop to save these materials for me instead
of throwing them out. I could go down to the trash bin
and collect whatever I wanted. I took some thread (I
was making my own clothes then since I couldn't afford
to buy any) and made a grid, longitude and latitude.
Then I bought some spray adhesives; at that point I
figured out which adhesives were permanent. I had
asked the companies whether they were permanent, so
the 3M Company sent one of their little chemists over
and I told him what I was doing. He explained which
ones to use. What I did was sprinkle the number spots
into the adhesive and then cover it with hot talcum
powder--sprinkle the talcum powder and sprinkle and
spray, so I achieved a frosty surface.

Gradually as I worked on those pieces my eyes be-
gan to bother me because I was working on such a
small focal line. My eye doctor suggested that I get
color television, something with motion that would cap-
ture my attention so that I would be exercising the mus-
cles of my eyes. I told myself, when you're working
with the numbers, look up and look at something that's
moving and keep it at a distance, so that you're chang-
ing the focal line.

I started doing at that point, in 1975, the video
drawing series, which uses the TV, the numbers,
and vectors. At the same time I started experiment-
ing, using color washes on paper and punching them
out, and using different kinds of paper, translucent
and thick, fuzzy paper. Now I'm even using leather.
I started making color drawings--I had been in the
Paris Biennale in 1975--but I stopped soon afterward,
because I really worked like a dog on that. My eyes
must have been down to my knees. I stopped doing
the number pieces. I started doing three-dimensional
color pieces. Gradually it worked its way into the

painting. I started off very tentatively with a white
canvas and I primed it. Then I put a layer of stark
white paint over it. I had punched holes with no num-
bers. I put those on canvas. I then painted over them
and I punched holes with no color on. I just had can-
vas with these layers, depending on the thickness of the
paper, of small holes and then gradually the paint sur-
face started building up. I mixed paste and gel and
acrylic. I would hold it up and take a pallet knife or
a serrated plastic knife and push the paint through.
Then I would get a three-dimensional piece, a stalac-
tite sticking out. I'd cover the whole canvas and turn
it around. I wouldn't work on it straight on in one
format; I would always turn it.

SS / Now you work on little grids.

HP / The sewn grids started about two years ago. Before
that I didn't cut the canvas. I just had the rectangle
or the square. Then I decided to break the surface.
I wanted a grid. I first tried to draw the grid on,
but I didn't like it. Then I cut out the grid. The
earlier pieces, like this one, have a woven surface
rather than having the squares like a tile sewn. These
are strips which I interwove. So you don't see the
wall at all.

SS / Like a basket.

HP / Like a basket; you can't see the wall at all. But it's
very heavy. It's double the weight. I found I was
going through canvas so fast and it was so expensive,
I had to devise another method. So I started sewing.
Here they're sewn on a horizontal. There is a "V."
I could weave it so that this one line would stay to-
gether, but I'd have to anchor it with stitches on the
horizontal. I didn't have to sew it or anything. This
version involved less sewing, but I think I like the
results of the other better, where you can see the
wall.

SS / Seeing the wall through the grid gives it another di-
mension.

HP / I do like that. What I find, too, is that it makes the
surface undulate because the squares are out farther
from one another. It just depends on how they are

sewn. You get a back-and-forth interplay of the sur-
face.

SS / Do you work on the individual squares or do you put
them together and then do it?

HP / What I do is I sew the piece, lay it out, and then I
take a ruler, a T-square, and a triangle and I make
red lines. Sometimes I make them small, sometimes
big, and now I'm even trying to draw within it. Then
I'll just lay it with canvas on the floor. I'll number
each square so I can put it together again. I'll have
the whole thing out with the grid, and each square will
be 1, 2, 3, 4, 5, whatever, and then I'll put arrows
so that 1 goes with 17. If I get confused, it's all off,
because it will get all out of kilter. Then what I do
is gesso it. Usually I'll put a color in the gesso,
like a luserine. What I like are colored layers, the
layers not all the same color, so what you get, be-
cause they are transparent layers, is an optical mix-
ing as well as a literal mixing. Then what I sometimes
do is take the dye markers and draw directly on the
gessoed surface and also punch some holes. Some-
times I'll punch some circles which I embed as I gesso.
It really depends on my mood. Then I'll tack the
piece up on the wall and start putting a thick paint on.
When the whole surface is covered, I'll put it on the
ground. I'll mix up a gel glaze and I'll embed in it
circles of colored dyed papers. Now I use leather. A
friend of mine brought me some leather that he found
somewhere in the trash. I had explained to him that
I was really stumped: I wanted something flexible, be-
cause when these pieces are shipped they are rolled.
I can't use heavy cardboard, which is lousy material.
It won't stay flexible. You can't roll it and unroll it.
So he just brought me a whole shopping bag of leather,
which is perfect because it's thick but it's also flex-
ible.
 I try to work very slowly and methodically. Then
when I've layered the whole surface with dots and glaze,
I put it on the wall again. Then I start with the three-
dimensional part. Sometimes I draw into it. There's
more drawing into the recent pieces than I've ever done
before. That process continues until I think I'm fin-
ished. On the top layers I put talcum powder, as in
the early drawings, and sequins sometimes. Sometimes
I do a double-powdered layer because it gels in such a

peculiar way. I've done a lot of traveling, and I went
to Egypt, where I saw the old wall paintings which are
dusty, dry. I love the surface of fresco anyway. It's
so beautiful. That's why I like the dyed paper when
it comes up through the paint. It's like an ancient
wall fragment but it's a new one. This is one of my
earlier pieces, so it doesn't quite have a lot of the
mysterious stuff that the new work has. This was the
first sewn grid piece that I did, in February 1977.

SS / Do the numbers have any significance?

HP / They mean nothing. I just like the way they look.
I think my recent work is visually more challenging
in a way. Some of the problems I see in this early
work I started to solve.

SS / When you do the small three-dimensional pieces in the
boxes, do you work on them at the same time as the
larger works?

HP / The intensity in doing the painting is great, just to
get the sewing done. It takes a month. The paint
part of it takes a month or more. I usually set aside
special time to work with drawings. I take little steps
with the drawings by preparing the grid. I paint into
the grid and put the thread on it, then prepare the
papers that I'll punch out. As for the actual working
on the drawing, I'll put in two months on some, maybe
more, to do nothing else but that. The TV pieces I
can do anytime, because that's just when the spirit
moves me; the camera is on a tripod. The video is
much faster, because most of it is done in a lab. The
visual part I do. I don't have to do the developing.

SS / When you do the three-dimensional pieces, the punched
paper, do you do those in a series? Do you work on
several at once or do you do them one at a time?

HP / I've worked on several at once. One show had about
fifteen pieces. I would say some of them I started
six months before and then finished. Then I started
the next sequence of maybe six to ten pieces. I'd do
a whole series of drawings and keep each drawing that
I had punched out in an envelope, so each envelope
would have a certain color to it, and then I would start
the backing, the mount. I would have painted on that

and put the thread on. I would figure out what en-
velopes I thought would work and then I'd put those
together. I would sprinkle them and use stencils to
isolate certain portions of parts of the color. Then
I just work on it. I work on one at a time, but yet
I do do them all together as a series. I think that
maybe if I had more time, if I didn't have to work,
I could split my day, and spend half a day working on
the paper pieces and half a day on the painting. But
I can't do that. So I just save it for the painting.

SS / Other artists have told me that. They can work on
graphics in the afternoon and painting in the morning.
I think it's very hard for anyone to work eight hours
straight on a particular piece.

HP / Yes. I'd think you'd get dried out, creatively. Ideally,
if I had that kind of time, I'd probably even do some
graphic work as well. I've done one print in the past
since I've graduated, with the A. I. R. portfolio, but it
was a group portfolio Since I am in prints on my job,
I considered it a conflict of interest to make prints.
I suppose I could publish them on my own. Once I am
out of that field, which is my primary income source,
then I can probably publish prints, or work with some-
one who publishes my prints. What concerns me is
that I don't want someone to say, "I'd love to publish
your prints," just so they can market the other things
they're doing, using the museum, by saying, "Oh well,
we've published Howardina Pindell, who you know is
blah blah blah." This is almost like an endorsement
of their activities, so I have to be careful not to put
myself in that position.

SS / Just for the record, you are curator of prints at a
major museum?

HP / I work for a museum. But I don't want the museum to
be seen as an endorsement of me, which it is not.

SS / Didn't you do a series of prints with Judith Solodkin?

HP / Yes. She did the A. I. R. portfolio. She did print the
litho that I did with them.

SS / Did you like working with a printer that way?

HP / I like working with her. I don't like men printers.

Well, it's not that. I don't like many printers. It's
really so dependent on your relationship with that
printer. They have to like what you're doing because
they're also doing it. Their touch influences how it
could look, especially in lithography.

SS / Sure it does, because they're artists, too.

HP / I think the best prints that are done today are by
master printers who are given as much freedom as
the artist in working the print. (Though I don't mean
they innovate and change what the artist has done.)
Judith Solodkin will spend anything that's required to
get what the artist wants. That gives freedom to the
master printer, too. She knows she's working with
the best. I don't mean best in terms of the artist.
She knows she's working with the best materials. She
knows the artist is getting what he or she wants. If
I start making prints, I'd want to work with the best
materials. If someone published a print of mine, I
would have to pick someone who would be willing to
spend the money to do it the way I wanted it. I would
have the freedom, if I had the money, to publish it
myself, which I think is ideal. Just find a printer I
would want to work with. My experiences with Judith
have been excellent, so I'd probably work with her,
gladly.

SS / It's a good way to get known, too.

HP / Sometimes it is. The print world is very separate
from the art world. But, many commercial people
who were primarily print people are now moving over
to printing, drawing, painting, and sculpture. It's
getting a little less specialized.

SS / Do you want to talk about the effect of the women's
movement on you personally and your views about it?
Are you active in it?

HP / I'm active and I'm not active. It's a double thing.
When I first came to New York, I wasn't active. I
didn't know anybody. The first person I worked with
on my job was Lucy Lippard, because I was working
in a department that dealt with hiring outside people
to do exhibitions that traveled throughout the country.
She was one of the people I was assigned to work with,

but she didn't know me as an artist at all. When she
did the Twenty-six Women exhibition at Larry Aldrich's
she was looking at a lot of work. She called and made
an appointment. I think that what happens is, when
you're in one job, people see you in that job only.
She was very surprised to see that I was serious about
my artwork, more serious than she had expected. She
was very involved in the women's movement at that
point. She was with a group called the Ad Hoc Women's
Committee. They had no black members. They were
trying to get me involved. At that point I said I didn't
want to get involved, because I had just come out of
the black movement in the sixties. If there were any
problems relating to blacks then they wouldn't touch
them. They wanted me for their things but they wouldn't
touch me. So I stayed on the outside of it. I know
the Ad Hoc Committee picketed the Whitney for not show-
ing blacks and whatever. But I had to deal with the
fact that I couldn't get my work shown by anyone.

At that point a lot of women were asking the same
questions, and the four or five central members of
A. I. R. were looking for members for the group of
twenty. At that time there were a lot of black shows.
The Whitney had a show that was controversial because
a lot of blacks withdrew from it. I had chosen to be
in it. My idea was that I have so few opportunities
to show my work. All these men came to me telling
me to withdraw my work. They're the ones who are
going to be shown anyway. I'll be the one that will be
left out. So I decided not to withdraw. A few years
after that I was in the Whitney annual. I think that
was a result of the pressure from the Ad Hoc group
because there were no blacks. About that time Barbara
Zucker, Dottie Attie, Mary Grigoriados, and Susan
Williams had a central group of people who wanted to
start A. I. R. They went through the women's slide
registry and through catalogs of shows, Lucy's cata-
log, and the annual. They made appointments. I had
never heard of them. It was very fair. It wasn't a
question of my knowing anybody; I didn't know a soul.
I just got a call. I was living in Westbeth at the time.
I remember they came up to see my work. They said,
"We'll call you." In about a month or so they called
and asked me if I'd like to be a member of the gallery.
I thought, "Sure, why not?" I was blasé about it, be-
cause I didn't know much. At that point they were
just forming discussions about what name we would call

the gallery and how we would structure it. We had
meetings to find a name for the gallery. We built
the space, which was very hard. I think there was
a lot of attention focused, because this was the first
attempt that women had made on their own to show
their work outside the system. I think that's why
A. I. R. did get such a good reputation--because it was
right at that perfect point in time.

And they showed good work. Before that time there
had been a group of women who had rented a space in
Soho, a group of ten women. There were other artists
at the same time who were doing that. I remember I
was in a group of men and women, blacks and whites,
that rented a space that's now a gallery. Artists felt
that not only were women not being shown but many
artists in general were not being shown. The irony
of it is that the proportions never seem to change, be-
cause we now have more galleries but also more art-
ists in New York. It's an endless problem.

SS / Do you like working with the co-op gallery?

HP / I left the co-op after I had two shows there. I showed
jointly with Harmony Hammond in 1970 or 1971, when-
ever the gallery first opened. What I found was that
I hadn't entered the art world in the "buddy system."
I didn't know many people. When it came to reviews,
the critics stayed away, because they knew I was black
and they were afraid the work would be bad by their
fancy definitions. In fact I had one critic who came
to me and said, "I was asked to review your show.
I was afraid to because I knew you were black. I'm
glad to see your work's this good." So a lot of crit-
ics just ignored me or they were afraid to come in.
They wanted to see what would happen. They wanted
to hear from other people.

SS / Do you think they were afraid to say anything negative
if they didn't like the work?

HP / Maybe they were afraid of that, but they didn't have
any problem with the other women who were in the
gallery. Then the next showing time I showed the
works on paper. I got no reviews, except for one in
which the critic said that I numbered like a woman
who was obsessive and mindless. Absolutely no one
else would cover the show. I was not really in the

"buddy system." I didn't go around and try to have
drinks with the critics.

SS / I suppose there is a lot of that.

HP / Yes. It's ninety percent that. I found that the gallery
was a very demanding situation; I not only had to go
to my job, come home, and do my work, but then
with co-op I had to go to meetings and take on com-
mittee projects. I was finally whittling away my studio
time doing what I thought was necessary to be a full
member of the gallery. A group of us who were feel-
ing that way went to them and asked if there was an-
other category that could be created. We will go out
and try to find other places where we can show our
work, but we will continue a relationship with the gal-
lery where we will help, where we can sit in the gal-
lery maybe once a month, take that drain off the mem-
bers. We'll do that and we'll also pay you eight dol-
lars rent a month. So if you have four or five of us,
you already have an additional amount in the kitty and
you can replace us with full members, so that these
full members can have our showing slots. They'll also
be giving you their full dues and they'll be giving you
their full time.
　　I think, in a way, A. I. R. is an ideal situation if
you have support from someone financially, because
you know you'll have a show every two years, and
people know where to find your work on a consistent
basis. Sometimes that can be a drawback, but in this
case I think it is a good thing. The bad things about
a co-op are that there is no central person whom any-
one can go to for information, and the fact that your
work is never on view at the gallery except when you're
having a show. You have no mediator at all. So
you're essentially stuck with doing what you were go-
ing to do anyway. If you're independent, you have to
do your own bookkeeping and paper work and curatorial
work. The good thing is that you have a place where
you know you can have a show and you can show any-
thing that you want. You don't have what I found when
I was showing in commercial spaces. When I was
working with one gallery owner, she was very nasty
to me and kept trying to tell me how to do my work.
She would say, "I don't like this." When I was doing
paintings that were all white, she didn't like white
paint. I said, "That's too bad, I'm not doing work to

please you." She said, "Well, add more color." I
said, "If color comes in, it will come in on its own
accord. Not because you told me to put it in." Or
some dealers will say it's too big, it's too large, it's
too this, or too that. With A. I. R. you don't have any
of those demands. So I think if a woman artist is mar-
ried and has a husband to support her or an outside in-
come of some sort, A. I. R. is an ideal situation. Or
let's say you have a teaching job and it's one where
you put in very few hours, then it's ok. But I found
I didn't have any personal life because I had no time
for it. It's a lot of work. It does distress me that
a situation like A. I. R. demands that you have to have
a certain financial freedom to be able to participate.
That to me is a paradox in the women's movement. It
means that only middle-class women, or only married
women whose husbands are making enough money to
support them, can be in the gallery. Or women who
have an income that allows them enough time so that
they can be full members of the gallery.

SS / So it's an economic prejudice. The women's movement
has been accused of being an upper-middle-class move-
ment.

HP / There were people in the gallery who were from the
upper-middle-class but didn't have, at that point in
their lives, upper-middle stability in terms of money.
And they eventually left. Some people left because
they were tired of the cooperative scene. One problem
is it does keep you in a narrower world. I find that
it also can get very self-congratulatory, which I don't
think is so hot for the work. I'm under a lot of pres-
sure on my own. I'm also looking at a lot of work,
and different kinds of people see the work. When I
was in A. I. R. it seemed as if only people in the
women's movement would see the work, or people who,
in a way, were feeling altruistic, who wanted to go to
a place where they could find women's work. I wasn't
dealing with the world at large.

SS / Like a convent?

HP / It was like a convent in a way. I'm also very politi-
cally active now in terms of trying to talk about the
art world as I see it and how I think it should change.
If I stayed in that narrow little world, I wouldn't be

seeing some of the things that I see. For example,
I learned a lot from my experience with Rosa Edmond.
I learned about how to deal with the dealers. I take
them seriously, and I don't take them seriously. It
is a capitalist system, so it is a profit-oriented sys-
tem, but to me it's a pity that the artist isn't given
the freedom to work and develop her ideas without her
work being linked to whether it's making a profit. The
I. R. S. says you're an artist if your motivation is to
make a profit. If your motivation is not to make a
profit then you are pursuing a hobby. The dealers
are out to make a profit. I think that's where blacks
run into a problem. Many dealers feel, regardless
of what is reality, that they cannot make a profit on
black artists' work. So they'll say to you, "I cannot
sell your work," even though that's a euphemism for
"I really don't think I can sell a black person's work."
They will make it appear that the work itself, the qual-
ity of the work itself or the scale or the size, has
something wrong with it, when indeed profit is the mo-
tive. A lot of artists get all twisted up and think that
they've got to make it. And the only way they can
make it is to go with a dealer who is going to make
a profit. They start making decisions in the studio
about the work and how it should be, rather than work-
ing and seeing it go wherever it goes.

SS / Does the co-op, did A. I. R. have a contract stipulating
 that you can only show with them?

HP / No, it wasn't exclusive. Some people do show in sev-
 eral places. The ideal thing with A. I. R. is that if
 you can afford it, you show both with them and in a
 commercial space. Often the commercial places won't
 touch you unless they have an exclusive with you. But
 I've tried to keep free of that, not only because I'm
 sort of locked out of it, but also because I like the
 freedom. I both like it and don't like it. I guess I
 had such an unpleasant experience with Rosa. She
 wanted an exclusive on every breath of air I had, but
 literally did not want to do anything in return.

SS / Would you have any advice for young artists coming
 out of school, particularly women artists?

HP / I think the main thing is to focus on the fact that there
 are maybe two separate priorities other than your life:

what you do in your studio is one thing, but when you
go outside, what opinions people have of the work--
don't give that too much importance. You know whom
you can learn from in terms of people who have rap-
port with you or your work. But don't go into the
commercial world thinking that they can decide for you
whether your work is good or not, because that's not
their main interest. Their main interest is making
money. Also don't let that world, unless you want it
to, determine for you what your work should be or
what your work should look like. You may walk into
a gallery and they say, "We don't show paintings that
are under thirty by forty inches," or "We won't show
anything that's over a certain amount, or that uses a
certain color." That's just pure bull. That has nothing
to do with the artist's reality. It's the profit mental-
ity. If you want to make a lot of money, just go out
and figure out how to make it in terms of doing the
work that fits what people want and making contacts
with the people you think can make it for you.

Also discipline is important, even if you have a lot
of time. When I come home from my job, I can do
four or five hours of work. It's a case of diminish-
ing returns when I try to do twelve hours. If I'm
smart about the day, then I'll split it, and do, as I
said before, drawing in the morning. I have to organ-
ize. I have to make it so I'm filling the time up in a
full way, so I'm not working on half a brain cell. I'd
burn myself out doing too much of one thing all day.
Some people might like that constant twelve hours.
Some artists go and hang out at the movies for half
a day. Some go to the bar all night then sleep the
rest of the next day then work five or six hours dur-
ing the day. Then stop, eat, and go to the bar. It
depends on what the artist as a human being wants to
do with her art. If you have a family, that's a whole
other thing, too.

SS / Is there anything you'd like to add?

HP / I'm going to do a piece for <u>Heresies</u>, The Third
World issue. I was invited to be in a symposium on
criticism; most of the other participants were art his-
torians, very cold, hard-line, objective, morally de-
tached, old-world criticism. I did a piece about crit-
icism and how criticism affects the real world as op-
posed to the world of ideas. First of all most critics

do not go to your studio, but they go to a gallery to
look at the work. The gallery dealer has already
made certain decisions about you being there, maybe
by selecting the work for you. In a way the critics
themselves have not really seen you, but they're see-
ing someone else's filtering system. They hung it,
they selected it, and it's in a certain space. I'm ask-
ing that some day someone do a scientific evaluation
of the art world, why it is the way it is. What are
the motivations of the critics? Why will some critics
only go to galleries like 420 West Broadway? Some
critics will only review men's work of a certain cal-
iber. Some critics will only review women's work of
a certain caliber. Some critics won't review women
at all. Some critics will review blacks for some rea-
sons and some won't. Let's say if you have work and
a critic knows the artist is a man or a woman the re-
view will be different. Artists should get used to see-
ing the critic as a human being with human failures
and positive sides, too, but not thinking of the critic
as the do-all and be-all. The critic is really in a
way an arm of the dealer in order to sell work. If
you ever have a review, and there's an illustration,
it's like an endorsement. The dealers kill each other,
I'm sure, to get on the cover of Artforum, because
that makes an artist's career and that image is an en-
dorsement, being on the cover, and they'll sell it eas-
ily. One must understand what is real criticism and
what is trade-journal publicity. A lot of alternate pub-
lications are developing now all over the United States.
The critics themselves are tired of being used as pub-
licity and want to be able to write criticism that isn't
meant to sell a product. They really want to exercise
the training they have. You find critics like Donald
Kuspit and Lawrence Alloway starting their own journal
of critical writing. There's a woman in Chicago, Siel
Morrison, who started her own journal, Format. I
think there are some other critics there who are start-
ing one called White Wall. There are journals of art-
ists' critical writings like Tracks and October. Many
critics get so abstruse that they're hard to understand.
One must understand what are the real things in the
art world and the things that aren't real in terms of
one's life. It depends on what you want. If you want
to make it, there are certain ways of going about it.
And if you really want to do your work, see what the
limitations are--how you may not mesh with the real

world, because it wants you to do something else. It's something I'm grappling with right now. It's pretty discouraging when you see the art magazines and how they function. You listen to artists fighting with each other, competing to the death like gladiators, in order to see who is going to get into a show, who is going to make it, who isn't; who is going to get a full-page ad and who is going to get a half-page. Then I think, "Wouldn't it be wonderful to go off somewhere and just do your work?"

FAITH RINGGOLD, painter, sculptor,
was born in New York in 1934 and was
educated at the City College of New York
(B. S. , 1955, and M. A. , 1959). She was
commissioned to do a mural, "For the
Women's House," for the Women's House
of Detention, Rikers Island, New York,
1971. She has taught African crafts at
the Bank Street College in New York
(1970) and is currently an artist-lecturer
in black art at Wagner College, and Afri-
can arts at the New York Museum of Na-
tural History. She received a C. A. P. S.
(Creative Artistic Public Service) grant
in 1971. Writings about her work include
Mel Tapley, "Harlem the Show," Amster-
dam News, December 27, 1975; "About the
Arts," Amsterdam News, June 5, 1976;
and Lucy Lippard, "Faith Ringgold--Flying
Her Own Flag," Ms. Magazine, July 1976.
She is the coauthor of "What's More Im-
portant to Me Is Art for People," Arts
Magazine, September-October 1970. Among
her exhibitions have been American Women
Artists, Kunsthaus, Hamburg, Germany,
1972; Women Choose Women, New York
Cultural Center, 1973; Faith Ringgold Retro-
spective, University Art Gallery, Rutgers
University, 1973; Second World Black and
African Festival Arts and Culture, Lagos,
Nigeria, 1977; and a solo show at Douglass
College, Rutgers University, 1978.

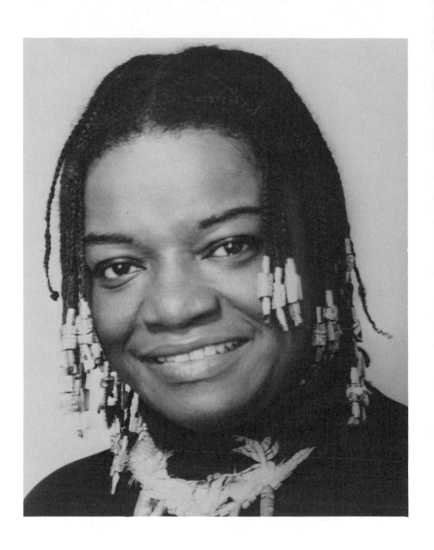

SS / Let's talk about showing in New York.

FR / When Perry Miller Adato was planning her original
women-artists TV series, she came to my studio. It
was 1975. She said that she was going to do a film
on women artists. I showed her my slides, my paint-
ings, all the way back to 1963. I went all the way up
to 1973, when I first started soft sculpture. What I
do is very political. Many women wouldn't dare do
anything soft because they don't want what they're do-
ing to be called women's art, sewing, or craft. So
they've got to do something hard that looks male.
Early on my work was also very political, in the sense
that people understand political art: that has to do
with black and white people and the sixties. I used
to do flags and things like that. I got the feeling when
Adato was here that she wouldn't use my work because
of its politics.

SS / Too strong.

FR / Yes. I could feel it. I got the feeling that she looked
at me and thought, "You know you're idealistic and you
think you're going to get somewhere doing this, and
maybe you will, but I won't touch you."
 Now, people, black people, women, might say, "If
that's the way I'm going to be viewed, I better turn
around and do something else." Not me. I figure this
is my life. Nobody promised me anything. If I turn
around, they didn't promise me anything. If I keep
going, they didn't promise me anything. But I prom-
ised myself something. I'm going to do what I want
to do in my life. I'm just so thankful I can do what
I want.
 Then the TV series came out, "The Originals."
There were seven women artists in the original series,
including one black woman, Betye Saar. Betye Saar is
comfortable, she's a fine artist, but she's not really
political. I've been watching to see what's happening,
and so far Alice Neel is the most political person.

SS / You don't think Betye's things are somewhat political?

FR / Well, she doesn't make statements. I make statements.
Of course, you can't have two black women; if you only
have seven women, you can't have two blacks, that's
against the rules. That's the quota. So, one black
woman, Betye Saar. All right? So here we go again.
 This happened to me with the black movement: the
men figured they'd silence me. But then, too, they
knew that when people started buying black people's
art, they wouldn't buy the women's anyway. And that's
what's happened. The guys get the galleries, the guys
get the opportunities. And the guys knew that in the
sixties. I didn't know that. I wasn't thinking about
women then. I was out there working to get black peo-
ple this and that. I didn't know I was working for the
guys. I found out and I said, "Well, that's not going
to be anymore. "
 There are many things that have to be done. We
black women artists are all split up; we're in separate
places doing separate things. Because for every black
woman who makes it, there's going to be ten thousand
black women who cannot make it. We're set against
each other. We haven't had the sense to get together
and to be together. I guess because we've been ex-
hausted from the general black movement, we just
haven't embraced our own movement. And we've found
out that, if you keep your mouth shut, you just might
get something by default.

SS / Do you think it will change?

FR / Well, of course, my situation is going to get better.
I can't speak for large groups of black women, because
there's no organization.

SS / Do you think that will come?

FR / I think eventually it will come, but I'm not concerned
about it coming. I think people feel that good things
must happen in America. I don't know whether that's
true. I don't think America's the center of the world
anymore. I think African women will lead the way,
as far as women's liberation is concerned.
 The African woman, she's got a country, she's got
the flag, she's got her own army, got the navy. She
doesn't have a racism problem. She's not afraid that
if she speaks up, her man will say goodbye to her.
The African man can't say goodbye to the African

woman. Because they've got a thing going there,
they've got a business. We don't have a business
here. Blacks don't represent the majority here. We
are a minority of people who, as long as we look like
we do, will never be able to assimilate. And there's
nothing wrong with that, it's just a fact of life.

You go to Africa and there are women with baskets
on their heads, uneducated. However, they are trying
very hard to send their children to school, and young
women are going to school. The young women are
trying to be policewomen, and women join the army.
I'm talking about Nigeria and Ghana as particularly
typical. I've heard many feminist statements made in
Africa; I never hear anything by black women in Amer-
ica. So I'm looking to Africa. I'm just here because
this is where I live and this is where I can make a
living, and I'm well established here to some extent,
and I can do a little something. If I were younger,
if I were my daughter's age, I'd go to Africa. I
wouldn't stay here.

I have not been active in women's-movement activ-
ities because I have found that they do not suit my pur-
pose. Whatever the movement is, it's probably good.
But chances are that it does not speak to my particular
situation, which is being a black woman in America.
It's a heritage that I'm very proud of, and without it
I can't do any art. I can only do what I know. I've
never seen a white person who didn't know Michelan-
gelo, or wasn't aware of Greek art, didn't understand
their European roots. I've never known any white art-
ist, of all the friends that I have, who has said, "I
don't want to know anything about the classical Greeks.
I'm not interested in the tradition of oil painting. And
the Renaissance, I'm not concerned with that." I don't
know anybody like that. But I know black people who
tell you, "I'm not interested in African art, that's not
my thing; I'm not African, I'm American." I've heard
many people say that, which I think is suicide. I mean,
you use all your things. I have the advantage of using
the American experience, such as it is, from Europe,
which I was trained in. And I have the advantage of
my own cultural classical form, which is African. I'm
very clear on that, I don't have any problems in that
area, but many black people do.

The art women in New York, around '75, started
having panels and inviting the guys to be in them; as
far as they were concerned everything was fine because

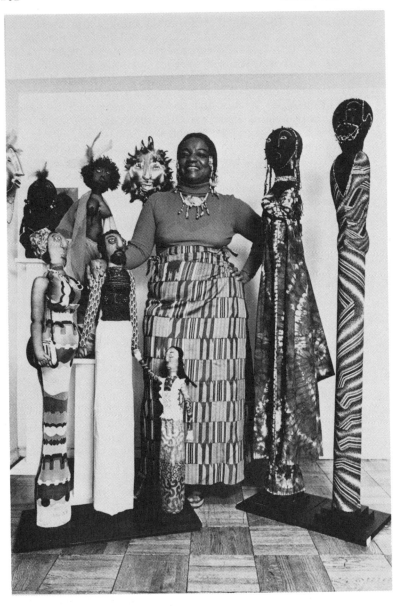

Photo credit: Ellie Thompson

it looks as though everybody is together and the men
accept the women and the women accept the men, and
so now we'll just sit around and talk. I looked at
them and I said, "Nothing's changed." And it hasn't.
It's still individual women who get there. And if you
don't have the stamina, if you don't have the power,
if you don't have the money to keep yourself up, you
don't get there. And that's that. The movement is
not going to change it, and the movement is not going
to put you there.

It's a very personal, private consciousness-raising.
You've still got to come home and deal with that hus-
band in your house and those kids who don't know any-
thing about any of it and they don't want to hear it.
All they want is what mommy's supposed to give them.
You've still got to deal with all of that.

SS / You were talking before about the pieces that you're
doing now. They're your society in a way.

FR / Yes, I think they are. After I came back from Africa,
I started using feathers and doing primitive things. I
looked at the first one I did and thought, "Oh, God,
there's something wrong with this." And I thought,
"I can't continue to do this; it's too primitive." Then
I said, "Wait a minute. What is primitive, what are
you talking about? You've been brought up in this
ultra-sophisticated New York milieu with its psychology.
But this is not a fragment of anything, it's not an un-
derstatement of something, it's not a part of something.
It's the whole thing." And that's what primitivism is.

SS / And they're powerful.

FR / That's what primitivism is. It's the whole thing.
It's the entire statement. It doesn't try to be subtle,
not say a little bit or hold back some. It goes and
says it all. So I said to myself, "Don't worry about
it. Do it anyhow and we'll see where it goes. Just
forget it. If you want to use feathers, use them."
Now you can see the last piece I'm doing. It's com-
ing back to a more relaxed feeling.

SS / The red one?

FR / No, the family. The three people on the floor. I'm
coming back to a more American statement. It's

evolved. I used my feathers, I did my primitive
thing, although I'm still going to use some aspects
of it because it's something I learned and I saw in
Africa.

SS / Your use of brocade is interesting ... it's not hard
but it's powerful, and the brocade is so sophisticated.

FR / Let me tell you what this brocade is. This brocade
is worn by Nigerian women on their heads. They wear
stiff, huge headdresses that stick out; they have points
that stick out and they wrap this cloth around their
heads. This stuff is very expensive. I had seen the
women with those huge headdresses with the stiff points,
but I didn't really know what it was. These designs
are made up for them and they're registered; see where
it says "registered design"? They're different types
of designs in different colors; they have registry num-
bers. The piece that I have might sell for two, three
hundred dollars here. I went to the marketplace and
I bargained there, and I bought them for much less.
I thought that brocade was just too much! The history
of this pattern probably dates back to the early slave
days. The Africans copy everything. They took silk
from Japan, silken cloth, and unraveled it and rewove
it into their own design. Artists are so much a part
of African life that it just amazes me that black peo-
ple don't embrace it. I made masks out of these bro-
cades.

SS / They're beautiful.

FR / I did masks in '76 and '77. After I went to Africa
my masks changed. I did my very first mask in 1973.
I've done many different kinds of masks. And all of
them can be worn.

SS / I would really be proud of myself if I had made that.
The underneath part is of foam, right?

FR / Yes, I just cut the foam and sew it, and then I fit the
nose on top, and stitch it, and feel, and push, and
it's sculpture, as my husband said recently, when I
took a few of these up to our house to finish them at
night. When he came home, he would see one and
I'd bring it back the next day and he would say, "This
is really some fine work you are doing." So I said,

"Do you like my dolls?" He said, "No, these aren't
dolls. This is sculpture." I said, "Oh, why do you
say that?" He answered, "Because of all the work."
Isn't that typical of men? He said, "Now the little
ones over there, those are dolls. But these big ones
are not dolls. These are sculpture because of the
work." He's full of crap, because there's a lot of
work on the little ones. But I love soft sculpture. I
am crazy about it. I like doing things with sewing,
and I don't see any reason why I shouldn't just because
somebody said that's what the women do. It is what
the women do. So what?

SS / It's sure going to take somebody like you to help the
Women's Caucus for Art along. Otherwise, what hap-
pens to the rest of us?

FR / We need a hard core of women who have the ability
to organize things. I think that people have to be open
and understand that everybody doesn't do things the
same way, and that you're not wrong if you do things
differently. I'm very proud of what's happening with
women, I think it's good. I'm not proud of what black
women are doing, because they're not organized. I've
tried to have consciousness-raising groups here. I
was one of the early founders of a Black Feminist Or-
ganization. I tried to start a consciousness-raising
group of my own. Nobody came. I said, "Listen,
why don't you people who are interested in art come
up to my house and we'll start a consciousness-raising
group?" But oppressed people always think they know
all the answers to everything. They're accustomed to
the big man having his foot on their back. So they
said to me, "What do you mean? All the artists? A
consciousness-raising group doesn't have to have just
people who are interested in one field. It can be any-
body." So I said, "Maybe yours can. The one I'm
having at my house has to do with people who are in-
terested in art. You can do anything you want. I'm
telling you what I'm doing. You mind?"

SS / I like it.

FR / Consciousness raising is for people with common in-
terests. It could be women who have small children.
It could be women who are widows. It could be women
who are blind. Whatever. But there's got to be some

meeting ground, and I figured a good one would be art.
It is a good meeting ground because there are art
consciousness-raising groups here in New York among
the white women in the art world, groups that I could
have joined. I wanted to belong to a consciousness-
raising group that had to do with black women. But
nothing happened and nobody came. That was miserable.

SS / That difficulty you were talking about earlier, the
double problem that black women face, isn't something
I ever considered before.

FR / Well, it's there.

SS / You are also an artist. Even if you were a white
male, you'd have trouble with that.

FR / Oh, right, right, right! That's what my therapist
told me once. She said, "Let's just think about the
fact that even if you were a white man, you'd have
problems. We can just talk on that level. And you
expect to be successful; that's the thing that upsets me.
Don't you think you're being unrealistic?" I said, "Well,
maybe, but this is my life, and I want to do what I
want to do."

SS / You always were going to do it, too, weren't you,
since the beginning?

FR / Let's put it this way: I always knew I wanted to be
somebody. I think that's where it begins. People de-
cide, "I want to be somebody, I want to make a con-
tribution, I want to leave my mark here." Then dif-
ferent factors contribute to how you will do that. Since
I've been an infant, I can recall feeling that I had
something special to give. I wasn't quite sure what
it was, but I always did drawings and I always did art.
I never thought of art as something people do for a
living. I thought art was just something everybody
did. It never occurred to me that I would be an Art-
ist, because art is something you can always do all
your life. It was only after I graduated from high
school and they said, "Well, what are you going to
major in?" And I said, "Oh, that's what they do!
OK, I want to be an artist."

SS / That takes guts.

FR / I wanted to go to Pratt Institute, but my sister was
going to New York University, which was very expen-
sive. My mother and father were not together at that
time, so I couldn't go to Pratt, because that would be
too much money. I had to go to City College; and
since they did not accept women in the School of Lib-
eral Arts in 1948, I had to go to the School of Educa-
tion. I majored in art and minored in education.
Now, of course, there are women in the School of Lib-
eral Arts. But not then. I got my degree in '55, and
women weren't there even then. If they were, I would
have switched over immediately. No, I got my mas-
ter's in '59 and women were not there then. They
must have entered early in the sixties. I had that ed-
ucation degree so that I would be able to teach, but I
had all my credits in art.

SS / That's not so long ago.

FR / No! That's why everybody is so shocked. When Lucy
Lippard did an article on me for Ms., the Ms. people
said, "We better call and make sure." They called
up City College and found out I was right.
 Once in Africa there was a black and African festi-
val of culture in Lagos, Nigeria. There were fifty-
eight nations of black people there; I was there with
some of the American participants. I couldn't hang
my masks there. I had made three black masks, the
woman mourning with the veil, and two others. The
three masks represent the history of black people in
America. They're Bena and Buba, two young black
people, and Mama mourning. It's the eternal story
of the weeping of mothers over the plight of their chil-
dren. I took those masks to Africa and the Africans
loved them, but I couldn't get them shown with the
American exhibition. I could not get my work seen;
I couldn't get my work hung at the festival there.

SS / What excuse did the people use? What did they say?

FR / I'm not talking about the African people. The African
people were fine. Fifty-eight different nations of peo-
ple were there; you had to worry about international
relations. The Africans had to be careful that they
didn't do something to offend some other nation. So
every country took care of its own business. The
Americans were in charge of our exhibition. They

felt my work was craftsy. I think in some funny way
they felt burdened as black Americans coming back to
Africa after the four hundred years when we first
started coming over here. Here we were returning,
some two hundred and fifty of us, for the first time
that that number of black Americans had gone to Africa
to be together in something. (I know tours go all the
time, but this was really a momentous occasion.) This
is one of the reasons why I stay in trouble all the time,
because I'm not supposed to say any of this. I think
they felt that we were supposed to bring a more en-
lightened concept of art, that we should bring art that
is more Europeanized, more so-called modern, more
Westernized. And here I was doing something that
had the look of primitivism, using masks, not at all
European. Not what they want people to think American
blacks are into. So they were negligent about putting
up my work. I went the day before the exhibit was
supposed to open, and they couldn't find my masks.
That was the second time they had been lost. And
then I found them. They weren't even thinking about
putting them up. The whole show was up. I wondered
where the hell were my masks going? Then a guy
said to me, "Oh, we planned to put them up there."
"There" was a bannister in the huge exhibition hall,
and then there was this high railing way up there. I
said, "No, my masks can't go up in the air like that."
Then he had my work with some craftsy looking things,
or he said, "We might put them in a case." In other
words, my work was craft, not to be considered ser-
ious art, and therefore should be pushed to the side.
I said, "I don't need this. I don't have to take this."
I took my masks and went down to the village. I took
them out of the show. The next day was the opening,
and the President of the state came with all the rib-
bons and the long procession and they were doing every-
thing with pomp and splendor. I was standing there
and I had my masks. I wore my masks at the open-
ing.

SS / You wore them?

FR / Yes. The African people loved my masks. They
 know that we are a black people coming home. They
 understand that. When they saw me in the masks,
 they thought it was perfectly natural for me to do that.
 They know the mask is an African invention and that if

it's coming home, that's fine, that's just beautiful,
it's a natural thing. Whereas the black Americans
felt that I should be doing something more Western,
more white. So Kodú, a young black woman I know
who has taken an African name, came over to me and
said, "Faith, I've heard about this problem. I want
to have you on television. I'm going to get a talk-
show spot. We'll discuss it; you can tell everybody
what it's all about." Nigeria now is at the beginning
of everything. They're like we Americans were in the
sixties. Everything's possible. They've got money,
they've got oil, they've got everything, they're doing
everything. Kodú was there from America, working
with the festival. She said, "Just to show you how
exciting things are here now, all I had to do is ask
for a television program and I got it." She said,
"We're on tomorrow morning." I went on the next
morning; I wore my masks and I talked about them,
about what they were and their political significance.

Many black American artists are busy trying to
prove that they can do art that is just as good as
somebody else's. And that somebody else is the Amer-
ican white. This is what they want to prove. And if
you're determined to do work that is just as good as
somebody's, you're obviously operating from a disad-
vantage to begin with. American black artists were
not interested in masks in terms of black people or
in terms of women because they feel as though that is
denigrating themselves. It's not elevating them. Their
concept is, if they're going to be black artists, they
have to reach up and aspire to a higher level of art,
which is European art as it is translated in America.

SS / Did any of the Nigerians feel this way?

FR / No. The Nigerians loved what I'm doing. But the
Nigerians were not in control of the American exhibi-
tion.

All non-Western people do crafts. Their art is
always craft, whatever it is. Everybody in the West-
ern art establishment, white men particularly, likes
to say that his art is "fine art." This conception de-
rives from Leonardo da Vinci, who first called his art
fine art to distinguish what he was doing from all the
other artists who were working at the time.

SS / Do you want to talk some more about the development

of your work? You got out of school and then you
taught art. Were you painting then?

FR / Yes. I was always painting. When the kids were
very little, I did watercolors, because I could carry
my watercolors around in a little package, and I could
go out in the country and I could use paper and I could
put it away easily. In '61 I went to Europe for the
first time. I had graduated, had my master's degree,
the kids were getting older, they were eight or nine.
If I was to be an artist, I was going to have to make
a studio in my house. I knew I had to take my art
out of the closet. I was separated from my first hus-
band, so I was living only with the kids. We went to
Europe because I wanted to see the paintings there; I
was painting at the time and that's where the paintings
are. I went there to see the art and to make sure
that that was what I wanted to do. In Europe I found
out I really did want to be an artist.
　　I came back and I opened up a studio. I really
loved it. In the meantime I had been going with my
present husband ever since I left my first husband.
He always said he loved me and wanted to marry me.
That was kind of boring, talking about that. But I
decided to marry him because, let's face it, I loved
him too. He's good to me. At that point I thought I
had to get married because that was the time that you
had to get married. I didn't have sense enough to say
to myself, "Look, you've got your master's degree, the
kids are getting older, you don't have to get married.
You can go on and do your thing."

SS / It wasn't an alternative, then, not to marry?

FR / Not really. So I got married, and we moved here,
and I set up my studio in the back. Actually there's
no back here but just a corner of the apartment. In
'63, I went up to Oak Bluffs in Martha's Vineyard and
started my first serious painting. I did a series of
paintings that I called "The American People Series."
I finished those in '67, and I had my first one-woman
show at a gallery in Manhattan, on Fifty-seventh Street.
My first show got very good reviews in Art News and
Arts magazine, and that was very, very nice. I did
large mural paintings. That was when I did my big
painting, "Die," in 1967, and "The Flag Is Bleeding,"
and my "U.S. Postage" commemorating the advent of

Black Power. In 1967 I was doing very political paint-
ings for that time. However, that was not an accept-
able way to do art in the art world. People did not
like political art. The black artists certainly didn't
like it.

SS / That's interesting.

FR / There has always been a problem of linking art with
money. Some women artists today will say there's no
women's art because they know that people don't buy
women's art. They think one should not say she's an
artist of something people will not buy. People didn't
buy black art then. They're not buying it that much
now, but they didn't buy it at all then. It wasn't prac-
tical to do all this political painting and link art with
politics when people don't want to buy that. Black art-
ists were saying not to do that. Just do abstract art.
Be untitled. I did political art anyway because I'm
always doing that. It was not liked in the sixties. The
black people didn't like it, the whites didn't like it, no-
body liked it. I did get quite a number of chances to
show them. Many people don't know me for anything
else but my paintings. They don't know about this
soft-sculpture development yet.
 I went into a whole period in the early seventies
when we were trying to relate art to poor people. I
was doing posters in that period. I did the "United
States of Attica" poster in 1971, which raised money
for the Attica inmates' families, and I'd give them
away to college campuses. I would give them a hun-
dred, two hundred posters and they would raise money;
they'd sell them for whatever the traffic would bear.
 In '72 I went back to Europe again. That's when I
discovered tankas, the framing of pictures in cloth.
 In 1970 we had an exhibition called "The People's
Flag Show" at the Judson Memorial Church. I'd been
doing flags all this time. I wanted to be on a com-
mittee to have a flag show. We met, and people said
I was going to get arrested. I said, "Don't be silly.
Who's going to arrest anybody about art?" True, at
my exhibitions I had noticed some guys in raincoats,
who didn't look like art lovers, who came in and took
photographs and left in a huff. I noticed that, but so
what? Anyway, we had a fantastic show, and Yvonne
Rainier danced with flags wrapped around herself. We
all made statements, it was fantastic. Two hundred

artists contributed works of art around the theme of
the flag. Jasper Johns was in the show, all the biggies
and littlies, everybody. It was beautiful. On Friday
we were about to close up, when three people came
to the door and said they wanted to see the show. They
turned out to be from the district attorney's office in
Washington, D.C. , and they arrested three of us for
desecration of the American flag. There's a long story
about this, that's very funny, that has to do with us
sneaking into the Tombs. I'm not going to go into it;
it's in the book I'm writing. The arrest was very funny.
They never did anything bad to us. In those days they
used to have what they called celebrity arrests, and that's
what we got.
 We had to close the show. We had our lawyers
ready, and the American Civil Liberties Union got us
to raise around $50,000. You're only as innocent as
you have money to prove that you are. We got con-
victed; we were fined $300. It was a suspended sen-
tence, but I wanted it turned around, and I still do.
I feel that it was illegal and unjust to arrest us. I
feel that I have a case and I want to go to the Supreme
Court and get that turned around. How the hell do I
know what's going to happen in this country next year?
There may be a witchhunt, and they may bring up that
old flag thing all over again.

SS / There's no reason why you should have to worry about
it.

FR / Everybody else who wants to use the flag for their
purposes manages to do it very nicely without any
problems. In 1971 I fell into a dormant period for
a while; that was a bad period. In 1972, as I said,
I went back to Europe and found out about the tankas.
And I started framing my pictures in cloth. I could
roll them up and put them in a trunk and send them
all over the country. I did my feminist series, which
was a whole political-landscape series with statements
written the way that the Chinese write statements in
their paintings. I wrote statements that black women
had made from preslavery days to now. I got them
out of a book Gerda Lerner had written, called The
Black Woman in White America. It's a rather good
book in some ways, and it certainly turned me on to
feminist statements that black women had made, that
I didn't know anything about. I thought I would record
twenty of these statements on paintings.

After I did that series I went back to Europe again
to be in the first American women-artists show there.
1972 was a big feminist year. I was traveling around
and talking. All the time, though, I had been teaching
art in the public schools. In January of '73 I quit my
job, so I could travel full time and do my work. Then
I started doing these masks. That's when I made the
one in the corner, there, "The Weeping Women" series.

I had been teaching African arts at Bank Street Col-
lege, but I never thought that any of that stuff had any-
thing to do with what I do. That was crafts; see, I
was thinking that, too. Then one of my students said,
"I don't understand, why are you painting? You're not
reflecting what you're teaching us." I thought, "Who
is this kid? Why doesn't she mind her business and
leave me alone? I have enough problems now and she's
bothering me!" Then I thought she had a point. That's
when I started making the masks as my art. I had
been teaching them for four years. I started making
the masks, using my beading technique, because I knew
how to do all kinds of African techniques of beading
and basket weaving.

Then I did the "Family of Woman" series. There
are thirty-two of those masks, women and children.
They're a commemoration of women I knew as a child,
because I was brought up in an extended family. I was
born in the 1930s, during the Depression. My father
drove a truck for the sanitation department, which was
a very good job in those days. We had money; every-
body else had no jobs, no money. We had a nice
apartment, and people used to come. There was al-
ways somebody who was getting dispossessed, so we
always had people living with us. It was nice, it's
fantastic how beautifully people lived together like that.

All my work has to do with what's happening in the
world. It always links up in some way. In '73 I got
very disturbed about the fact that black women were
not making a black women's-liberation movement. Black
women were not being felt as women. In fact there
was a series in the New York Times about black peo-
ple, about the new middle-class black. The articles
discuss blacks in the sixties. My daughter, Michelle
Wallace, called me up and said, "They managed to
leave the women out of it altogether. They didn't even
mention Angela Davis. We're just not there." In '73
I was very disturbed about this attitude. That's when
I said, "I'm going to forget about America; I'm going
to move to Africa." I hadn't been there yet. I could

imagine those women there before we were brought here
as slaves, which was the beginning of our oppression.
Having been brought here as slaves, we did not have
the pedestal to be put up on that white women had.
We had a kick in the ass and an order to get out to
the fields. This has, I believe, a great deal to do
with the fact that we are not into women's liberation.
We have to deal with the pedestal first. You have to
get up on the pedestal first, fall off it, bust your ass,
then know what to do next. That's why I did my "Slave
Rape" series. This was a group of tanka paintings
in which I show the beauty of the black woman before
coming here: in Africa, where she's free to be what
she is, and how she was taken and brought here. I'm
going back to that again.

SS / Your more recent work is softer.

FR / Yes. But you see these women? There are the women
who are in my "Slave Rape" paintings, only they're
running around in Africa. I don't have many of those
paintings; people bought them all up.

SS / Why that particular series?

FR / They loved them. I wish I hadn't sold all the ones
that I did. When I went to the University of Minne-
sota, a young woman came up to me and said she was
more moved by those paintings than any others. She
said, "You've got to go back, there's more to be said."
Because people didn't talk about rape in '73. And I
was talking about slave rape. I was making it clear
I was talking about black women. A black man told
me, "I don't approve of this. This is not what I like
to see." I said, "I don't think I have to ask your per-
mission to talk about my history." I'm just going to
keep right on doing it. In fact I might do some soft
sculptures on that theme.
 In '74 I started making my first sculptures, and I
hung them because I didn't know how else to do it.
The first ones had ropes in their legs. I used Wilt
Chamberlain as my first model, Wilt the Stilt. My
husband said to me, "Now don't make him up without
putting something in his pants. If you do that you're
not telling the whole story."
 So I gave him his penis. All my people have their
sex organs. I made a lot of Wilts and I would exhibit

them around. I used rope at first. I had not yet de-
veloped the facility for creating the foam rubber. The
head was made of painted coconut. I guess the first
foam-rubber shapes that I created were the penises.
I had to find a way to make legs because the students
want to see them. That's one of the values of having
a chance to show your work; you can develop because
you get feedback. After I was done traveling, because
I didn't teach from May to September, I would spend
time developing legs and bodies and creating forms.
 I started doing that, and I started my couples, try-
ing to create some feeling for the relations between
men and women. I believe that the relationship be-
tween men and women is the most difficult relation-
ship there is. It's very easy for women to say, "I'm
not going to have anything to do with men and I'm just
going to be with the women," or for men to say, "I'm
not going to have anything to do with women, I'm just
going to be with men." That's a cop-out. It's very
easy to do that, but to hang in with the opposite sex
is very difficult. If we can handle that, then maybe
we can handle all the other things in the world that
we can't handle now, like the problem between the
races. I think the male-female thing is first, and
everything else is after. Because that's the one that
goes into our bedrooms, that's the one that we can't
avoid. I can go certain places in this world and never
see another black person. I can go certain places in
this world and never see another white person, again
in life. But I can't go anywhere and never see another
man. There's no way.
 So that is the first consideration. I did a whole
series of couples. I still do male-and-female-relation-
ship things. All the time I'm developing my ability to
create sculptural forms using the foam rubber.

SS / Are you still doing masks?

FR / Yes, I'm still doing masks. The ones I do now, such
as "The Wake and Resurrection of the Bicentennial
Negro," are used in performance pieces. I've been
developing two things: the sculptures and the masks.
Now I'm doing stand-up sculptures. But they're com-
ing from the dolls that I've been doing since '73.

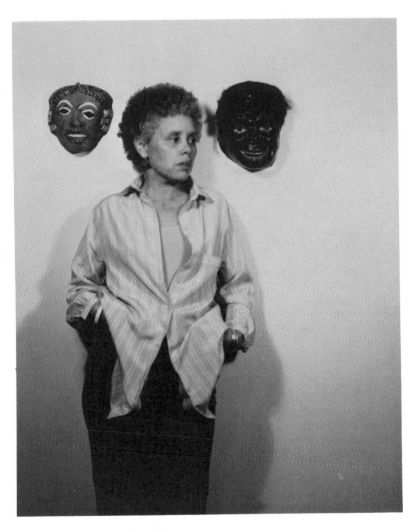

Photo credit: Lezley Saar

BETYE SAAR, construction artist, was
born in Los Angeles in 1926 and educated
at UCLA (B. A.), the University of Southern
California, Long Beach State College, and
San Fernando Valley State College. She
currently lives in Los Angeles. Her work
is in the Amherst Collection at the Univer-
sity of Massachusetts; the Wellington Evest
Collection, Boston; the Golden State Mutual
Life Insurance Collection, Los Angeles; and
the University of California at Berkeley.
She received a National Endowment for
the Arts fellowship in 1974, and appeared
on "The Originals: Women in Art" series,
WNET-TV, a PBS station in New York.
Her work has been discussed by Cindy
Nemser, "Conversation with Betye Saar,"
Feminist Art Journal, Winter 1975-76.
Recent exhibitions include Contemporary
Black Artists in America, Whitney Museum,
1971; Black Artists Exhibition, Los Angeles
County Museum of Art, 1972; and one-woman
shows at the San Francisco Museum of Mod-
ern Art (1977) and the Smithsonian Institution,
Washington, D. C. , 1977.

SS / Would you like to begin by talking about your development as an artist?

BS / My development as an artist probably began at birth, because I was always aware of light and pattern and shadows and color. Also probably textures. However, I did not feel that I was an artist until much later.

SS / How did your training as a graphic designer affect your emergence into fine art?

BS / When I was a student I studied interior design at UCLA, and later (after graduation) I designed postcards, brochures, and things like that. When I decided to get a teaching certificate after the birth of my second daughter in the 1950s, I began to be interested in printmaking.

SS / Were there any teachers who were particularly helpful and supportive, or whose work you admired?

BS / Dick Swift, who was a teacher at Long Beach State University, was very helpful and supportive. Later, after I left that university and moved to Los Angeles, I attended USC, and Don Lavier Turner was very helpful to me. I would say that both those instructors were the most helpful and supportive.

SS / What effect did Joseph Cornell's work have on you?

BS / When I worked in prints, I dealt with nature and my children. When I first saw the work of Joseph Cornell at Pasadena Art Museum (I think it was in 1957), it was the first time I had ever seen an assemblage. Naturally I was curious about it and decided that I wanted to participate in that kind of art experience. I then began to collect things. I went to a fantastic garage sale where a couple had accumulated things for more than thirty years and they were selling them off very reasonably. I found quite a few things at that time that started me in the making of assemblages. It wasn't until the transition between the prints and the

assemblages that I began to consider myself a serious
artist. Up until that time I suppose I considered my-
self to be a designer or a craftsperson or someone who
was interested in the arts. But I began to feel a ser-
ious link between the way I expressed myself, my feel-
ings, my ideas, and the materials that I worked with.
And also my work began to sell, and I began to get
more publicity and more of a reputation. That helped
me to make a decision to be an artist.

SS / I know that you began working as a serious fine artist
in your middle thirties. Did the pressures of being a
wife and mother have anything to do with this? Or do
you think that you might have become serious earlier
if you had not had these duties? Also, the fact that
your husband was an artist--what influence did this
have on you?

BS / Naturally, when my children were young, I did not have
the time or the energy to make art. As they became
older, then I began to have more time to make art.
My ex-husband was also an artist, and this at times
did present problems--especially when I began to get
some publicity and recognition.

SS / Many of your early works are strong political state-
ments. Would you care to comment on this?

BS / During the late sixties, during the black revolution,
the work became very political. I think that was my
way of responding to what was happening in the United
States and the treatment of the blacks in the South and
also a reaction to the death of Martin Luther King. I
had previously started to collect derogatory black im-
ages, and I recycled them into my work to express
rage or pain or just how I felt about this country po-
litically.

SS / Throughout your work I sense a powerful sadness.
Would you speak on the source for this? Also, death
imagery and the passage of time are powerful forces
in your work, do you feel that time passing is sad in
itself?

BS / The political statements in my early work mellowed,
became softer, became more feminine and became the
nostalgic works. During 1975, when my great-aunt

passed, I acquired a great deal of her materials, her
personal materials, such as letters, gloves, handker-
chiefs, flowers, and other paper material, which I also
recycled. This became the large body of work that is
the nostalgic series. Sadness is probably connected
with this, because it deals with passing of time and
with death and with loss and with the leaving behind
of materials and memories. Death imagery has played
a role in my work. I used to rely on it more strongly
than I do now. The colors, dark colors, black, skele-
tons, even the boxes, which are coffin-like, were very
important in my work: in the ritual works because
ritual somehow implies death and in the nostalgic pieces
because they deal with memorabilia that have a strong
death connotation. The more recent works have less
of that, as I am aware that I would like to move away
from using the death imagery. I think, probably the
passing of my aunt brought about reminders of feelings
of pain that occurred with the passing of my father as
a child. That was one way of dealing with the death,
by using these kinds of dead objects or memory works.

SS / Your work, you have stated, has been in three main
 areas, political, nostalgic, and mystical. How did
 these developments come about?

BS / My work merged from the prints into the assemblages.
 The assemblages first began as extensions of prints,
 and were concerned with the occult and mystical sci-
 ences; I had always been strongly influenced by occult
 diagrams I had seen as well as having an interest
 in palmistry, astrology, and phrenology. From the
 mystical images I began to derive a more universal,
 philosophical symbolism. And that is still apparent
 in my current works, although it may be merged with
 a political statement or ritual statement or with a nos-
 talgic statement.

SS / Would you like to talk about your use of color and its
 meaning for you?

BS / Color has always been important to me; sometimes my
 work begins as color. With the nostalgic pieces about
 my aunt I started with a black box or a cherrywood
 box or an oak box and would collect materials that
 worked with the box. For example, with the black box
 I have a black fan, a black rose, a black glove, because
 it all seemed to work to reinforce the death imagery.

SS / When you begin a work, do you have a complete idea
to start with or does the piece grow as you go along?
Do you work on one piece at a time or on several pieces
at once?

BS / I usually start on two or three pieces at a time, work-
ing on them, arranging, rearranging items, moving
them about, taking things out, putting them back in,
until I reach a point where one seems to be ready to
be finished. Then I concentrate my time and energy
on completing that. I rarely start with a complete
idea or even make a sketch to go by. I work intui-
tively, spontaneously, dealing with just the materials.
Sometimes the materials will give me one direction
and a message will develop other than my original con-
cept. I usually go with the new idea. The most cur-
rent work I can work on a little bit faster. It seems
to be little bit more abstract and flow a little bit eas-
ier, so I work on five or six pieces at one time, mov-
ing quickly from one to the other, and then concentrat-
ing on one as it nears completion.

SS / You mentioned that the boxes that you often use could
be said to be like coffins? Can you elaborate on this
idea?

BS / Yes, the boxes do seem to be like coffins, and as I
move away from that connection to death I seem to be
making fewer and fewer boxes and dealing more with
collage and two-dimensional surfaces, or a solid sur-
face, such as the printer's linecuts in which I decorate
the outside surface front or back or top or sides.

SS / How has your teaching affected your work?

BS / I consider myself a dedicated teacher. I like students
and respond to them, and have what I consider a good
rapport with the students. I get inspirations from
them; sometimes they work with certain materials or
imagery that give me some insight about an approach
that I would like to incorporate into my own work.
Ideas come very quickly from the least little thing
for me, and sometimes students stimulate ideas. I
like teaching, for those and other reasons.

SS / I would like you to comment on your thoughts on the
women's movement--what impact, if any, has it had in
your life and work?

"Gently Stalking Solitude" (1978)
Mixed-media assemblage, 9 3/4" x 7 3/4" x 1 3/4"
Photo credit: Lezley Saar

BS / I became involved in the woman's movement with
 Woman Space--not with the original Womanhouse proj-
 ect, but later on when they required a space. I had
 some feeling that the movement really didn't pertain
 to me because I was still involved with the black move-

ment. I didn't feel that I could particularly relate,
and in many cases it was difficult for me to relate.
But I also felt that the opportunity had presented itself
and that I should take advantage of it, that there might
be some kind of educational exchange between the
women of Women Space and myself. Sometimes it
was difficult because we just came from different points
of view.

SS / Have you ever been discriminated against as an artist
because of your sex or color?

BS / I have always tried to move away from an elitist at-
titude toward art, and since my art is not particularly
mainstream, sometimes I felt like an outsider. Some-
times I was discriminated against because of my sex
or because I was black, and sometimes I was discrim-
inated against because of the kind of art I made.

SS / Some people have stated that the feminist movement
is a white upper-class cause and that it has not much
to say to black women. What do you think of this?

BS / I feel that in the main the feminist movement is a white
upper-class cause, because Third World women, be-
cause of other necessities of just survival, do not al-
ways have time to devote to a movement like the fem-
inist movement. Also I have felt that even though we
do participate, black women still have a token part in
the woman's movement. I think that this feeling is
supported by documentation that has been made about
the feminist movement either in exhibits or in publi-
cation or in art forms, such as, for example, Judy
Chicago's "The Dinner Party," where there is just a
token representation of black women. I think that
probably has to do mostly with black or Third World
people still being invisible. We are still treated as
an invisible source or element. The research on black
artists is available, but not readily available. Docu-
mentation about women has been scarce, but documen-
tation about blacks and Third World people is even
scarcer.
 We have just been intentionally eliminated from his-
tory. The obvious ones, such as Sojourner Truth or
Phillis Wheatley or some famous entertainers, may
be written about, but there are many, many blacks and
Third World women who have made contributions to art

and music and literature and sports and science who
are just not given credit. Names may be used but
there is no mention that they are black or a Third
World person.

I don't have any particular anger or bones to pick
about this; it's just something that I am aware of. I
feel that as an artist, as a woman artist and black art-
ist, the imagery that directly pertains to being a black
woman has to be brought out to educate others, to make
people aware of black history, of our own sensibilities
and sensitivities. My current work is more abstract
and moves away from that, because I don't feel that it
is necessary for me to continue to preach. My inter-
ests pull along other paths and that's where I go.

I feel that my work has always had an element that
deals with a universal spirit, with an integration of dif-
ferent cultures, with different religions, with different
peoples; and I feel that as the planet moves closer to
the new age, that as consciousnesses are raised, my
work will be more and more accepted. Not that the
mainstream art flow has been greatly important to me,
but that art and literature and music will be more in-
tegrated into a universal plan.

SUSAN SCHWALB, silverpoint artist, was born in New York in 1944 and educated at the Carnegie-Mellon University, Pittsburgh (B. F. A., 1965). She now lives in New York and is a member of the Coalition of Women's Art Organizations, the Women's Caucus for Art, and Women in the Arts Foundation. She has served as art director for Aphra, a feminist literary magazine (1974-75), and Women Art News (1975-77). Her exhibitions include Watercolor Drawings, Open Mind Gallery, New York, 1974; Orchid Series, Rutgers University, 1977; and Women Artists 78, City University of New York Graduate Center, 1978.

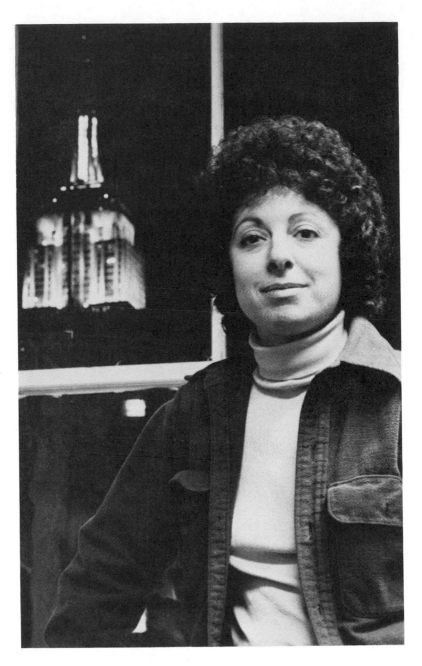

Photo credit: Remsen Wolff

SS / Let's start talking about when you decided you wanted
 to be an artist.

Sch / When I was a little girl, I wanted to be an artist, and
 I was encouraged from an early age. I think I took
 my first formal painting class when I was eight. I
 always wanted to be an artist; I didn't know what kind
 --that was never very clear to me. The first person
 I studied with was Anna Meltzer, who was a rather un-
 usual woman; I studied with her when I was eleven and
 twelve. She was a traditionalist, a very interesting
 artist who, like a lot of artists, doesn't have "a name."
 She did at one time publish books, and worked in a mu-
 seum. I don't know that I learned a whole lot from her,
 although I remember the pictures that I made there.
 I went to the High School of Music and Art, which
 was the first time I felt somewhat normal being an
 artist. I studied with some very good people there;
 it was a very supportive environment for me. I would
 have really died, I think, in a regular high school.
 Interestingly enough, I studied with May Stevens, who's
 now well known.

SS / How about your mother, Evelyn Schwalb, who is also
 an artist?

Sch / I knew you were going to ask me that. My mother
 has been a very strong influence in encouraging me.
 It tends to be good and bad if your mother encourages
 you to become an artist, when she is also an artist.
 She had a rather mixed career and background. She
 didn't get interested in art herself until she was mar-
 ried. She has problems with work, but she has al-
 ways done artwork on and off over the years. She
 likes to say she is my Theo. You have to have some-
 one who keeps believing in you. Admittedly, if it's
 your mother, you're not sure she's really telling the
 truth or not. Certainly when I was a young person
 she was extraordinarily important, and she certainly
 is today, because she still is quite a supportive per-
 son, both emotionally as well as financially.

187

Most artists don't like to talk about money, and
how they survive. I just had a conversation with some-
one about that, how most artists don't like to admit how
they make a living, or who helps them. I think it's
peculiar, because it's such a struggle; it's helpful to
know that someone else is going through what you're
going through. I think that's the case in everything.
No one pays my rent; I pay my rent. I think it's im-
portant to talk about that. I have always made a liv-
ing. I'm doing all kinds of commercial artwork, I
did a lot of design work at one time, and book publish-
ing, and I do paste-up, mechanicals, freelance; you
name it, I'll do it. Hire me by the hour. Anything,
just something to pay the rent. Most artists do sup-
port their careers and themselves. On the other hand,
many successful artists have been independently wealthy
to the extent that someone has paid a lot of the bills
for them, in order for them to have time. That was
certainly the case with Louise Nevelson. I don't know
exactly how many artists have to go out and earn a
living while they are working. I, for one, resent doing
it all the time.

SS / What do you think the solution would be--government
aid?

Sch / I don't know what the solution is. I have a lot of fan-
tasies about these things. It would be nice if the gov-
ernment supported artists, but I think that's wholly un-
realistic. And then you wonder under what stylistic
rubric would they support artists? I think that's the
problem right now with grants. In fact there is a hid-
den academy structure, whether or not we want to say
it. There's an established lineage of what's acceptable
art, and what's trendy, and there are people following
in that pattern, whether it's realism or minimalism or
whatever it is. If you're not in that trend, you're in
a lot of trouble right now, when you're talking about
grants, and you're talking about exhibitions.

SS / Talking about showing work, and to get back a little
bit to your developing as an artist, I know you were
in a show with your mother recently. How does that
feel?

Sch / Oh, it was charming. I was especially pleased for
her because I knew it would charm her for us to be

in a show together. We talked about doing a show to-
gether. I didn't know that that would happen so easily,
either that she'd have enough work or that the work
would be compatible enough to show together, or that
we could ever find anyone to show it. I was glad that
that worked out.

SS / Has she had a direct influence on the type of work that
you do?

Sch / No. I don't think so. I wonder if anybody specifically
has. I was talking about the academy before. My
problem is that I'm not in the academy. A curator
recently came to see this series of orchid drawings;
he wanted to know how I felt being outside the main-
stream--how was I surviving that. And sometimes
it's isolated; I can't think of another artist to call up
and talk about work with. I can think of artists to
call up and talk about the problems of surviving as an
artist, the emotional and financial problems, or advice
on how to show. I'm grateful for that ability to call
people. When I did the Rutgers exhibitions, a lot of
friends, artists, advised me. Either I had been learn-
ing from them over the years by watching or, speci-
fically, I called several people up to ask advice on
how to get the show reviewed or how to handle certain
aspects of the show. Fortunately I know people like
that. I don't have a group of people that I can iden-
tify with artistically. And I would love to have one
other person; that would be nice.

SS / Maybe you'll get a following.

Sch / I don't know. At this point I'm doing work that isn't
easily labeled, although people want to label it, they
want to identify my work with someone else's. Occa-
sionally another artist may mention a relationship with
my work, but the work is not similar at all, it's just
maybe the subject matter.

SS / Yes. That's a good thing to talk about ... the sexual,
political labeling that you must get.

Sch / Yes, I'm concerned about that because I never thought
my work was political. I believe political work is
propaganda. That to me is political art. That's how
I always understood the terminology. But a dealer did

tell me my work was political. I really was surprised.
From her point of view it meant there were, to her
mind, vaginal overtones to the work. But it's crazy.
Because I don't know that art work that has phallic
imagery as overtones is considered political.

SS / Is the vaginal imagery intentional? Or did it just
 come about?

Sch / Well, it's evolved, I think. When I was doing water-
 color five or six years ago and an artist said to me
 how sensual my work was, I didn't know what she
 meant. I said, "What do you mean, sensual?" There
 were for me floral images with other fanciful images
 with them. The work was more literal at that point.
 All flowers have that sensual feeling. I was at the
 MacDowell Colony a few years ago. I was doing land-
 scapes, which was what I primarily did before these
 orchid drawings, although these are landscapes, these
 have that landscape quality as well. But I was working
 from an existing landscape, at that point, in the country.
 I found that a great many of my pieces, much to my
 surprise, contained body imagery. It had to be pointed
 out to me, actually; an artist came to me and said,
 "Gee, I know you're doing landscapes but there are
 forms of a woman's body, or of a figure." It was
 something I hadn't even been aware of in the work,
 although obviously I had chosen it. I am aware of
 that tradition. I have seen work by artists who see
 the figure as a landscape, and I admire that tremen-
 dously, but these orchid pieces have evolved.... I
 know that there are some drawings that, depending
 on what line, what context, I place the original form
 in, have more of a feeling of a woman's body than
 others do. But it wasn't how I started the series;
 I don't think that's how you make art at all. The first
 set of drawings I made that had sensual overtones
 (after making them, and I liked them) scared me tre-
 mendously. I've tried to explain this. When I started
 them, I wasn't sure whether to hide them or not. I
 did them; I had them on the wall. But I wasn't sure
 I was ready for people to look at them or to see them;
 they seemed very personal to me. I wasn't sure how
 people would react. It concerned me. It made me
 nervous. And several artists encouraged me to go
 ahead with the series; they kept telling me how beau-
 tiful the works looked. I've just done that, essentially
 not caring what people see or think about the work.

SS / All artists tend to reach that point, I think.

Sch / It's still hard, because I want very much for people
to like my work, to accept my work; I have all the
ego drives of most artists. I want people to be able
to see my work; I like having my name in the paper.
I admit to all of that. So my feelings are mixed.
 These orchid drawings are very personal to me.
The symbolism of an unfolding is a personal feeling
and symbolism. They are flowers, but they are also
symbols of women. Yes, I have been skirting all of
this, talking around this, because I think work has to
be seen for what it is. I want you to look at it. I
don't want to tell you what it is. But for me they are
symbols of woman, of her beauty, of her struggle and
her determination and her independence. I've been re-
reading a little bit from a journal that I keep. I'm
expressing my interpretation that the orchid is an ex-
pression of woman's power, her beauty and sexuality,
and of potentiality. I don't want to title them, or label
them, although a couple of the works do have hidden
titles based on some personal image that I was think-
ing about while I was doing them. Maybe at some
other point I might openly title them. At this point
they are still "the flower"; I work from flowers as my
takeoff point, and I don't know whether I'm keeping the
image or not. After doing a show it ends the flow of
a series to a certain extent; I've been struggling a bit
since the Rutgers show.

SS / How long have you been working from the flowers?

Sch / I was always interested in floral and botanical forms.
As a student I never found working directly from the
human form especially interesting. But this particular
series of orchids started about two and a half years
ago. At that time I had a friend working at a florist's
shop, and I just began to covet an orchid that was in
the shop. She used to give me flowers at the end of
the week, the ones that they couldn't sell. And even-
tually this flower began to get old, and she gave it to
me. For a year or two preceding I had wanted to
focus on one subject. My studio felt crazy to me.
I had eight different series with eight different subjects
going at one time. This was a little room, and in
every corner I had some other little project, I had
done four drawings on something. And I just thought,

"Gee, why can't I get interested in one thing?," although I wasn't looking around thinking, "Now what shall that be?" But it was a feeling that I had, that I did want to focus in on something. When I got this flower, it sat here for a while, and after it dried I did about five to ten drawings of it. At that point I just became interested enough and I thought, "Well, maybe, can I do 50? Can I do 100?" I spent over a year working on that original flower.

I've done quite a number of drawings based on this original image. It's funny about an orchid, because I know I have some childhood memories about what an orchid is, for me. I don't know to what extent these memories influenced my work. But I do remember that when I was ten I did receive an orchid for my birthday from a sweet young man who came to a party that I had. It was an incredible gift! They're exotic flowers; especially if you live in the Bronx, an orchid is from the other end of the world, and they're expensive and unusual things to get. Special occasions, special things.

SS / They're a very unusual shape.

Sch / Yes, I'm just drawn to that. I was drawn to the images and the shape. I'm not sure whether I'll stay with this indefinitely or not. It's hard to say. Somebody today was telling me she might be able to get me some used orchids, and I'm instantly interested in that because I have never purchased an orchid. People who know of my interest have given them to me. Maybe sometime I'll buy myself one, a total indulgence.

SS / Get a black one.

Sch / Are there such things? That would be nice to have.... But, really, in the end, all explanatory information about art is essentially superficial. You do it and you can then explain why you do it. I keep making orchid drawings. I have a compulsion to make pictures and to work as an artist, even though I agree with our conversation earlier that one does sometimes question...

SS / ... the validity ...

Sch / ... the validity of everything, including the validity of being an artist and making individual artworks in a

very traditional manner. I think that my lineage is traditional, as an artist, although I like and have been interested in certain performance art and conceptual art and all kinds of things. I tend to like being a visual artist, working in the studio--although not all the time, of course and when I'm doing that, at that moment, it's all worth it, it's worth the struggle, it's worth the fact that I have no money, it's worth the fact that my life is ridiculous in most people's terms. I just go ahead.

SS / But your medium is quite traditional. Would you like to talk about that?

Sch / Well, silverpoint is an old medium. I've done a little research on it; it was the first popular drawing medium, in the twelfth, thirteenth, fourteenth century, up until the Renaissance. It was what people first drew with, this piece of metal. I suppose maybe before that they drew with a stick on the ground, but the first drawings were made in this technique. And it's really a rather simple technique; basically you draw with a piece of metal. I draw with a piece of wire, but I have shown people that you can draw with anything that's made of silver or gold or copper or anything that I'm using. It could be a flat piece, or one could get other kinds of effects than I get with it. The only complexity is that you must draw on a special kind of paper. You must prepare a surface or buy a surface to work on. I do both. I buy commercial papers. I think if I had to make every single paper I'd just never get anything done. I use watercolor to coat certain of the large pieces, as well as gesso. There's a variety, but you do have to use a coated surface. The chemicals are imparted onto the surface. I find it delightful that I'm using the original drawing technique. I found, when I was working with pencil previous to this, that I kept sharpening my pencils to get a finer and finer point, until I began silverpoint, where I had that fine point. I also rather like that the silverpoint does some kinds of transformations, it does do subtle color changes over a period of time; oxidation of some of the metals is interesting to me, that it goes from one color to another. Silver, when you put it on, looks grayish, and when it oxidizes it will be more brown. The tonality changes.

"Orchid Transformation #2" (1978)
Silver and copperpoint, 24" x 18"
Photo credit: Edward Peterson

SS / There's a difference between the ones on the top and
 the ones on the bottom.

Sch / Yes, those are older pieces, so that there's been a

coloration change. I like that aspect, that it does have
an aging process. That interests me.

SS / Do you feel an influence on your work by Georgia
O'Keeffe?

Sch / I would be very flattered to be mentioned with her,
because I think she's a great artist. I have known
her work, I admire her work tremendously. It's
strange that until I did orchids I never took a great
interest in her orchid pieces. I had seen them before
I did these; it's strange, because the show that I re-
member, the big show at the Whitney in the early sev-
enties, the pieces I remember from that show were her
cloud paintings. I have admired what she's done with
shells and orchids, but I don't know about a direct in-
fluence. I have seen her work, I love her work. I
don't think I am really doing what she is doing exactly.
I don't believe we're really interested in all of the
same things. What I've read about her concept of the
flower is that she's not interested in any sexual impli-
cation. On the other hand, I do see these implications
and I can't deny them--although it is unconscious for
me, as is the case in most art. Once it's out of your
unconscious and there, it's there.

SS / Perhaps it's true that influences are unconscious, too.

Sch / I don't know how you pin that down. There are people
where it's very clear who influenced their work by the
stylistic mannerisms they adopt. If you studied with
Hans Hofmann, who developed a school and a very dis-
tinct manner of painting, influence could be shown.
People compare me with Georgia O'Keeffe because of
the orchid image. I don't think they compare me with
her because of the way I draw, the kind of shapes
that I find.

SS / I was just thinking of the difference between how the
flowers that you buy, or get from friends, are con-
scious influences, and that artists also have uncon-
scious influences, too, that they're not aware of, that
they pick up.

Sch / Yes, because I have tried to work with some flowers,
but I can't work with them. They're the wrong shape.
I just got a bunch of one kind of flower, I tried a few

drawings with them, and I couldn't do anything. I just
abandoned that individual flower; it's just not the kind
of shape that I wanted to work with.

SS / We were talking about your mother's influence on you.
Did your father have any influence on you? Did he
support you?

Sch / My father's not an artist and has limited art sensi-
bility and limited education in art. He sent me to art
school, he paid for my education. I know he's very
proud of me and of some of the exhibitions I've had.
Like most people, he doesn't understand the process
of creating a work of art, the time it takes, the con-
cept. He can see the finished product, but what you
have to do in order to make that, how many hours in
the studio it will take, what you're giving up for it...

SS / ... and how many years it took you to get...

Sch / ... to any one point. I have so many years to go, to
my mind, in learning and being an artist. I think I
was, strangely enough, educated to become an artist
and allowed to become an artist because I was a woman.
I don't know, if I had been a man, whether I would
have been indulged. Although I did train to support
myself.

SS / But you have commercial training also.

Sch / Yes, I did study both. I took design courses in col-
lege--I just couldn't see the function of taking a paint-
ing degree. I wanted to know what I was going to do
with a painting degree. I am a little pragmatic about
that. I was interested in design early on, anyway.
At one point I got very interested in it, thinking that
that was what I wanted to do. In my college years
and for a few years afterward I actually focused more
directly on design as a profession. The decision to
become an artist was a very hard one to make. I
told you I wanted to be an artist when I was a child,
but to come to grips with being a fine artist and func-
tioning that way was very hard for me.

SS / Does the commercial work that you do have any effect
on your other work?

Sch / I actually stopped doing a lot of design work because it

was too draining. I still do some. It doesn't affect
or not affect me. I can draw very well, but I cannot
do illustration. At this moment, if I could think of
some other way to make a living, I would do it. But
I don't know anything else. You know, I'm not trained
in some other field. It's unfortunate that when one is
an artist one has to train in something else, in order
to survive and pay the bills. I would much rather be
an artist and survive. But it's much harder to do this
in our society, or in most modern societies. In the
Renaissance most artists had patrons to survive; if you
didn't, you didn't become an artist.

SS / Would you like to talk at all about the women's move-
ment, and its effect on your work and your life?

Sch / It's certainly important for me. I had been involved
with women artists, as opposed to the women's move-
ment at large, although recently I did have more con-
tact with the movement. It was important for me, be-
cause it was the first time I met a large number of
other artists. I came into the women's-art movement
feeling very isolated and very alone as an artist. It
was and still is very important to me to have met art-
ists and have the support of other women artists. I
suppose it must have had an influence on my work. I
consider myself a feminist, but I hate to be classified
as a feminist artist. I don't know what that means.
It's very political, and I don't want a title of that kind.

SS / Do you think it's a danger, if a woman is active and
shows in feminist shows, of being categorized that way?

Sch / I think you can be categorized that way, though artists
have told me that it's detrimental to your career if
you're identified with being in the women's movement.
The art world is a ridiculous place, and I can think
of artists who have identified with the women's move-
ment who are successful, and those who are not iden-
tified and are successful. I think it has little bearing
in the end. It has to be the work. I believe that.
I do believe that good work does and will surface, no
matter what happens, in the long run.

SS / What about the fact though that women, it is still true,
have a difficulty in showing in galleries, and particu-
larly the big-name galleries. You say good work will
surface and be shown, but I'm not too sure.

Sch / Well, not unless there are changes in thinking. There
was a time when it was completely unacceptable to be
a woman and to be an artist, and within recent years;
it's lucky now that it's a more acceptable position, just
because it's one less thing one has to suffer under
constantly.

SS / Do you think it has changed?

Sch / To the extent that, at least publicly, no one will put
you down. I think a great many dealers are still re-
luctant to take different kinds of work. But then,
they're in business. It is a very funny cycle. I'm
more concerned about the trend-setters, the people who
determine what is art and what isn't, what is going on
and what people will buy, and the fact that corporations
are the money-spenders in all arts, and so then it's
what's acceptable to their tastes. I think it's a rather
limited kind of thing. I think it's probably better now
than it was for women. I think, however, there's
still a long way to go. It's still difficult. The best
system for looking at work is not to know the gender
of the artist in judging a work of art.

SS / Do you think men's and women's art are different?
There's been lots of talk about female imagery.

Sch / You mean women's sensibility in art?

SS / I was thinking in particular of the book From the Cen-
ter, by Lucy Lippard, in which she says that women's
art is basically different from men's and that she feels
it needs to be different for a while in order to gain
recognition.

Sch / I think you may find men as well as women handling
what is considered women's subject matter. I think
what women are doing is making art that has not been
acceptable before. For example, one now sees a re-
surgence of fabric art done by men and women. And
it's culturally women's art. For myself, I'm the only
one who can make these pictures; they're my pictures.
 The fact is that women can now get together and
talk, and there are women's shows and women's courses
and art history has changed. There are all the other
materials available. When I was a student, I had no
major women instructors at the university level. The

few women who were there were ridiculed because they
were women. They were looked down upon, they could
not be as important as men. I wondered how I was
going to become a famous artist, being a woman, since
I saw so few.
 Later, seeing an exhibition of <u>Four Hundred Years
of Women Artists</u>, at the Brooklyn Museum, I was very
moved, because I was in the presence of all these
women, I felt all their souls and of course their work.
The saddest thing was that when it was over, it disap-
peared, and one can't go to a museum and see that
kind of equal representation, or see a great many of
those artworks and those artists.

SS / You were pleased with the show, then, and you felt
 that it was a good representation?

Sch / There were artists who were missing; it was probably
 not the best work by every artist, but it was an extra-
 ordinary show, just from the point of view that there
 were women working always. There were really good
 technicians working and good artists working, and often
 some great artists working. I don't think the climate
 has been especially good historically for a woman to
 become a great artist, based on the society. At this
 point it certainly is. The struggle is less, and there
 just are more women working, and encouraged to work
 and supported to work, so that there have to be more
 artists emerging. If you only have five women working
 and two thousand men working, from five you may not
 have an emerging great artist. If thousands and thou-
 sands are working, then there will be certainly top art-
 ists coming out of that number.

SS / Do you think that the women's-art movement will go
 on full force as it is now? Or is there some danger
 of it petering out in the next generation?

Sch / It depends upon how students react to it, and what the
 continuing goals are of the women's movement. I've
 been very active recently; I was very involved. In
 fact I was so involved it was too much for me. I
 backed off just a little at this moment. I don't know
 what the future is for it. Until art-history books re-
 flect a more equal representation, there has to be a
 struggle.

SS / Why does anyone want to be an artist?

Sch / I tend to believe you don't have any choice. People
have argued with me about that. If you have a certain
creative zeal or spark or soul, you don't really have
a choice about what will happen. I know I have to make
artworks, that if I don't make them, I don't feel well.
Something's wrong. I'm a different person on the day
that I've been working in the studio from the days that
I'm not in the studio. If for any reason I, for an ex-
tended period, can't work, where I'm sick or I have
to make money, or I'm out of town, if for some rea-
son I'm not in the studio making pictures or I haven't
made artworks, I start to lose a sense of identity. I
do think that you don't have a choice, you must do it
--although, I suppose, you have a choice to the extent
that you can give up at some point, which people do
all the time. They decide it's too hard a life. I
made a list this year of all the things I've given up
in order to make art. The more serious I've become,
the more dedicated I try to be, the more I try to work,
the more time I've devoted to art and less to some
other things. It was a very long list of things I do
not have anymore. The things that no longer inter-
ested me, or things I no longer have time for. Things
I like doing, but that I don't always take the time or
allow myself time for. I don't really resent it, al-
though it would be nice if you were a rich artist and
theoretically had more time. It's an illusion of mine,
that I'd have time for more things.

SS / I'm sure you'd have other problems if you had an in-
heritance.

Sch / There's always another problem. Incidentally, there
is something curious about being a feminist and being
an artist. I experienced this contradiction recently.
The women's movement's emphasis on women's inde-
pendence, financially or otherwise, is kind of contra-
dictory to the situation of an artist. As a feminist I
am independent, but the problem of money in art is
a substantial one. I'd be happy for someone to help
pay the bills. I think it's very hard for most people
to understand the life of an artist.

SS / And why you want to do it.

Sch / I mean they don't even understand what you do alone
there in the studio. They ask, "Isn't it lonely?" It

isn't--in the studio. Outside the studio, it's lonely.
You come home at night and you're tired and there's
not always someone there to talk to you. I never found
being alone in the studio lonely; that's the most pleas-
ant or the most torturous thing, depending on how it's
going, how your work is going, how your life is going.

The hardest thing to come to, either for myself or
any young artist, is to admit to being just what you are,
and believe that, whether people are caring or not car-
ing about your work. Certainly I've found the support
of friends, family, invaluable. I couldn't have sur-
vived without that.

SS / You mentioned that you keep a journal.

Sch / I've been keeping one ever since I was about seventeen.
I have quite a number of books filled. It started out
as a sketchbook, and I used to write in the back. And
it developed that now it's all written. I no longer keep
drawings in it, although I sometimes keep a sketchbook
around. I write about my work, about the things I see.
I'll go to an exhibition and take notes. If I see an art-
work that's really extraordinary, I'll write what I think
about it.

I write in it at different times, when I'm in the
studio, late at night, and can't sleep. I tend to do
most of my writing when I'm distracted, to unwind.
In the studio writing is sometimes a way to get into
my work, as well as to unwind or sort out a problem.
I find rereading my journal interesting. It's a record
of myself and my work. Maybe one day I'll reach the
point where I can do something with it.

Photo credit: Mary Baber

NANCY SPERO, painter, was born in Cleveland in 1926 and studied at the Art Institute of Chicago (B. F. A. , 1949); Atelier André L'Hote; and Ecole des Beaux Arts, 1949-50. She lives in New York. Her work hangs in the Judson Memorial Church, in New York, and the Massachusetts Institute of Technology. A film about her, "The Art of Nancy Spero," by Patsy Scala, appeared in 1972. A selected bibliography of writings about her work includes Lucy Lippard, From the Center (Dutton, 1976); Lawrence Alloway, "Art," The Nation, September 25, 1976; and Corinne Robins, "Nancy Spero: Political Artist of Poetry and Nightmare," Feminist Art Journal, Spring 1975. She has received a C. A. P. S. (Creative Artist Public Service) grant for 1976-77 and a National Endowment for the Arts fellowship, 1977-78. Among her exhibitions have been Collage of Indignation II, New York Cultural Center, 1971; Women Choose Women, New York Cultural Center, 1973; American Women Artist Show, Gedok-Kunsthaus, Hamburg, Germany, 1972; and Words at Liberty, Museum of Contemporary Art, Chicago, 1977.

SS / Let's talk about your early life and training. I know
you were born in Chicago, and went to Europe. Do
you want to talk about Europe at all? Any of the in-
fluences it had on your work?

NS / Chicago was under two influences at the time I was a
student. From the late thirties on there was an influx
of people from the Bauhaus establishing the Institute of
Design. Art at the Institute of Design was design func-
tional or pure. I and my friends were interested in
German Expressionism, Pre-Columbian Art, Oceanic
Art, insane art, etc. We used to haunt the Museum
of Natural History. "Primitive Art" was piled in cases.
It was as if the art was just pouring out of the place,
it was so rich in artifacts. The school of the Art In-
stitute was in the museum. There was a sense of con-
tinuity, of the students being right in the same building
as the museum. This was important. I am put off
when I have to pay now, going into a museum, because
in my early training I had this special entree to the
Art Institute of Chicago. One then assumes a kinship
or a natural alliance with museums. However, this
didn't prevent the students from carrying out actions
against the A. I. C. My first political actions in the
art world were in organized struggle against the A. I. C.
--actions and exhibitions that were enormously suc-
cessful.
 Chicago's always called itself the second city, and
I think I felt that way in confrontation with New York.
This attitude is typical of Chicago artists. For all the
art activity in Chicago, I always felt trapped in its
provincial responses. I left Chicago for good in 1956.
I disassociated myself and my work from what was
going on there. I disassociated myself from the his-
tory of Chicago art. For instance, my husband, Leon
Golub, is very much a part of the history of Chicago,
because he was considered of prime importance in
spurring the so-called "monster school" of painting.
Because of my attitude to many (male) assumptions in
this group, I opted out--partly out of resentment per-
haps, but primarily I was looking for different options

204

of how to function. We both wanted out for different
reasons--we found Chicago stifling.

SS / What about Paris?

NS / We went to Paris in '59. We went to Paris really to
bypass New York, to bypass Abstract Expressionism.
One would look at these massive art movements and
have to be swept up in them or fight them continuously
--which is also a drag. I showed at Galerie Breteau,
an interesting gallery with good space. Denise Breteau
had taken it over from her husband, who was furious
at her audacity. It was known to the younger artists
in Paris; it had an avant-garde reputation, an under-
ground reputation. She didn't have enough money to
operate it at a snappy commercial level, so it retained
an underground aspect that suited her very well, which
I really liked very much.

SS / Were there artists who influenced you there?

NS / No. I was still oil painting: tarot cards, lovers,
whores, "canopic" figures, and tomblike figures--
disembodied figures influenced in part by antiquity.

SS / And when you came back here, you started working
on paper?

NS / I was really fed up with oil painting. The Vietnam
war was going on. When I came back to the U.S., the
war struck me forcibly at both a personal and political
level. When one is an expatriate, you lose responsi-
bility.

SS / It's a different view in the press over there.

NS / That's right. But when you're in your own country,
you feel a certain responsibility, issues are involved,
and your're right here to participate. It coalesced with
my need to change media, and I had had enough of my
elusive disembodied art. I started to work on a ser-
ies of "war paintings" on paper, and they became really
wild. Instead of working for months on increasingly
dark paintings, the new work was quick and colorful,
spontaneous--but with horrendous subject matter. I
looked for the most extreme subject matter of destruc-
tion and devastation to symbolize the Vietnam war.

Bombs, helicopters, victims. The bomb assumed an-
thropomorphic form: the trunk of the body became the
trunk of the bomb; the cloud part, the explosion, would
contain ferocious heads spewing out the poison of the
bomb. The effect was very violent and the brushstrokes
were violent.

SS / Sex and violence seem to play a competing but inte-
grated role in your work.

NS / Yes. In this series sex and power, force, became
synonomous. I used sex in political terms.

SS / Isn't that true in your work still?

NS / Yes. Absolutely.

SS / The tongues are like daggers, in a sense.

NS / Very phallic. Besides being phallic, they are also de-
fiant. The work has many connotations.

SS / It's not erotic in a pleasant sense. I sense, when I
look at your work, a great deal of rage and hostility
and anger. Did this come about because of Vietnam?
Or was it there before, do you think?

NS / It was there before. In Paris I made oil paintings of
mostly lovers, sometimes mothers and children (earl-
ier there are more ferocious images). Many are ele-
giac. Some of the paintings approach violence, sexual
or otherwise; some of the mothers are pretty extreme.
I painted a mother with two children around 1956, an
image of protection, but it also looks like she's going
to eat her children. Another is titled "La Mère Fer-
oce," the ferocious mother. I did several "Fuck You"
paintings, small paintings on paper. Just kind of heads,
like the victims in the war series, emerging violently,
tongues extended, yelling "Fuck You." It's just gen-
eral rage. In a way it was probably beamed at the
art world. I didn't realize that there are certain rages
directly focused on the art world until the coming of
the women's-art movement.

SS / Do you think a lot of this was underneath and then the
movement helped you focus on it?

NS / That's right. The women's movement helped to demystify my illusions. I still can't understand everything about it myself, and I haven't gone into it sufficiently. But I understand quite a bit of what rage means to women.

SS / There's so much dealing with pain and torture in your work.

NS / When I started the war series, there was perhaps a pent-up rage, but the impetus was much more an absolute loss of faith, a great disappointment in the American system.

In 1969 I started working on Artaud, who was absolutely obsessed with pain in his body and mind. He was incarcerated for mental illness nine years before his death. Pain is all that he wrote about, the subject that I quoted from him, that I fractured from his fractured writing. The Artaud paintings became a personal political statement. I reacted to his description of physical pain, and his anger and anguish as an artist in bourgeois society. In his position as a pariah he couldn't fit into society.

SS / He's considered wonderful now that he's dead.

NS / Absolutely. I used his writings because they are violent, and there is nothing like them that I know. They express brilliantly extreme states of mind, extreme states of existence. For one year I used translations; subsequently the quotations are in the original French. I dared to transmit the ravings of a man (a man shunted aside from human intercourse) to personify how I, a woman, view lack of power.

The process isn't totally direct: it is layered. There are allusions to art things and art situations, there are all kinds of signals; it isn't a straight kind of reportage or quoting of Artaud. Also it isn't supposed to be illustrative, but it is supposed to show the effects of dismemberment, isolation, and violence. It is intended as political statement.

SS / What about the image of the printed word? That seems to be very important.

NS / I use printer's wood-type alphabets. I've used language on and off all along. I even have stuff from art school

that has language on it. But not with the great consistency of the past few years. I rely on it! I find language essential, direct verbal communication.

SS / Have you always worked at night?

NS / I can really only work at night.

SS / And you don't need so much sleep?

NS / I work until 4 or 5 a.m., but I compensate in the mornings.

SS / Aside from the imagery, there seems to be a particular darkness to your work, and I wonder if that comes from working at night, because you don't really use a lot of black; it's strange.

NS / It's possible. Because there is a quietness and a darkness and an isolation. There's no sun streaming through the window. I did a piece called, "The Hours of the Night." There were twelve hours in the Egyptian "The Book of the Dead," and I only made eleven. I didn't want the painting to be symmetrical. There are eleven vertical panels, each nine feet tall. The whole piece is about twenty-two feet long. There are messages, feminist messages, war terminology from Vietnam, smoke-damaged paper from a fire about four or five years ago, and all kinds of signs of violence and sex in the isolation in the night.

SS / That's when you need to work, so it makes sense. When did your work take on overtly feminist imagery?

NS / After "The Hours of the Night," I decided to use only the female figure. That was the start of the overtly feminist paintings. I worked on "Torture of Women" two years. In "Torture of Women" I am treating women with the seriousness with which men are usually treated, as the subject. The painting depicts the near-universal subjugation and sexual abuse of women from Babylonian mythology to the fascists of South America.

SS / Do you want to talk about the piece you showed me here

NS / Oh, "Canine Love," yes. That's a quote from one of

the church fathers in the twelfth century. Canine Love!
It sounds beautiful in Latin, Canino Amore. Gratian
issued his claim that women copulate indiscriminately
and promiscuously just like dogs.

SS / But that's a very exciting piece, I think, because it's
torn and cut and yet seems to rely solely on the let-
ters and the repetition. The paper you work with is
interesting. It's fragile and hard at the same time.
Would you like to talk about the papers?

NS / I work on hand-molded paper. The sheets are pasted.
Each sheet is attached to the next to make nine-foot-
long panels. This started with the war series when I
bought some Japanese rice paper, and I found I couldn't
work on it scratching and rubbing, reworking the im-
ages. I kept ruining the papers, so I decided I would
have to transfer images and glue them to the rice pa-
per. I would paint a helicopter on the rice paper and
then paste on eagles, victims, and other images. This
technique freed me to move the images or type around,
to cut and vary the disposition of forms, making the
format infinitely changeable or nonstatic. I can change
a piece if I don't like it subsequently; I can substitute
something else. I merely have to dampen the collaged
image and carefully remove it from the piece. I had
an aluminum plate made from one of my drawings for
"Torture of Women." An image of a woman bending
over, inspired by Egyptian art. It is a protective ges-
ture, but it is also a vulnerable position. She has four
breasts.

SS / The four-breasted figure is terrifying, too.

NS / That's right, because it's animal-like.

SS / That's a sexual position, too.

NS / Yes. And yet protective, the goddess hovering.

SS / You wanted to talk about your feelings about feminism
and art.

NS / I had a strange experience when I went up to Columbia
University to see the graduate M. F. A. exhibition.
There was a picketing, and evidently there had been
a violent demonstration of students protesting Columbia's

involvement in investments in South Africa. I could
see that the art hung in the rotunda of the library was
equated with the establishment. The picketing students
equated the artwork with the power of the university.
Columbia appeared big and powerful, structurally very
impressive; one can understand how the students felt
that the artists were participating in the system. Very
much like what goes on in the art world, too. The
artist who participates in museums may be under at-
tack for political reasons or resents being forced into
complicity with the government as it uses art (example:
M. O. M. A. and Abstract Expressionism) to enhance its
own image.

I have been thinking the last few months that some
women have been getting some art-world attention and
it's all very pleasant. I haven't gotten anything mone-
tarily, and I still have the same old problem with the
political aspects of my artwork, but nevertheless I
have more recognition and acknowledgment. Other
women are having things happen, too, and some are
doing well financially. In analyzing all this I think
that, because things have happened so rapidly, it is
time to assess again what our goals are and just what
is this alternate structure that we have built up or hope
to arrive at. Do we really want to join the other? I
think we have to to have our voices heard here as well
as through alternate structures, to assess joining the
established structures as well as figuring the need for
alternatives. Actually, we have not met our original
goals whatsoever, and we have been stopped in our
goals. Women artists are caught in tokenism.

People are going to continue to say, "What do you
women want? All the attention is on you, just what
is it you want?" Actually, if you take a hard look at
it, I don't think the situation is that much better, if
at all, than it ever was. I remember going around
with a group of W. A. R. (Women Artists in Revolution)
in 1970 to confront museum curators. We were de-
manding fifty percent equal representation in museum
shows. Well, this has not occurred. The Whitney
Museum, for all the picketing and agitation that has
gone on, still has not gone beyond twenty-five percent
representation of women artists in its biennials.

SS / I still think that it's true that women's work is viewed
differently today, evaluated differently, than it was in
the past.

NS / Absolutely. Women's work is being looked at more
 seriously, even if not as equal. There are more
 women who have the front rank in art these days. Yet,
 when it comes to the big things, there is still omni-
 present, virtually unshattered male control.

SS / Like the big retrospective shows.

NS / Yes. And in the galleries that have the most power
 there is still about the same percentage--or more ac-
 curately nonpercentage--of women.

SS / Do you have hope for the future? Do you have hope
 for women's future? That it will get better?

NS / It may have to be a new generation that comes up and
 takes over, because you need new ideas. It can't al-
 ways be the same people. Energies wear thin, and
 there have to be new strategies and philosophies com-
 ing in.

SS / But that will happen, don't you think?

NS / Feminism is a revolutionary state of consciousness,
 of taking nothing for granted. All assumptions con-
 cerning art, history, anthropology, are open for re-
 evaluation.

SS / The movement has affected everyone. One of the rea-
 sons I asked you if you did feel there was hope for the
 future and for women is that your art seems very angry
 and very negative, and I wondered about our civiliza-
 tion. Do you feel hopeful? Or do you think it's a de-
 caying civilization?

NS / My most recent piece, "Women: Appraisals, Dance
 and Active Histories" (it took three years to complete
 and is 20 inches high by 225 feet long), is full of neg-
 ative comments (by men) on women and their status.
 It also contains dozens of quotations speaking for women
 and their actions in the world. It can be considered
 very optimistic, a frieze of dancing women. In pro-
 testing, as I did in the war series, I intend a certain
 kind of hope for a better future. Systems are incred-
 ibly vast and powerful. And I don't mean the art sys-
 tem. Real power. But perhaps women's actions can
 affect these worlds of male domination.

SS / The whole works.

NS / Yes, the whole works.

SS / Do you think the art world is different, or the same
 thing?

NS / It is seemingly a special world, protected and isolated
 from the real world, yet it has its built-in pitfalls and
 anxieties, power pressures, and coercions. It's the
 same thing. The art world is a very small part of
 the real world, a reflection of it.

MAY STEVENS, painter, was born in
Boston in 1924 and educated at the Massa-
chusetts College of Art (B. F. A.) and the
Academie Julian in Paris. She lives in
New York, where she teaches at the School
of Visual Arts and is represented by the
Lerner-Heller Gallery. Her work is in
the Whitney Museum, the Brooklyn Mu-
seum, the Herbert F. Johnson Museum
of Cornell University, and the Everson
Museum in Syracuse, New York, among
other public and private collections. A
selected bibliography of writings about her
work includes Grace Glueck, "A Survey of
Women Artists," Art News, October 1980;
Donald Kuspit, "Art of Conscience: The
Last Decade," Dialogue, the Ohio Arts
Journal, September-October 1980; and
Moira Roth, "Women and Art in 1980.
Part I: Rosa Luxemburg and the Artist's
Mother," Artforum, November 1980.
Among her recent and projected exhibi-
tions are International Feminist Art, The
Hague Gemeentemuseum, The Netherlands,
with travel to six other Dutch and Belgian
museums and kunsthalles, November 1979-
February 1981; Art and Politics in the
Seventies, Wright State University, Dayton,
Ohio, 1980; Issue: Twenty Social Strategies
by Women Artists, Institute of Contemporary
Art, London, 1980, to travel to Glasgow,
Bristol, and other British cities; Images
of Labor, District 1199 Cultural Center,
New York, 1981; and a one-woman show
at the Lerner-Heller Gallery, New York,
1981.

Photo credit: © Lenore Seroka, 1978

SS / Would you like to start by talking about when you knew you wanted to be an artist?

MS / It's hard to pick out a particular starting point: I used to draw in elementary school. The kids would bring me sheets of paper and I would draw things for them. I was the class artist. So art was always present--in some form. As for being an artist in a professional sense, that was something I knew nothing about.

SS / When did you decide to go to art school?

MS / When it came time to choose a college, I chose an art school instead (the Massachusetts School of Art, now the Massachusetts College of Art). I was deliberately seeking something less academic, less conservative and traditional, than I imagined most colleges to be. This was New England, the Boston area, in the forties. My background was working class, but conservative in everything that had to do with religion, politics, and family. I consciously wanted to make my life more open, riskier, less predictable.

SS / Did your family give you any trouble about getting to an art school as opposed to college?

MS / No. As I remember it now, I went through a kind of crisis in my last years in high school. I was a very good student and I was expected to apply to very good colleges. But it was obvious to people who knew me that I was very troubled. I could not make those choices that everybody was making, that I had to make. I really didn't want to go to college. I didn't want to follow a path that I felt was laid out for me by others. I didn't want to be an academic success and end up being a teacher. I was an artist, a person who loved art and poetry. I spent hours walking by the tidal river near my home, an inlet from the sea, where there was oil scum on the beach and broken down wharves of an abandoned boatyard. I would lose my-

215

self in the sky and the light. I collected stones and empty shells, investigated the barnacles on the rotten wooden pier (dangerous to walk on) and listened to the sound of the water as it tore at the underpinnings of the very place where I was standing.

SS / Were you pleased with your art training? Were there any teachers who influenced you?

MS / It was low key, but nevertheless the life I shared with a small group of fine-arts majors was intense and passionate. Our teachers were not stars, but they each had their own peculiarities, their own frailties, and their own passions. They were supportive. They were humanistic. Most of them were men, and of course most of the students were women, especially because this was during the war years. We young women became very close. We had our own wonderful growing together, talking and thinking and learning, and just being together. It was tremendously stimulating, the life we shared. That's what I remember most. The teachers are shadowy beside what we got from each other.

SS / Later were there artists that affected you in your work?

MS / Our gods were the Post-Impressionists. We studied, looked up to, tried to emulate Van Gogh, Gauguin, Bonnard. And Cézanne, Picasso, and Matisse. No Americans at all. And no women. We didn't know of any.

SS / You have said that hard work and no shortcuts were part of the ideology of your background. How did that affect the way you worked?

MS / It's simply that I did not think about trying to break into the art world or seeking out people who could help me. I did not address myself to those problems. I knew there was a powerful art world out there, but it was so far away, so unapproachable (especially from Boston, where I was), that I didn't even dream of trying to become part of it. Boston had very little art life, few galleries, few one-person or group shows by living artists. All I knew is that I would paint. I had no intention of making paintings to sell. That would

defeat everything I was about. So I had to figure out
how to support myself and still have enough time and
energy to paint. Painting and making a living had no
relationship to each other. I knew that from the be-
ginning, and that made things easier for me.

SS / More real?

MS / Yes, I didn't try to put together an impossible combi-
nation, or what seemed so then, and, in truth, would
have been. I didn't know anybody who bought paintings.
I didn't even know anybody who bought reproductions;
well, I did know some people who bought reproductions.
 At some point in my life I became very conscious
of the fact that women could do things. One of my
earliest heroines was Joan of Arc--I made a picture
of her.
 When my son was small we played a game at the
table where you had twenty questions to guess who the
other person had chosen to "be." I would always pick
a famous woman, an important woman, one who had
done something in the world. Later I realized I was
doing it not only because it gave me pleasure to think
about them but also to teach my son. I wanted him
to know that women were people of consequence.

SS / How did the Paris years affect you?

MS / It made the art system a little more comprehensible,
because I joined a gallery and had my first exhibition
there. I was reviewed in the Paris press. I was
accepted in several large national annual exhibitions:
the Salon d'Automne, the Salon de Mai, the Salon de
Jeunes Peintres, and the Salon de Femmes Peintres.
So, suddenly, I was showing, I was being reviewed in
the same journals, at the same time, as Picasso and
Léger! And I was being taken seriously; those review-
ers treated me, my work, with respect. It was in-
credible. And it happened overnight.

SS / When you came back, what kind of work did you do?

MS / In my first exhibition (Paris 1951) I showed one paint-
ing with a specifically political theme; it was called
"The Martinsville Seven." Its subject was seven black
men who had been accused of a crime in Virginia. An
international protest had grown up around them. This

was the one painting in my show that was negatively treated. The critic of the New York <u>Herald Tribune</u> (which put out a Paris edition) said it <u>was defaced by</u> its title.

My work continued to take political positions, although not consistently. But enough so that many critics over the years have found it not "pure" enough, nor formal enough. Too disturbing.

SS / Do you feel that art without content is too reductive?

MS / The problem is with defining content.

SS / There are certain artists that are more formal, like Matisse.

MS / I saw the Matisse exhibition at the Modern. I felt myself in the presence of such joy. I was high on what I saw there, especially the cutouts, the drawings, the books, the swimming pool. Joy is content.

SS / When you start a painting, do you approach it in an intuitive way or are you more intellectual? It's hard because it's often mixed.

MS / I don't usually know where I'm going. At least I don't know where I'll end up. I've been influenced by the way the Abstract Expressionists think about their work. I watch what's happening as I work, carry on a dialogue with the canvas, as it were. I start with a concept, but after the initial moves I have to stand back and figure out what the canvas wants to do, where it's going. The surprises, the unexpected entries, have to be incorporated--or rejected and eliminated. If the painting is going to live, there must be an organic growth in its making. It's a little like the novelist who creates characters and then has to let them live their own lives. For me everything is in question until the very end. Sometimes even after that.

SS / Do you find painting large group portraits a different experience from painting individuals?

MS / But they are all painted as individuals even though their combination has an ideological meaning. Figures go in and out of these paintings as it develops. In the end it is different in color, composition, and

even in its dramatis personae than the original concep-
tion. The whole meaning of the painting shifts with
these changes. As I work I'm looking for the right
mix, for the flow between the various elements, the
resonance I need. I clarify the meaning of the paint-
ing for myself as I work. I don't know what I mean
until I've said it.

SS / Were you ever influenced by any historical paintings?

MS / I'm familiar with art history and I'm influenced by
everything. While working on "Soho Women Artists"
I looked at the Arezzo frescoes of Piero della Fran-
cesca--"The Death of Adam" and "The Legend of the
True Cross" with the beautiful still figures of the Queen
and her attendants, the flow of their garments, the line
of their heads and curve of their necks.
 When I did "Mysteries and Politics," which followed,
I was less specifically tied to a format. Originally I
thought I would move across the surface of the twelve-
foot-long canvas using figures that were nearly six
feet tall or would inhabit that space fully, moving from
the irrational, the mysteries, through color, gesture,
situation, to the rational, the political part, changing
the method of painting as I went, trying to invoke
those oppositions: the magic and the reality.

SS / Would you like to talk about the "Big Daddy" series?

MS / I showed some of them at Douglass as part of the
Women Artists Series that Lynn Miller curated. I
have great admiration for what she did in bringing
all those women in for the students at Douglass to see.
 As far as "Big Daddy" goes, I have already written
about it, spoken about it, and Lucy Lippard writes
very effectively on it in From the Center: Feminist
Essays on Women's Art. It's been explained and over-
explained. So much has happened since 1976, when I
did the last of them.
 During the eight years (1968-76) I worked on the
"Big Daddy" paintings people would ask me when I was
going to stop doing him. I would ask myself. But I
couldn't stop artificially. Also I wasn't ready to move
on in the sense that I felt I had nowhere to go ... that
was as meaningful to me.
 When I finally began to do other things, I used "Big
Daddy" as a background presence. It wasn't easy for

me to get over him. The move away was made pri-
marily through my version of the "Artist's Studio,"
taking Courbet's painting as a model. I did that 6' x 12'
painting while still working on "Big Daddy" themes in
other work. In my "Artist's Studio" I used the tri-
partite division Courbet used with a group of the art-
ist's visiting contemporaries on either side while he
works at the easel. I substituted myself for Courbet,
a "Big Daddy" painting for his landscape in progress,
my friends for his, and showed the artist seated be-
fore her easel/canvas. I chose Courbet because I like
his painting and I like his politics, his activism, for
which he suffered a great deal. Someday I'd like to
work with his "Burial at Ornans," a great, great paint-
ing, abstractly, ideologically, and in its realistic de-
tail.

SS / Do you want to talk about your use of color and form?
Is your use of color symbolic?

MS / Not in any one-to-one way. In the "Big Daddy" paint-
ings I used mainly red, white, and blue. Often I
wrapped him in the American flag, or used flag ref-
erences. I wanted the color to be as bold and blatant
as possible, so I limited myself and stayed away from
naturalism in color, from shadings and mixtures. I
used a cobalt for the background, in almost all of them;
I was unable to find another color that could be so flat
and opaque and still convey a sense of light and space.
 I still use that blue, but it has changed both by
deepening and becoming modulated by other colors.
I've begun to use purples and lavenders increasingly.
I allow myself more variations just as I allow myself
more mystery. I am more interested in complexity
than I was.
 I've recently fallen in love with a certain golden
ochre, which I found in the robes in Piero's frescoes.
I'm looking for a way to use it. I couldn't do a paint-
ing just for the love of ochre. It has to be part of
something. It has to work with form and meaning.
Where to use it, how to use it, why--I like savoring
that struggle ahead.

SS / Your use of lavenders and pinks in "Soho Women Art-
ists," does that have to do with the notion that these
are considered "feminine" colors?

MS / Not really. The purples came about because I started

mixing the red, white, and blues I had been using.
And I discovered a lovely transparent red-purple named
thio violet. The pinks developed naturally out of all
this.

Of course I'm fully aware of all the associations
colors have. I think of pink as tender and vulnerable.
I like it for that, its quality of being naked, exposed.

SS / I'm sure you're aware of Lucy Lippard's ideas about
women's imagery. Do they have any relevance for your
work?

MS / I am not interested in central imagery, which some
women have felt strongly about as an expression of
female identity and sexuality. That imagery is more
relevant to abstract artists than it would be to me.

As for a feminist tendency in art, I like Judy Chi-
cago's "Dinner Party" for its ceremonial aspect, for
the celebratory nature of women, across history, sit-
ting down together at the same table laid with embroid-
ered runners worked in the needlecraft of the time,
and set with plates and goblets expressive of that wom-
an's essence.

I like to look at pattern painting and the decorative
art of Miriam Schapiro and Joyce Kozloff and Cynthia
Carlson, although as a figurative painter I use patterns
differently. I have used handwriting and lettering as
pattern and information in some of my paintings. I
have spelled out Artemisia Gentileschi's history in gold
letters behind her nine-foot-high figure in a recent
panel.

SS / What about the idea that women have to make a state-
ment in a feminist way in order to be recognized as
artists first? Later that may not be necessary.

MS / And I have heard just the opposite said. Both ideas
are much too self-conscious and calculating. I also
dislike being prescriptive. I tell my students that their
biggest job is to find the thing they want to say. Even
when I was doing paintings against the war, I did not
feel then that everyone should be doing that.

What I would like to say is that I don't think that
any woman artist who is alive now, who is intelligent
and responsive to the world in which she lives, is un-
touched by the activity, the thought, and the excitement
that's been going on in the women's movement over the

"Mysteries and Politics" (1978)
Acrylic, 78" x 142"
Photo credit: eeva-inkeri

past years. Whether she's conscious of it, whether she admits it, or not. We are all touched by it. It's part of the way we think and speak today. It's the reason, or a large part of the reason, that we think and speak in such numbers and with such power.

It's too bad when some women refuse to recognize this, or feel they have to deny it. It's because they're full of fear. Some women are still afraid to acknowledge themselves as women. Most of us are more able now to admit our sources, our influences.

But it's all right to do anything you want to do -- what matters is to take it far, to take it deep.

SS / There are some people who think that art that uses fabric or portrays children cannot be serious.

MS / I think that's stupid.

SS / Would you like to comment on how the women's movement has affected you as a person and as an artist?

MS / First, the "Big Daddy" paintings were seen as strongly anti-patriarchal because women read them as such. I had conceived of them as anti-establishment, but of course it's the same.

SS / In some of them it seems that the heads are phallus-like symbols. Is that intentional?

MS / No, that's another definition that was given to me, which I accepted. But I am not Freudian. I haven't had therapy or analysis. That mode of thinking is not one I fall into naturally. I used to be annoyed when every vertical was seen as phallic. But in this case the analogy makes sense.

It's interesting when others see things in your work that you haven't seen. Sometimes their insights touch something in you. Conscious intention is not the whole story. I like to stop work, take a long walk, and try to come back to the work to see it as if for the first time. To see what happened while I was away.

SS / Have you personally felt that you were discriminated against because you are a woman artist?

MS / I know I have been. Being married to a man who is an artist makes it clear.

I was considered the artist's-wife-who-also-paints
for a long time. Even though my education, commit-
ment, amount of time devoted to work, etc. , were al-
ways equal if not superior (in certain respects) to my
husband's. When there were similarities in our work,
it was always assumed I was influenced by him, never
the reverse. And many small things. Like the gal-
lery owner who said, when I showed him my work,
hoping to show there: Why do you want to paint? You're
too attractive to paint. As if a woman only becomes
an artist when she has nothing else going for her!

SS / How did you respond?

MS / I have a very bad habit of responding to sheer stupid-
ity with an open mouth; I am aghast. I'm one of those
people who thinks of the savage retort at home later.

SS / One of the things I find interesting is that several of
your "Big Daddy" paintings are in collections in the
Midwest. One tends to think that is the home of Amer-
ican ideological conservatism. Do you think that's
strange?

MS / The most shocking thing was when some of an earlier
series of paintings I did on the civil-rights movement
in the South were acquired by southern museums. I
like to think those interested in art may be more lib-
eral, relatively, than others.

SS / Right. You mean than the populace in general?

MS / But it's important to realize that racism, for example,
is more easily transcended by those who aren't compet-
ing for jobs at minimum-wage levels.

SS / Where do you think your work will be going in the
future?

MS / I'm doing an artist's book for which I received a grant.
It's called Ordinary. Extraordinary. It will juxtapose
the lives of Rosa Luxemburg, who was a Polish/Ger-
man revolutionary leader, and my mother, who was a
housewife. I want to work with those contradictions.
I want to say that Rosa Luxemburg was both ordinary
and extraordinary and Alice Stevens is also ordinary
and extraordinary. As are we all.

The book will be composed of their own words, and images from their lives, collaged together. I showed some of the images (in color xerox) at C Space in New York, and I'll show them in Texas in April.

Speaking of putting political art into a conservative context, the Rosa Luxemburg work will be in Lubbock, Texas, at Texas Tech University--and that should be an interesting juxtaposition. But the people in the art department there felt it would be useful. I was there and I spoke in my usual fashion bringing in all kinds of political ideas (feminist and socialist). It took a while for people to understand what I was saying. At first they didn't even understand my jokes; how could anyone speak about very serious material and still make jokes?

By the time I gave a second lecture there, there was a lot of interest and controversy, people taking sides. I had broken through the wall of shock. There was shock reaction (which mainly showed itself in po-lite silence) to the first lecture. The second time it was more informal; people asked questions. There was more give and take. People were either very responsive or very upset. (The division was largely, but not entirely, male/female.) Also they cared about what I said, that I was criticizing their art department, which was overly staffed with men, and many of their practices in the art department. Not that they were very different from what I find all over. They were defensive, which meant they didn't totally reject what I was saying.

SS / At least you roused them. Would you like to speak about your own teaching?

MS / I've been at the School of Visual Arts for more than fifteen years and have designed several courses for women art students. I've invited many distinguished women to speak at the school. The last was Adrienne Rich. When she read her poem about Paula Modersohn-Becker, the students wept. I think when Adrienne reads, or Audre Lorde, another guest I've had, lives are changed.

Of Woman Born, Rich's book on motherhood as ex-perience and institution, was a part of my painting "Mysteries and Politics," in a vital way. I had just finished reading it when I started the work. Much of the emotion that went into the painting was stirred and

released by her words. I hope to include her in one
of my future works.

Several friends were at that point in their lives
when they had to decide to have children or not--just
at the point when I was reading that book and starting
to plan that painting. They were women in their late
thirties or early forties who were well along in their
careers as artists or art historians. They had to de-
cide if they could psychically afford to give up the idea
of ever having children; it was a difficult period for
women who believe in and fight for the liberation of
women, for their own selfhood.

SS / You have a son. Would you like to talk about how
 that affected your work? You did a series of paint-
 ings about him?

MS / When he was small and I was with him all the time,
 he was my main subject. Someday I'd like to use him
 again.

SS / Are you glad you had a child?

MS / Watching him grow was like watching the history of
 the human race unfold. It was breathtaking, all-
 absorbing. We used to say (from Pinocchio): "Little
 Steven made of pine/Rise, the gift of life is thine."

AMY STROMSTEN, photographer, was educated at the University of Michigan at Ann Arbor (B. A. , 1963), as well as at Stanford University, 1961; Cooper Union, New York, 1965-69, and San Francisco Art Institute, 1964. She belongs to the Art Workers Coalition, Minority Photographers, and the Ad Hoc Women's Group. She currently lives in New Jersey and teaches at Rutgers University. She has also taught photography at the New School for Social Research in New York City (1974). Her photographs have appeared in many publications, including textbooks, Popular Photography, The New York Times, and The Village Voice. She directed and produced a documentary radio program about Diane Arbus for WBAI-FM in New York City. Her exhibitions include Photomedia, Museum of Contemporary Crafts, New York, 1971-72; Women Choose Women, New York Cultural Center, 1973; Women Photographers, Emanu-El Midtown YW-YMHA 1972-73; a one-woman show at the University of Rhode Island, Kingston, 1973, and a one-woman show at Douglass Library in the Women Artists Series.

SS / Perhaps the best place to start would be when you
first got interested in photography.

AS / I wasn't interested until pretty late. I had a Brownie
camera, and the first time I took pictures seriously
was when I was an exchange student in Finland. I was
in high school. I took the Brownie and made a com-
plete documentary of the lake near where I lived out
in the country. Much later I went to Cooper Union,
which was what one often did then. At Cooper Union
I knew that I had to take photography; it was required,
but I put it off until my junior year because I knew I
wasn't going to like it. I was going to be a painter.
I had the sense that photography was not art, because
photographers do not draw. Then I took the photog-
raphy course. I'll never forget the minute that I saw
people working with the developer. I was very excited
about it. I loved the process of it; I loved doing it.
Not just taking the pictures so much as actually making
the stuff happen in the darkroom. By the time I got
done with Cooper I went through a crisis of giving up
painting, and it took a couple years giving up all the
paint stuff, and putting up a darkroom.

SS / When you were a student, were there any photograph-
ers in particular who influenced you? Or teachers?

AS / Not when I was a student! I was too dumb about the
whole thing. When I was a student, I lived next door
to Diane Arbus, and I had no idea who she was, that's
how dumb I was. Somebody told me she was really a
famous photographer, that I ought to get to know her.
So I showed her my photographs. I can't tell you how
naive I was. I would take my photographs in, and she
would give me comments about them. She did like my
work, and she was good for me. She asked me if I
wanted to be in her class in life photography. I never
did take the class.
 I was going to Cooper, and I had a male photogra-
pher as a teacher. I had heard he was very famous
and I saw his work, but we didn't connect. He didn't

230

like my work particularly. I was taking pictures of
my daughter. I had just had a baby and gone through
a divorce also, so I was having a struggle. I remem-
ber taking my photos in for a critique, and he said,
"Well, I don't like babies. I really can't give you a
critique." I couldn't believe it. I left school over
that. I didn't have a mentor at all except Diane.

SS / Did you ever see her work?

AS / I saw some of it, when I was in her apartment.

SS / It didn't affect you?

AS / No. What affected me was that she was an incredible
human being. She told me exactly what to do. She
saw through my nonsilver work. She said, "What
you're doing, you're using it to paint. You're making
frustrated attempts at painting, when what you really
need to do is look over and really deal with photog-
raphy." Secondly, she saw that I shouldn't stay in
New York. She said that I was really not a city pho-
tographer, that I was very involved with something else
that doesn't happen in New York. She told me to get
out of the city. It was on her advice that I went down
to North Carolina for a while. I remember writing her
a letter from there saying, "You were right." This is
where I started to take off as a photographer. I got
a sense of what I wanted to do. When I came back,
after she committed suicide, I was pretty wiped out,
and I did move out of New York then. You see, I had
no idea at the time what she was saying. I just didn't
know.

SS / To go back for a second, you were talking about the
professor who didn't like babies. How did you feel
about that?

AS / Looking back I can see that when I got involved with
the feminist movement, which was early in 1970 (I
was in the first women's march, and I was in the Ad
Hoc Women's Group), I began to realize what had hap-
pened with him. In that group, in early consciousness
raising, I realized what had happened to me. This guy
put down my art because he had evaluated it in a dif-
ferent light, namely making babies. I got very enraged
about it at that point. I hated this guy. I have since

learned not to feel that way, because it wasn't him;
that was how it was at the time. He is a good pho-
tographer. At the time, though, I had a big resent-
ment about it.

SS / Did you have any other problems in school with being
a woman art student?

AS / Oh, yes. At Cooper we organized a woman's group
because we felt very, very discriminated against. We
felt that the men in our classes were being treated
with great favoritism. The teachers took the attitude
that we were getting married, and we would make
little block-print cards at Christmas, and that would
be the extent of it. They did not take us seriously.
We all knew that. I just went through school with the
assumption that I wouldn't be taken seriously at school.
I don't know how I developed any sense of myself. It
was partly from the Ad Hoc Group, because Lucy Lip-
pard was at that time a leader of it, although we
shifted around to different lofts. I think that was when
I began to have a sense of myself as an artist.

SS / How about when you started to show your work? Did
you have any difficulty because you were a woman?

AS / Not because I was a woman, I don't believe that. I
think the difficulty for women artists, as I see it, is
believing in yourself and making a living, not becom-
ing submissive to someone else so that your career
suffers; all those elements are givens. When you go
to show work, I don't actually believe that you're dis-
criminated against. When I've taken my work around,
except with one or two galleries that just haven't re-
sponded, I haven't felt discrimination as a woman.
I've had good luck. I took my work around when I
was young and I got into a good show at the Museum
of Contemporary Crafts, the photo-media show in 1971;
I wouldn't say it's been easy, but no one has made me
feel that I'm inferior because I'm a woman.

SS / Maybe because photography is such an up and coming
field, there's less discrimination than there is in the
traditional fine arts.

AS / Maybe. It's hard to work in a studio; they'll tell you
it's hard to do fashion photography, but I never wanted

to. Right now it's easier to get a job teaching as a
woman than as a man, because institutions still have
to make up for the discrimination of the past.
 I feel that it's a great time to be a woman photog-
rapher, but I don't show in women's shows anymore.
I don't believe in it. I think that it's a very bad tac-
tic, and I don't advise my students to do that. I tell
them to work out the problems of being photographers
and try to deal with their own concepts about that.
But as far as showing, you show as a person, you
show for the concept. If you show in a women's gal-
lery I think you get wiped out, I think you're going to
be bypassed.

SS / It labels you, in a sense.

AS / Yes, it labels you, and also I don't think you're going
to be taken seriously. You've got to compete in the
world, you can't just sidle off to some private, clois-
tered area.

SS / Do you think that men's and women's work differ,
strictly because they are different sexes?

AS / No. I've never believed that. Especially in photog-
raphy.

SS / What advice would you give a young student about being
a woman photographer?

AS / One thing I do try to do is give students confidence,
because nobody ever did that for me. Nobody ever
said, "You're really good, you're really gifted, you
worked hard, you'll make it." I try to identify stud-
ents as being very gifted if I really think they are. I
say, "I think your work is good. Why don't you study
with so and so." I'll recommend someone as a teach-
er. I try to get them to understand that it takes hard
work and time. I believe that if you're good and you
put in time, then you can do a lot. I think that peo-
ple assume that it's instantaneous, as soon as you push
the shutter. But there's an incredible amount of work
to making a photograph.

SS / Do you ever discuss the problems about making a liv-
ing as a photographer and keeping your ethics?

AS / Yes, all the time. I teach at Douglass, as you know,
 and I often bring in my commercial work and explain
 what I'm doing. I've taken classes to New York very
 frequently to meet clients of mine. Once I was doing
 a job for an interior designer; I was photographing all
 sorts of hotel rooms to be renovated, because I love
 doing architectural photography. I took my whole class,
 and they were there while I did all the interactions,
 and they watched me do the billing and all kinds of
 things, so that they would understand the nature of it
 as a business. It's not a dirty business; you can
 choose what you want to photograph. You don't have
 to photograph things you don't believe in. There are
 many clichés about art that I think are stupid. I do
 commercial work, and I enjoy it. I did a raft race,
 for instance, on the Delaware, for New Jersey maga-
 zine. And there was nothing sullying about that. I
 loved it; I took my kid camping; it was fun. The
 "classic" dichotomy between being an artist and a com-
 mercial photographer is just bullshit; I don't believe
 in such a division. It's silly. You can do both.

SS / Does your commercial work affect your private work?

AS / It helps it, in my opinion, because I have to develop
 skills. I did an annual report down in Pennsylvania
 last year for a big company. There was every kind
 of fluorescent light in the world in the factory, and it
 was color. I'll tell you, learning to measure color
 temperatures is an important thing. Now, if I want
 to make a color photograph for myself I'll know how
 to do it in fluorescent light. I can tell you exactly
 what it's going to look like. Where I've had to learn
 something for a commercial job, then it's helped me
 in my own work.
 I have a wide-angle lens, which is my basic lens
 now. I could never have afforded it if I didn't do com-
 mercial work; it's a $795 lens. I paid for it by com-
 mercial work, and I always used it in commercial work,
 so I can't say that it's hurt my art to do this kind of
 work.

SS / Do you feel that a student can make it financially do-
 ing commercial, creative work?

AS / Depends if they're good, and if they work hard. There
 is plenty of photography to be done. That's the reality,

that you have to spend your day earning money, and
then the rest of the time you try to do your own stuff.

SS / Do you like to work in color? Most of your work
seems to be in black-and-white.

AS / I do work in color, but I can't do the paintings. I
take color pictures. I have piles and piles of color
negatives. I figure that, if it's important, then I'll
buy a color printer, and I'll learn to do it. Also the
reason I do the nonfilter work is that it does involve
color, it involves brown and blue. I'm also working
in a process called quick print, and that involves all
colors.

SS / Contemporary photographers have negative feelings
about color photographs because they feel they're not
as true, or they can't control them as much.

AS / That's because we don't know how yet.

SS / You think it will get better?

AS / I think it's a question of money. I would much rather
work in color, if I could afford it. It's just that a
box of color paper costs $50, and the chemicals are
expensive. I believe that in about ten years it will
all change and we will all be working in color. I think
that people will look back on black-and-white photog-
raphy as a thing of the past.

SS / Do you want to talk about the kind of projects you're
working on now?

AS / I have two main projects. I'm just finishing a book
on mobile homes and vans. It's the perfect vehicle,
it's a mobility vehicle, it's a mobile home, a mobile
van. It's a way of talking about America, and the
landscape. I had read the Philip Slater book The Pur-
suit of Loneliness, and another book called At the Edge
of History, by William Irwin Thompson. They both
talk about the cliché, mobility in America. I really
find it fascinating the way Americans physically move
around so much. That's really what I was photograph-
ing. I was married to an architect for a long time,
and he was very interested in site planning and the
way we use the land, and at that time I was very in-

terested in that myself. One of the jobs I had was
for an urban-renewal project in California, and I did
some thinking about what we do to the land. Many of
my photographs have to do with land use and what
we're doing to ruin our landscape, which once was so
pretty. That's part of the book, the way that the mo-
bile home looks on the landscape.

One out of every twenty people lives in a mobile
home in America. You don't realize it when you live
in New Jersey or New York, because here we don't
have as many. But when you go, for example, to
Tennessee, you see the whole state is covered with
mobile homes. You can't look anywhere and not see
one. It does an extraordinary thing to the landscape.
It's a very sad way to live. It's not the mobile-home-
owners' fault; they don't have an option.

SS / Another point I was interested in was that you said you
spent some time living in a mobile park in Florida,
and you photographed the people. I think it's inter-
esting that you use these people in a rather negative
way, as a commentary. And yet the people aren't
aware of that. Does this bother you at all?

AS / It doesn't bother me, because I don't think I'm crit-
icizing the people; I'm criticizing the system. I think
it's really sad that that's where they're stuck. It's
certainly not their fault. I'm essentially trying to show
what the system does to them. That's what the free-
dom-of-choice picture is about. We talk about having
all these choices and options and we really don't. You
can't buy a house in this country unless you're wealthy.
And you can't live in a decent place unless you're
wealthy. That's why so many millions of people buy
mobile homes. There's no other alternative for them.
I'm showing that concept. The people are incidental
to the larger form.

The second project I showed you, the Vietnam proj-
ect, has to do with coming to terms with the sixties,
coming out of my own feeling of being linked to anti-
war protests. Now I'm meeting with people who were
soldiers in Vietnam, so I'm trying to figure out where
that era all fits in. I find that I like these people. I
meet Marines who have killed people. I find that my
own biases from the sixties don't hold water; I have to
reevaluate those feelings. I don't know how to talk
about this without using a cliché, but I've gotten to

know people who were in Vietnam, and I've listened
to their stories, and what I've been realizing is that
they can't talk about it. No one wants to hear about
Vietnam. If you fought in World War II, you're a big
hero. If you fought in Vietnam, you do not discuss it
with anyone, anywhere, anyplace, because you're not
any kind of a hero, because we all hated the war. I've
become very curious about it, so I'm collecting scrap-
books of pictures that were taken in Vietnam by Amer-
ican soldiers. I find that this book is a real bomb-
shell, that these guys really go berserk when I talk to
them. That they've never talked to anyone, they haven't
shown anyone the pictures. They get very excited about
it. A very emotion-packed thing. I can't just show
their pictures; that would be meaningless. What I'm
doing is using a Van Dyke process that combines three
chemicals and you pour them; I take the chemicals and
mix them and pour them onto the large sheets of paper
and let them dry. And then I take the photographs of
Vietnam and some photographs I made in the sixties
and blow them up very large, on large negatives, and
then contact print that on the Van Dyke print. And
essentially it makes a new collage that has to do with
the Vietnam experience.

SS / What do you think of Rauschenberg's work?

AS / I like Rauschenberg.

SS / I recalled that he has some similar things.

AS / He's done some blueprints, yes. I don't think he's
done Van Dyke. But I'm definitely influenced by Rau-
schenberg. I think he repeats too much; I think he
could do about half as much work. It's very redun-
dant. But I think his work is great.

SS / There's an interesting correlation between both those
projects, the Vietnam and the mobile-home photographs,
and that's the isolation of the individual. I felt that
isolation in your photographs. Would you say that's
a major theme in most of your work?

AS / Up until a year ago it was, yes.

SS / It seems that in the mobility series the people were
treated more as objects, visually.

AS / Definitely. I didn't know them. They were definitely
 just in landscape. And the portraits are very differ-
 ent, because they're not wide angle, they're more per-
 sonal. And I know the people well. I know these
 people, and I know what they have gone through, I
 know their stories.

SS / The work seems quite different, and you said it's the
 first time you have ever done portrait work. You want
 to talk about this project a little bit?

AS / I've always been interested in subject matter. I don't
 think anyone should be a photographer who's not inter-
 ested in content, because that's the beauty of the photo-
 graph, that you do have content. If you're only inter-
 ested in form and in design, I think you're better off
 as a painter. Somehow for me total abstraction is
 not workable in photography. Content is very impor-
 tant, and I usually come to a project because of sub-
 ject matter that I'm interested in. I was interested in
 alcoholism, and I was interested in alcoholic recovery.
 One thing that puzzled me was why you couldn't photo-
 graph A. A. I like to photograph everything. I was
 thinking, "You can't photograph A. A.; it's against the
 rules, you can't do it." And it bothered me for a long
 time, that there was something you could never photo-
 graph. People have never been photographed as alco-
 holics. After a while I got permission from the peo-
 ple, one by one. I've been doing it for a year and a
 half, going to different places in the world to do these
 people. The idea is just to show that as an alcoholic
 you can recover and you can look great, and do well.
 It's just a very "up" project. I want them to look
 great, these photographs, I want the design to be good,
 but I want the people to look like what they are, I want
 who they are to come through. I wanted there to be
 eye contact in this.

SS / Has it given you a different feeling about portrait work,
 now that you've been doing this? Do you enjoy it?
 Would you like to do more?

AS / No. If somebody asked me to photograph someone for
 them, I don't know if I'd do it. I've done book jackets.
 I don't like just to take a person's picture. This A. A.
 project is exciting because I've been trying to make a
 statement about people, and I know exactly what I'm

doing. I feel like I'm meant to do it, and it's just meant to be. But just to do a portrait ... it's the pits. I really don't like portrait work.

SS / Let's go back to talking about the way you work. I think what struck me was the attention to detail and the light and dark, and the way, in the mobility series, you abstract, in a sense.

AS / Most of that detail comes from the lenses I use. I do use a good camera. I believe you shouldn't photograph if you're not going to do it right. You spend years learning how to use equipment, and to do all these things. I think you should become a good technician. I think it's stupid to go into photography and do any old thing. The medium offers so much technically. That's what photography is about--it's about becoming technically good and then using that technique expressively. That takes a long time. I don't even talk to my students about aesthetics. I teach them about film, and how to print. About the detail, I try to develop for sharpness; I'm looking for a very sharp medium. I also underdevelop slightly, because I like a thin negative, which makes the print darker and with more contrast, and that I like. I use certain printing papers, and I use certain chemical formulas in the darkroom that will give me the look that I want. An immense darkness behind. I'm very involved with line. I will look for lines, as in the photograph of the professor of classics I have. I will look for a situation where I can work with the lines, where the lines will go diagonally. I would say my favorite artist is probably Richard Diebenkorn, with whom I never studied, but I did go to the California Art Institute for a while and I was very aware of his work. What I picked up from him was the way that a line can go diagonally and so much can happen, from that line. He uses windows and doors also. I learned from looking at his work to put a situation together where I can use lines and entries, or exits.

SS / Your liking the dark background--does that have to do only with the visual impact or also with a statement?

AS / I'm trying to get as much emotional response as I can. A very flat picture isn't going to do it. It's more mysterious if you have dark.

SS / And it is a mystery in a sense. Particularly in the
 mobile-home series.

AS / Also a lot happens in the black areas. It's funny,
 because I like abstract painters. Rothko's a painter
 I like. As I said, though, I don't like abstract photog-
 raphy, but I saw so much happening in Rothko's work
 in the black as black. That's what happens with silver
 nitrate in a photo. I fill up an area that looks like it's
 all black. I've got a good photograph of Notre Dame
 Cathedral in which there's just a tiny little area where
 you can see the steeple and the rest of it seems to be
 dark; then you start looking and it has so many rich
 gray areas with things happening in them. And that's
 what I'm really interested in. I'm close to the dark
 sensibility rather than all white light catching, light
 development.

SS / What is your next project?

AS / I don't know yet. The alcoholism book will take me
 a while.

SS / Do you have more pictures to do for that?

AS / I have more people to photograph for it. The series
 will be shown at Neikrug Gallery in 1981, and then it
 will be published. Creative Camera is going to pub-
 lish five of the American landscapes, together with
 some of the alcoholics. There's a connection, and
 there's a written part to go with it. That'll come out
 next year. I'll probably go to London in a few weeks,
 and work a little there. I don't know after that, I
 really don't know. I have never boxed the Vietnam
 photographs. I'm not done with them. After that,
 I'll just see.

SS / What connection do you see between your American
 landscape work and the alcoholism work?

AS / It's partly what you said before, the isolation. Also,
 in the picture that you like with the brewery and the
 cemetery, there's a giant beer bottle looming against
 the cemetery, and there the connection between death
 and alcohol is very strong. That picture was a turn-
 ing point, because that's the last landscape picture I
 did before I got involved with the alcoholism project.

I really believe that I'll know what to do when it's time to do it. Right now I'm very involved with that project; I'm trying to get Betty Ford to let me do her picture, and some other famous people so that it's not all just "everyday."

SS / What kind of response do you get from these people? Do most people allow you to photograph them?

AS / Some people don't want to be photographed, and some change their minds. I have a release that allows people to call me and change their minds. One nurse I photographed was willing at the time, then got trans- ferred to another hospital where she felt that they weren't as enlightened about alcoholism. She called me and asked me not to use her photograph. That's fine. Up until the day of publication anybody can with- draw.

SS / What about your teaching?

AS / I like to teach at Douglass. Some of the students are great. I want to emphasize what I said before about feminism. I'm a mother, and I've given blood to fem- inist things in my life. I try to say to my students at this point that it's good to be a feminist, you have to be if you're going to survive. But to photograph specifically as a woman I think is a mistake. I toyed with the idea of doing a piece for Heresies magazine on women alcoholics. I thought, "I'll make alcoholism a women's issue and then I can publish it there," and then I realized that was bullshit. It's not a women's problem, it's a people problem. Most of the things I'm interested in aren't really women's problems. They're women's and men's problems. I don't see men as having such an easy time either. I'm not thrilled about the fact that men make twice as much money or eight times as much money as women. That's a disaster, and all those economic things are true. We've got to work constantly on those inequities. But I see that the task at hand is to be very successful in a man's world and then make it your world. That'll solve our problems. I don't think it'll be the same for my daughter; I think it'll be all right for her.

SS / Do you want to talk about motherhood and your work? Do you have any problems in trying to work and raise a little child at the same time?

AS / And mostly alone. It was horrible, absolutely horrible.
I'm not sorry, although I couldn't have managed with
more than one child. I don't see how anyone with
more than one child could be an artist. Although peo-
ple do it, and it's great. I did get flack from women
in the women's movement who said that I could never
be an artist and a mother. The reason I left the or-
ganized women's movement was that there was so much
hostility toward me and the child, and that the idea of
being a mother was criticized.

SS / Do you think that the women's movement has divided
women in the country?

AS / Yes. And made women very defensive. Since I've
been in New Jersey I've met so many women who
apologize for not working and not being feminists, and
it's so silly, because someone has to raise children.
That's also a great joy. I have gotten more pleasure
out of my daughter than out of my work. I love her,
and she's delightful and I have a great time with her.
I take her with me on trips all the time. She doesn't
like photography very much. I'm glad I have her.
It's very hard, though. For instance, I have to spend
half of what I make on child care; I always have that
expense.

SS / And the fact that women aren't making as much as men
makes things very difficult.

AS / Right. We make less and we pay half of it for child
care. You must have good child care. I did have
her in day-care centers when she was little, and it
was very bad. Disastrous. So I finally settled on
what's comforting to me, to have someone live here
and take care of her. Perhaps I won't do that any-
more; she's going to be ten next year. After she's
ten maybe I won't need that help any more. In her
early years I felt that having live-in help was one way
I could feel I wasn't making her life worse. With
children you go through all kinds of problems, and you
can never be free. You have to worry about them all
the time.

SS / Do you feel that she was ever jealous of your work?

AS / Oh, yes. She used to be. When I go into the darkroom,

she can't open the door because it will ruin the prints.
I kill her if she opens the door. So it's very isolat-
ing for her. But it's worked out. I feel that it's OK.
I did read a study that daughters of women who work
have higher self-esteem, that they see women feeling
good about themselves. Even though they spend less
time with their mothers, they will feel good about
being women.

SS / And about doing something with their own lives.

AS / Yes. She's very proud of me for being a professor
and a photographer; she tells her friends about me.
I know that she's proud of me, and that is very im-
portant. And she's planning, of course, to do some-
thing. She's not going to stay home.

SS / An interesting series for a photographer would be a
series on housewives' isolation.

AS / A woman from Bergen County did a very good book
on New Jersey housewives. This might be my next
project. I was thinking of doing pictures of Jamaican
women who live in as domestic help in very wealthy
towns. Everybody's got a live-in housekeeper, you
know, because you can't take care of your house and
your kids and work and everything. There's a whole
interesting underworld of Jamaican people who live in.
They have their own lives. They spend more time in
these houses than anyone else does. I've been think-
ing about that--that the people who really do live in
these houses aren't the people who own them.

SS / I'd like to ask you about the whole issue of photography
as a relatively new entry into the fine-arts community.
Do you feel that photography is given equal time with
sculpture and painting?

AS / Yes. Photography gets plenty of attention. It's a
great inflated market right now. I don't know how long
that'll last, because there aren't that many good pho-
tographs being made. There's an awful lot of garbage
being shown.

SS / That's true in the other arts too.

AS / It's true in everything. Eventually it'll settle down.

Photography gets plenty of attention. The real step-
child of the art world is printmaking, which doesn't
get reviewed, doesn't get shown as often. I think
that's really a problem, because printmaking is such
a viable thing. Photography is overkilled right now.
I see so much photography in magazines, I can't sub-
scribe to them all. I can't read them all. I'm very
glad I chose photography when I did. I had no idea
it would become so popular. I'm happy that Douglass
has a full-time photography job for me, because that
wasn't possible five years ago. I was the first per-
son in photography they hired. To me that's good,
I'm lucky. I don't know how long my luck will last.

"Bride, Route 1" (New Jersey)
Black-and-white photograph